Shaping Traditions

Folk Arts in a Changing South

A Catalog of the Goizueta Folklife Gallery at the Atlanta History Center

JOHN A. BURRISON

Object and Gallery Photography by William F. Hull

The University of Georgia Press *Athens and London*

© 2000 by the University of Georgia Press

Athens, Georgia 30602

All rights reserved

Designed by Kathi Dailey Morgan & Sandra Strother Hudson

Set in 10.5/15 Minion by G & S Typesetters

Printed and bound by Sheridan Books

The paper in this book meets the guidelines for
permanence and durability of the Committee on
Production Guidelines for Book Longevity of the
Council on Library Resources.

Printed in the United States of America

04 03 02 01 00 C 5 4 3 2 1

04 03 02 01 00 P 5 4 3 2 1

Library of Congress Cataloging-in-Publication Data

Goizueta Folklife Gallery (Atlanta History Museum)

 Shaping traditions : folk arts in a changing South : a catalog of the Goizueta
 Folklife Gallery at the Atlanta History Center / John A. Burrison ; object and
 gallery photography by William F. Hull.

 p. cm.

 Includes bibliographical references and index.

 ISBN 0-8203-2150-8 (pbk. : alk. paper)—ISBN 0-8203-2208-3 (alk. paper)

 1. Handicraft—Southern States—Exhibitions. 2. Folk art—Southern
States—Exhibitions. 3. Goizueta Folklife Gallery (Atlanta History Museum)—
Exhibitions. I. Burrison, John A., 1942– . II. Title.

TT23.5 .G65 2000

745.5′0975′074758231—dc21 99-043746

British Library Cataloging-in-Publication Data available

The publication of this volume was made possible in part by the support of the
Atlanta History Center.

Contents

Credits and Acknowledgments

FOR THE EXHIBITION

The Goizueta Folklife Gallery is made possible by a gift from Mr. and Mrs. Roberto C. Goizueta in memory of their son, Carlos Alberto Goizueta. The exhibition is sponsored in part by the Ford Motor Company, the Woodward Fund, and the National Endowment for the Arts, a federal agency.

Curator: John A. Burrison, Georgia State University
Coordinator: Janice Morrill, Atlanta History Center
Designer: Staples & Charles Ltd., Alexandria, Virginia
Media Production: Hillmann & Carr, Washington, D.C.
Fabricator: Murphy & Orr Exhibits, Forest Park, Georgia
Media Research Assistants: Susan Bryant and Craig Chaney

Advisory Committee

William and Florence Griffin, Atlanta; Maggie Holtzberg, Georgia Council for the Arts, Atlanta; Joyce Ice, Museum of International Folk Art, Santa Fe, N. Mex.; Ivan Karp, Emory University, Atlanta; Jerrilyn McGregory, Florida State University, Tallahassee; Cleater J. and Billie Meaders, Warner Robins, Ga.; Tom Rankin, University of Mississippi, University; Robert Teske, Cedarburg Cultural Center, Cedarburg, Wis.; John Vlach, The George Washington University, Washington, D.C.; Charles Wolfe, Middle Tennessee State University, Murfreesboro.

Additional Advisers

Gregory Coleman, Atlanta; Rossie M. Colter, Philip Simmons Foundation, Charleston, S.C.; Dorothy Downs, Miami, Fla.; Betty DuPree, Qualla Arts and Crafts Mutual, Cherokee, N.C.; David Evans, Memphis State University, Memphis, Tenn.; Joseph Hickerson, Archive of Folk Culture, American Folklife Center, Library of Congress, Washington,

D.C.; Sarah Hill, Atlanta; Beverly Patterson, North Carolina Arts Council, Raleigh; Delma Presley, Georgia Southern College Museum, Statesboro; Dale Rosengarten, McClellanville, S.C.

Object Donors and Lenders

Jack Alexander; Jim Allen; Mrs. J. O. Andrews; Atlanta Caribbean Association; Malcolm Bell Jr.; Big Bethel African Methodist Episcopal Church and Gregory Coleman; friends of Elizabeth Howell Bloodworth; Eleanor Brazell; Margaret Brock; Mary Seago Brooke; Jerry Brown; Roger Brown; Mrs. Castalow Burton; Lynne Byrd; Alma Cagle; Sherman Cagle; James B. Cartright; Pteleen Cash; Bennie Caudell; Center for Applied Research in Anthropology, Georgia State University, and Board of Regents, University System of Georgia; Ceramics Circle of Atlanta; Tom Chandler; Lourdes Chavez; Ann Cousins; Michael Crocker; Current Historians, Atlanta History Center; Annie Jo and Blueford Dyer; Joen Fagan; Forward Arts Foundation; Mrs. Rowland H. Geddie; Roberto C. and Olguita Goizueta; D. X. Gordy; Henry D. Green; William and Florence Griffin; Curtis Harris; Clara Head; Chester, Grace, Harold, Matthew, and Nathaniel Hewell; Benjamin Ray Holcomb; Louise Irwin; Helen Sewell Johnson; Jerah Johnson; Rhonda S. Johnson; Betty and Mak Kemp; Neill Harvey Lassiter Jr.; Steven Maroney; Charles C. Martin; Ola McDonald; Anita Meaders; Arie Meaders; Cleater J. and Billie Meaders; Lanier and Betty Jean Meaders; Mexican Center of Atlanta; Ernie Mills; Ronald Mitchell; Robert Mize; May Siong Moua; Martha and R. E. Mulinix; Anna Mary Camp Murphy; Jud Nelson; Mr. and Mrs. James Harold Nettles Jr.; Mrs. Broadus Phelps; Mary H. Philbrick; Mrs. H. V. E. Platter Jr.; Bets Ramsey; Olivia Harris Reischling; Cindy Rounds Richards; Marie Rogers; William Rudolph; Annie Scott; John D. Sewell family; Carl L. Stepp family; Jean Thomas; Kenneth Thomas; Andrew L. Thome Jr.; Joseph Treadway Jr.; Carol Tuggle; Betty Upshaw; Hulon Waldrip; Mrs. J. B. White; Max E. White; Retta P. Zuraw

FOR THE CATALOG

I am especially grateful to Bill Hull, Atlanta History Center staff photographer, for his fine photographs; as always, it was a pleasure to work with him. The assembling of illustrations was assisted by Kimberly S. Blass, Atlanta History Center, and Shelby Spillers. Thanks also to Atlanta History Center executive director Rick Beard and to Georgia State University's Department of English for their support.

Shaping Traditions

Introduction

Shaping Traditions, a permanent exhibition that portrays an American region through its folk culture, opened in the Goizueta Folklife Gallery of the Atlanta History Museum (a component of the Atlanta History Center, operated by the Atlanta Historical Society) on May 18, 1996. International visitors who came to Atlanta that summer for the Centennial Olympic Games had to search hard for evidence of the "old" South in the city. *Shaping Traditions* offered them an authentic slice of this culture and an unusual perspective on the modernization that is transforming it. A local newspaper review concluded, "This joyful and informative overview of southern [folk] culture is a welcome addition to the city and a must-see for Olympic visitors who want to understand our region."[1]

In most museum exhibits, the curators who shape them are virtually invisible, appearing only as names on a credit panel; rarely is the public made privy to the stories behind the scenes. But exhibits, like other human creations, are subject to economic and political realities, intellectual trends, and personal biases that may not be obvious to museumgoers.[2] In this introduction, I share some of my experiences as both collector and curator. This inside history of *Shaping Traditions* and the collection on which it is based will help explain the decisions that resulted in the final product.[3]

EARLY HISTORY OF THE BURRISON FOLKLIFE COLLECTION

In 1966 I came to Atlanta from my hometown of Philadelphia to develop the folklore curriculum for Georgia State University's Department of English. Armed with a graduate degree in Folklore and Folklife from the University of Pennsylvania, I relished the opportunity to explore a state that, for folklore research, was still unmapped territory. Little information was available beyond Joel Chandler Harris's Uncle Remus folktale

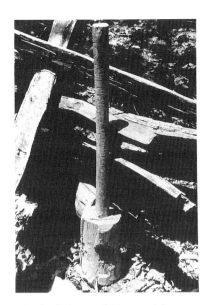

Wood-splitting maul (Cat. no. 1) from an abandoned farm in Cherokee County, Georgia, the first object the author acquired for his folklife collection in 1966. *Photo by John Burrison.*

books of the 1880s. For every neighboring state, by contrast, representative folk song collections had been published; surely Georgia was not lacking in such folk-cultural riches.

As my interest and training were primarily in musical and oral traditions, that's what I and my students began documenting (my first week in Atlanta, for example, I recorded a blues harmonica player who worked the night shift in the building that housed my office). But it was not until a visit that fall by my friend and former Penn classmate Henry Glassie, who already was on his way to becoming the premier American material culture folklorist, that I developed an interest in tangible expressions of Georgia folklife such as folk architecture and crafts.

After guest-lecturing to my classes, Henry wanted to see something of the Georgia countryside, so with student Kay Cothran (who would go on to obtain graduate folklore degrees at Penn) we took an excursion into north Fulton and Cherokee Counties. As we were tramping around an abandoned and overgrown farm, I tripped over something lying in the weeds. Hewn from a yard-long piece of hardwood, with one end wider and heavier than the other, it was a curiosity to me, and I asked Henry what it was. "That's a really good thing," he replied; "you should be collecting such handmade items. They're as important a part of folk culture as the music you've been recording." He directed me to Henry Mercer's *Ancient Carpenters' Tools,* where I learned that the object was a maul for splitting timber.[4] So began my collection of folk artifacts.

Later that year I was invited to join the board of Georgia Mountain Arts, a new organization whose mission was to promote north Georgia crafts. Having stumbled across Allen Eaton's 1937 classic, *Handicrafts of the Southern Highlands,* in college and been stunned by the beauty and dignity of the people and objects in Doris Ulmann's photographs, I was drawn to Appalachia and had begun to make forays into upland Georgia. So I volunteered to research and assemble objects for a Georgia Mountain Arts exhibit sponsored by the state arts council, mindful of Henry Glassie's words in his first book: "Material folk culture is not yet a thing of the past alone—there are informants by the thousands, artifacts by the millions waiting to be studied. . . . But daily, there are fewer who can provide the fieldworker with detailed information[;] . . . daily, there is less to study and the answers become more difficult to obtain."[5]

The collecting began in earnest. I spent virtually every weekend for the next year and a half scouring the countryside for older items as well as for practicing traditional craftspeople. The first month or so was frus-

trating; I was having little success finding older examples of folk crafts to purchase other than a few things in antique shops with no history attached to them. The people I met who owned such objects understandably treasured them as family heirlooms; I had not yet developed techniques for locating those willing to part with their handmade treasures so they could be preserved and publicly appreciated (later appeals in the *Georgia Farmers and Consumers Market Bulletin* were to produce the desired results).

Then, one day, I found myself in the town of Homer in Banks County. Someone had directed me to a quilter named Ola McDonald who rented rooms in an old, unpainted former inn. Yes, the feisty widow had some quilts; I especially admired her "Double Wedding Ring," begun in 1910, which was being used to cover her sofa bed. No, she wouldn't sell the quilt; but, being "a pack rat by nature," she'd trade it for a new blanket that she could use when her grandchildren came to visit.

It was about 2:30 on a Wednesday afternoon, the day that stores closed early, at 3:00. I sensed that this was a test of my commitment. I and my traveling companion raced to the department store and, just at closing time, bought the desired blanket for all of nine dollars. On our return Ola seemed surprised that we'd gone to such trouble, but, true to her word, we exchanged bed coverings. Soon thereafter, a postcard arrived from her urging another visit; in a dream, the Lord had spoken to her about giving me her most treasured possession. It turned out to be an ornate crazy quilt begun in the 1880s with squares contributed by many of Ola's girlfriends, pieced from the crown linings and bands of their boyfriends' hats and embroidered with the young men's initials, a sort of romantic history of Homer decoded in an accompanying typed narrative. This was the kind of contextual information I was seeking to help make folk artifacts come alive.

Another early experience made an indelible impression on me. In the mountains of Fannin County we had been given directions to Louanna and Dubby Walker, elderly spinsters in the literal as well as figurative sense, for they were among Georgia's last practitioners of traditional handweaving. It had recently rained, so the wooded dirt road to their home could be traveled only by foot, and somewhat perilously at that, since it was punctuated by broad puddles and slippery red mud. After a mile or so this trail opened onto a clearing in a tranquil cove. At the edge of a corn patch stood a handsome old log cabin. A frail, bonneted figure in an ankle-length dress was seated on the steps. She was ab-

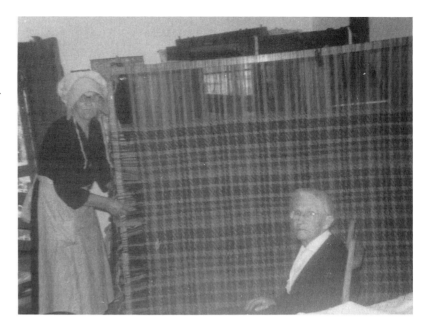

Sisters Dubby (left) and Louanna Walker, traditional weavers of Fannin County, Georgia, at their afghan frame in 1967, a year before the author's visit. The top of their loom can be seen in the background. *Photo by folklore student Janice Ballew.*

sorbed in what appeared to be an animated conversation on an imaginary telephone. Our approach startled her, but when we expressed an interest in weaving, she welcomed us and explained that she had been speaking with her sister, who was inside in her bed—dying.

Our hostess, who several years earlier had abandoned the loom, insisted on showing us the work of sixty years (and more, for she and her sister had preserved examples of their mother's weaving as well). With solemn pride she unfolded what seemed to us to represent the summation of their rugged lives there in that isolated cove. There were coverlets—artistic showpieces of the mountain woman—woven of natural-dyed homespun threads in proto–"op art" patterns with names like "Sunrise on the Walls of Troy"; more subtle, all-white counterpanes with textured patterns; and blankets in a simpler striped weave. There were also smaller rag rugs and place mats that had occupied the dying sister in recent years. One of these was still on the loom, never to be finished.

As I passed the bed of this bonneted woman whose life was ebbing away, the fragility of some of these rural-based crafts struck me hard; I was literally witnessing the end of a line. I left the cabin galvanized into documenting these traditions for posterity. We modern city dwellers and suburbanites, detached from our roots, have much to learn about the beautiful and useful work of our forebears' hands; I was beginning to realize that a better understanding of traditional crafts in the South

could help rewrite the conventional view of the region's history and artistic achievements.

Trip after trip the collection grew, crowding my apartment. Only a small portion, in fact, could be utilized for the 1969 exhibit at the Walasiyi Inn at Neels Gap, south of Blairsville, leaving me with the question of what to do with the remainder. At Georgia State I was offered a cavernous room in the new classroom building (designed to house a never installed escalator) as a by-appointment museum and learning laboratory for folklore students, which temporarily resolved the problem. I was now free to extend my collecting into the rest of Georgia and adjoining states (folk culture seldom respects political boundaries; traditions on the Georgia side of the lower Chattahoochee Valley, for example, are no different from those on the Alabama side).[6]

In 1968, toward the end of my work on the Georgia Mountain Arts exhibit, I made a first visit to the Meaders Pottery in the foothills of White County. I had read about the shop in Eaton's *Handicrafts of the Southern Highlands,* but with no background in ceramics and unable to make sense of the old pots I encountered (which, to my eye, all looked much the same), I was resisting this craft. Meeting Lanier Meaders changed all that.[7] I became intrigued enough to make Georgia folk pottery a fourteen-year research specialty and began to pursue its history as well as the living tradition that Lanier represented. In the process I acquired lots of pots, which became a strength of the collection.

An account of the acquisition of one of these should serve to illustrate my pot-hunting adventures. In 1971 I read an article that mentioned an enslaved South Carolina potter named Dave.[8] Working at a plantation pottery near Aiken, Dave created some of the largest examples of American folk pottery (a pair of his food-storage jars in the Charleston Museum measure nearly three feet tall and have capacities of forty gallons). He often signed and dated his pieces and even inscribed poetry on some.

Shortly after reading this article, I and a student were heading in a leisurely way to the South Carolina Pottery in North Augusta, the last gasp of the Edgefield District stoneware tradition to which Dave had belonged. As we traveled along a back road in east Georgia, I spotted a big jar with four lug handles under a tree in a front yard. It was covered with a greenish brown alkaline glaze typical of the lower South. Knowing how rare southern wares of that size are, I suspected it might be the work of Dave, the African American potter-poet. We were greeted by a friendly woman who explained that she'd found the piece in a storage shed when

she and her husband moved onto the farm, and she'd put it to use as a planter. Together we examined it, and, sure enough, incised into the clay was Dave's signature, an 1858 date, and twenty-five tick marks on the shoulder indicating the gallonage. In addition, a couplet in flowing script read, "A very large jar which has 4 handles / Pack it full of fresh meats— then light candles."

I was kindly allowed to photograph the piece, but when I offered to buy it, the owner wasn't interested, declaring, "I *love* my pot!" How could I argue with that? Yet I was concerned about its safety, the rim and handles already having suffered damage from falling branches. A couple of years later I happened to be in the area again just after a freak snow-storm and wanted the friends I was traveling with to see the pot. I sub-stantially upped my initial offer, now concerned about the soil in the pot freezing and causing it to burst. But the owner wouldn't budge.

A couple of more years later, when the pot was recurring in my anx-ious dreams, I made a special trip with checkbook in pocket to give it my

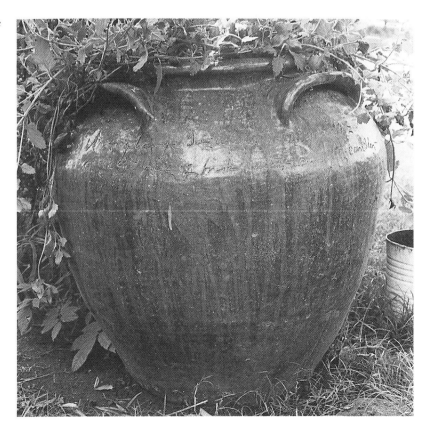

Large meat-storage jar (Cat. no. 188) made in 1858 by Dave, enslaved African American potter-poet of Aiken County, South Carolina, as found by the author on an east Georgia farm in 1971. *Photo by John Burrison.*

best shot, at the same time respecting the woman's love of her pot and not wanting to hound her. When we reached the farm, it looked at first as if the pot were gone, but it was only hidden by the overgrown plant. This time things went differently; her husband had lost his job, and they needed the money. Besides a new cash offer, I promised to bring a large pot for transplanting. She told us to come back on Saturday, when her husband would be home; she'd leave the decision to him. We returned with a wad of bills where my bank account used to be and *two* big plant pots. The husband was agreeable to the deal. So we carefully removed the plants and soil, transplanted them, cleaned the jar with a garden hose, and hauled it off nestled in blankets in the back of a station wagon—five years after I first spotted it.

Exciting as such historical finds are, they pale beside the discovery of a living master folk artist. In 1970 I was visiting Lanier Meaders and his mother, Arie, in the course of making a television documentary, *Echoes from the Hills.* I noticed that Arie was sitting in a new handmade rocking chair and that the tops of the rear posts displayed the telltale pinholes left by a pole lathe. I was not aware that this medieval European type of tool, its turning power supplied by a springy pole and foot treadle, was still in use anywhere in the United States. Arie explained that the chair was made by a farmer a couple of miles away. When I asked why she'd never mentioned him, she replied, "I thought you were only interested in pottery!"

Following Arie's directions, we arrived at Walter Shelnut's farm and were greeted by his wife, who explained that he'd gone to town but would be back soon. She invited us to look around. Every building on the place, from the neat frame house to the log blacksmith shop, had been built by Walter's hands. A converted chicken house served as the woodworking shop. Inside was the pole lathe I had anticipated; other tools, from the shaving horse to the mallets and wood-turning chisels, were also handmade. This "textbook case" so excited me that I couldn't catch my breath; I had to step out into the woods behind the shop to calm down.

At this point Walter arrived home, and after introductions we were invited to set up the motion picture camera and lights and film him at work in the shop. Walter explained that he made about a dozen chairs a year to satisfy neighbors' needs, selling them for six to ten dollars each, depending on type; his father and grandfather also had been chair mak-

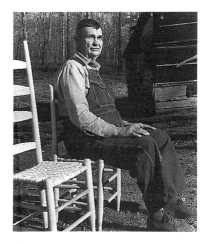

Chair maker Walter Shelnut of White Creek, Georgia, 1973. *Photo by John Burrison.*

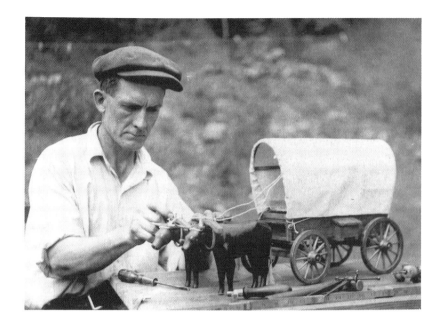

Memory miniaturist Carl Stepp of Mc-Caysville, Georgia, putting the finishing touches on his covered wagon (Cat. no. 368), 1931. *Courtesy C. L. Stepp.*

ers in the community. Over the course of many visits I got to know this slow-talking, self-sufficient man, acquiring an assortment of chairs and tools (including a pole lathe made to my order). He died on March 17, 1978, the weekend his neighbors, Arie and Lanier Meaders, were with me in Washington, D.C., at a special Meaders Pottery event hosted by the Library of Congress's American Folklife Center.

I have been particularly interested in assembling groups of items like the Shelnut materials that, together, tell a story. For example, my first appeal in the *Georgia Farmers and Consumers Market Bulletin* yielded a letter from C. L. Stepp of McCaysville in the mountains of Fannin County, who offered to sell a model of an oxen-pulled covered wagon that he'd made in 1931. A visit to Carl Stepp showed him to be no mere whittler but a true artist with an eye for naturalistic detail. A retired mill-wright and machinist with a well-equipped shop annexed to his home, he was receptive to the challenge of building folklife models for the collection. Over the next several years he became my master of memory miniatures, creating groups of utensils and tools, a syrup mill and evaporator, and his final and most ambitious project, an idealized model of the farmstead on which he'd grown up.

By 1979 I had accumulated more than eight hundred items, occupying every nook and cranny of the room at Georgia State. Their real value, as

I then saw it, lay in their potential for interpreting the handmade life of Georgians both past and present. But with no funding (I had invested a good third of my teaching salary in the collection, fortunately before interest in such objects would drive market prices beyond my reach), no staff, and little spare time, warehousing them in a protected environment was about all I could manage. (I was able to draw on parts of the collection for such public exhibits as *The Meaders Family of Mossy Creek: Eighty Years of North Georgia Folk Pottery* at Georgia State's Art Gallery and the state-sponsored *Missing Pieces: Georgia Folk Art 1770–1976*.) But this rather unsatisfactory situation was about to be resolved: I was asked to vacate the space for a new classroom.

Part of the author's folklife collection at Georgia State University in 1978, a year before it was moved to the Atlanta History Center. *Photo by John Burrison.*

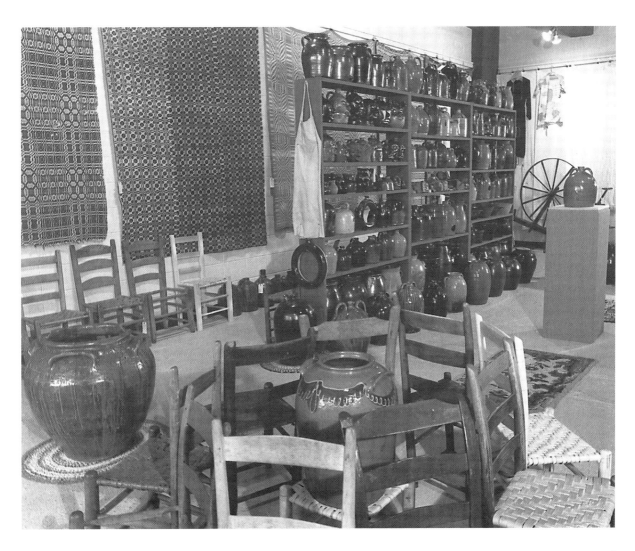

ASSOCIATION WITH THE
ATLANTA HISTORICAL SOCIETY

My involvement with the Atlanta Historical Society began in 1972, when I commissioned Lanier Meaders to make a set of wares that could be used at the society's Tullie Smith Farm to replicate 1840s life. In 1979, when I was given notice to vacate the Georgia State space, I contacted my friends Bill and Florence Griffin—lovers of all things Georgian, Atlanta Historical Society trustees, and frequent visitors to the collection—and asked if they thought the society might be interested in acquiring it. Their enthusiasm was contagious, and an agreement was reached with the society's board and then director, William Pressly, who both recognized what the collection could add to the society's interpretation of Georgia social history.

With plans for the collection at first nebulous, the objects were packed up and moved to storage on the society's grounds. In 1984 we were able to air four hundred items in *Tangible Traditions: Folk Crafts of Georgia and Neighboring States.* For the first time, the learning potential of the collection could be properly exploited, which warmed the cockles of my educator's heart. The exhibition stayed up for nearly two years in McElreath Hall; it then went back to storage as plans for a new Atlanta History Museum took shape.

During this waiting period the collecting activity slowed. A number of opportunities presented themselves (sadly) with the deaths of people who had important collections. One of these was Ethel Collins Clement, a former weaver in the beautiful valley of Choestoe (a Cherokee name meaning "Place of Dancing Rabbits"), below Blairsville. When I first met this shy mountain widow in 1969, she kept me at bay on her porch. But through the good graces of her relatives, Ethelene and Grover Jones, I was able to gain her trust, and she showed me her coverlets and blankets (which reached from floor to ceiling in a closet), most of which had been woven in 1949 when the loom was last set up. I was only able to obtain one blanket, however, while she lived.

When I learned of her passing, I contacted other relatives, Annie Jo and Blueford Dyer, who had inherited much of the estate. They responded positively to my appeal to represent "Aunt Ethel's" work in the *Tangible Traditions* exhibit by donating a coverlet in the "Habersham Burr" pattern (apparently her first, woven when she was sixteen). The Dyers later contributed another coverlet and blanket, a homespun suit

tailored for Ethel's father, and an album of manuscript weaving drafts by which the coverlet patterns were "programmed" on the loom. Now we could properly tell the story of the remarkable Collins family.

Early in my travels I met Ed Mauney of Blairsville, whose job as a mail carrier had gained him access to some wonderful things. I particularly admired his mountain rifles and musical instruments, but he had no interest in selling anything. Years later I learned of his death and with some trepidation contacted his widow (whom I had never met). When she told me that she'd already sold a lot of his "stuff," my heart sank, but it turned out that she'd kept the best items, including those in which I was interested. We were able to buy from her, among other things, a rare boy's rifle and group of handmade tools by north Georgia gunsmith James Gillespie, accompanied by Mauney's research notes.

These collecting activities sometimes have taken me far afield. In 1973 I launched a series of trips to the British Isles to investigate Old World

Weaver Ethel Collins Clement of Choestoe, Georgia, with some of her textiles, 1970. *Photo by John Burrison.*

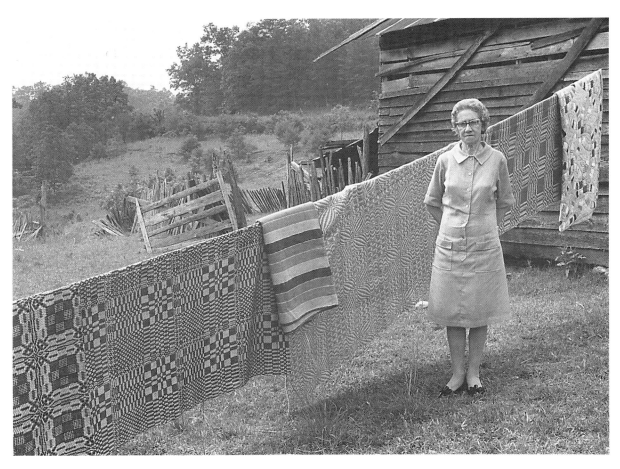

Cooper Ned Gavin of Ballinagh, Ireland, presenting his noggin (Cat. no. 17) to the author for the folklife collection to show Irish influence in Appalachian folk culture, 1986. *Courtesy Ned Gavin.*

sources of southern folk culture and to develop courses in Irish and British folklore. On the 1986 trip I visited Ned Gavin of County Cavan, Ireland's last rural cooper, to order a noggin, an ancient type of wooden eating vessel. The idea was to exhibit it alongside an old North Carolina mountain noggin and one I planned to order from east Tennessee cooper Rick Stewart to show the Ulster influence in Appalachian folk culture.

A week later I and my archaeologist partner, Linda Carnes-McNaughton, crossed the border from Northern Ireland (where we had been researching pottery in County Tyrone for the Ulster Folk and Transport Museum) to pick up Ned's noggin, arousing the suspicions of a British Army border guard who thought we might be smuggling arms to the IRA (he didn't know what to make of the pottery shards his search of our car "boot" revealed). Ned was pleased that his work would appear in an American museum and had a newspaperman friend photograph the presentation and write a story for the local paper.

Another "hole" was filled with the discovery of Georgia's only practicing traditional decoy carver. Although part of the Atlantic Flyway, Georgia never had a rich decoy tradition like its neighbor, North Carolina. The only maker I knew about was Lacey Norwood, who worked in Savannah in the 1920s; one of his homely cork-bodied duck decoys was kindly donated by Malcolm Bell Jr. for *Tangible Traditions.* But the challenge of finding a living carver remained, and in 1990 I voiced this interest to my American Folklore class.

The Atlanta History Museum opened in 1993 with the temporary exhibition *Handed On: Folk Crafts in Southern Life* and now houses *Shaping Traditions.* Photo by John Burrison.

Student Gregory Ware took up the challenge, and after he pursued a number of blind leads, Ducks Unlimited, a conservation organization, directed him to Ernie Mills, a third-generation carver who had moved from Delaware to Perry in middle Georgia in the 1970s. On reading Gregory's documentation paper, I immediately contacted Ernie. With our shared experience as transplants from the Mid-Atlantic, we hit it off instantly. I ordered working decoys of a ring-necked duck and drake wood duck, birds often hunted in Georgia and reflecting Ernie's adaptation to the state. He has since donated a hen wood duck and a group of tools and unfinished decoys to illustrate the process as well as finished products.

This brings us to *Handed On: Folk Crafts in Southern Life,* an exhibition of one hundred objects for the 1993 opening of the Atlanta History Museum and the second Atlanta Historical Society airing of a part of my collection. Originally, it was to be a simple "teaser" suggesting the collection's scope. But Rick Beard, the society's new executive director, had something more ambitious in mind: a show that could stand on its own and travel.[9] In Atlanta, this exhibit was reinforced by four Craft Days with demonstrations, films, and lectures on traditional southern pottery, woodworking, basketry, and textiles. While *Handed On* was circulating to other museums, plans were being formulated for a new, permanent folklife gallery.

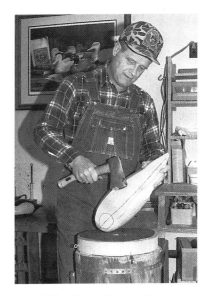

Ernie Mills of Perry, Georgia, shaping a decoy body with his hatchet, 1993. *Courtesy Ernie Mills.*

SHAPING TRADITIONS TAKES SHAPE

Museum interpretation of folk culture per se has only recently caught on in the United States. But the movement began in Europe back in 1891 with Skansen Open-Air Museum in Stockholm, Sweden, and was introduced to Great Britain in 1936 via the Highland Folk Museum (begun on the island of Iona and now located at Kingussie, Scotland). These folk museums are designed to show the continuity of, as well as the impact of history on, the traditional stream of a culture. In other words, they serve as a barometer of change for a society while emphasizing the "glue" that helps hold it together. American museums incorporate folk materials on a long-term basis mainly into exhibits of history or decorative arts, so it was necessary for me to look overseas for applicable models in planning the Atlanta History Center's folklife gallery.

One of those models was the Welsh Folk Museum (now called the Museum of Welsh Life), the most ambitious such facility in Britain. The first clue to its size and importance is that it has its own exit off the M4

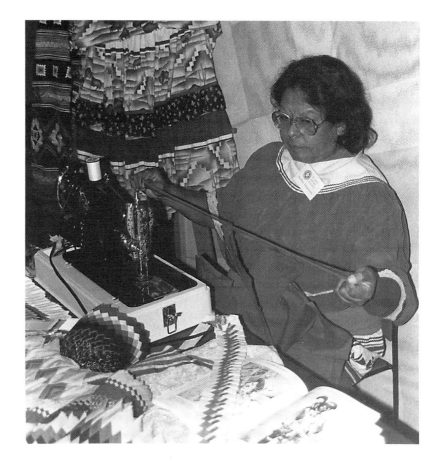

Madeline Tongkeamah of Okeechobee, Florida, demonstrating her Seminole Indian patchwork clothing tradition at one of the Atlanta History Center Craft Day programs supporting *Handed On*, 1994. *Photo by John Burrison.*

motorway. Occupying about ninety acres in the village of St. Fagans (4 miles west of Cardiff and 150 miles west of London), the museum was established in 1946 and is still evolving. On my last visit in 1991, the open-air component, with appropriately furnished examples of vernacular architecture (most rescued from destruction and moved from their original sites), had grown to some thirty buildings from all over Wales, representing a time span of many centuries. The industrial-era terrace of six ironworkers' houses, furnished to show different periods of their history from 1805 to 1985, had recently opened, but an archaeology-based unit illustrating the life of Iron Age Celts was still being erected. In the indoor galleries, the human dimension of inanimate objects is brought out by photographs of people making and using things like the ones displayed. Beyond its education, preservation, recreation, and research functions, this museum supports the struggle to maintain a Welsh national identity after centuries of English rule.

Similar reasons can be given for exhibiting southern folk culture. The South's character was shaped by an agrarian way of life in which folk traditions played a major role. Rural values operated even in Atlanta, which was an important center for traditional country music—both black and white—through the 1930s.[10] We have arrived at a time, however, when most of the younger generation has lost touch with that life and its ethos. My collecting was motivated by the concern that many of the artistic traditions contributing to the region's identity were being abandoned in the rush to modernize, and by the hope that a permanent exhibition would give later generations access to their roots as an antidote to the homogenizing impact of American mass culture.

It was clear from the outset that the folklife gallery would be costly. Indeed, the estimated budget came to $1.25 million, much of it needed for fabrication. Despite the Atlanta Historical Society's successful fundraising record, I was worried about where the money would come from. *Turning Point,* an even larger permanent exhibition based on the enormous DuBose Civil War collection, was scheduled to open at the same time, and I knew resources would be stretched thin. I also knew that a grant for media production anticipated from the Folk Arts Program of the National Endowment for the Arts (which had supported our previous efforts) would cover only a small portion of the total costs.

Several years earlier, a fund-raising gathering for the folklife gallery arranged by outgoing Atlanta Historical Society director John Ott met with a disappointing turnout of anticipated big donors. But Olguita Goizueta was there. She and her husband, Coca-Cola Company CEO Roberto Goizueta, who had come to this country with little more than the clothes on their backs as refugees from Castro's Cuba, liked the idea of celebrating the multicultural traditions of ordinary people. John's successor, Rick Beard, built on their initial interest to secure a major gift that would make the Goizuetas the project's "angels."

This meant that we could afford some of the country's top exhibition professionals to turn our dream into a high-quality reality. The Alexandria, Virginia, firm of Staples and Charles was chosen as designer; we had been delighted with the firm's work on *Handed On,* for which Bob Staples, once employed by the Eames Office (a California outfit known for its modern chair designs), had created beautiful poplar-framed display cases. He would carry this organic look, in keeping with the objects themselves, into the more complex *Shaping Traditions* design.

My 1986 visit to the Ulster Folk and Transport Museum had impressed on me how effective videos integrated into a gallery could be in illustrating handcrafting processes and "animating" objects. I wanted this human presence, conveyed also in sound recordings and still photographs, to be a major feature of the exhibition. The Washington, D.C., media firm of Hillman and Carr was selected to produce five short videos that answer the visitor's question "How is that made?" and present the artists' own voices and personalities. Two of these videos (Cherokee basket maker Lucille Lossiah and folk arts recently transplanted to Georgia) were newly filmed, and three (Charleston blacksmith Philip Simmons, Meaders family potters, and chair maker Walter Shelnut) were restructured from existing footage.

Three soundtracks, drawn from unissued field recordings as well as commercial releases, contribute oral and musical folk arts.[11] The first is a selection of folk songs and ambient sounds relating to farming, hunting, and fishing traditions treated in the "Living off the Land" section. The second offers a choice of folktales, secular folk songs, and instrumental music in a booth designed to encourage small groups to listen thoughtfully. And the third is a sampler of sacred songs and sermons in a setting resembling a small church. The audio and video items, as well as the photographs, were chosen with the help of an expert media advisory committee and obtained by dedicated staff assistants.

A physical and conceptual description of *Shaping Traditions* should set the stage. The exhibition occupies five thousand square feet and includes more than six hundred objects, selected largely from my collection but supplemented by pieces (mainly furniture and textiles) from the society's general holdings. The structure is "permanent" (in the museum world this means at least ten years before major revision), but object rotation and some new acquisitions can be accommodated. As with the previous two exhibits, the region represented is the lower Southeast (although many of the ideas apply to the South as a whole), and recently made as well as older items are shown to illustrate continuity and change in ongoing traditions.

While the objects in *Shaping Traditions* are as interesting as those in an art museum, they are interpreted differently. The exhibition presents folk artifacts contextually to show how they relate to the culture and history that helped shape them. At the same time, viewers are reminded that these are the products of individual creators. A number of exemplary folk artists—both living and historical—are showcased with bio-

graphical sketches and groupings of their work. Some of these artists are heretofore unsung; others are recognized widely enough to have been awarded National Heritage Fellowships (the United States' equivalent of Japan's Living National Treasures designation) by the National Endowment for the Arts.[12] Families that have carried on artistic traditions for generations are likewise featured.

The exhibition begins with some definitions. As applied to visual art, the term *folk* is especially problematic. In 1994 the Georgia Council for the Arts held a forum to assess what had been learned about Georgia folk art since the pioneering *Missing Pieces* project of 1976. Keynote speaker Henry Glassie criticized two earlier forums of national scope for being "unnecessarily and disturbingly disruptive . . . because of a lack of communication between people who ought to be friends."[13] Those people included dealers and collectors as well as folklorists. The Georgia forum,

Part of the "Living off the Land" section of *Shaping Traditions*, illustrating the exhibition designers' artistic vision.

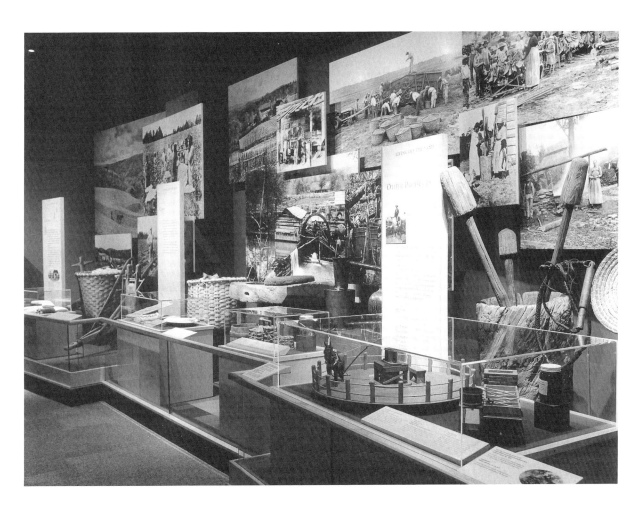

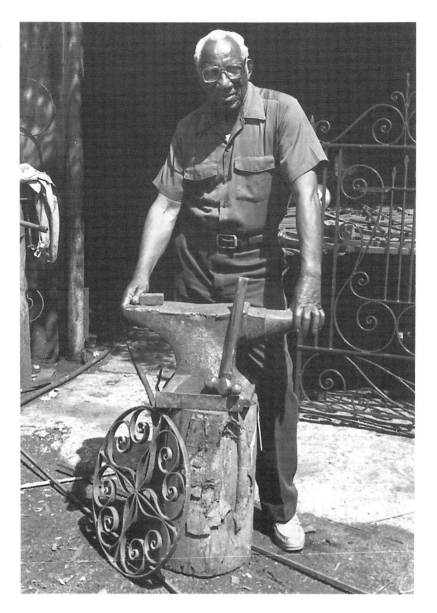

Blacksmith Philip Simmons of Charleston, South Carolina, 1991. A gate from his workshop (Cat. no. 451) was commissioned for *Shaping Traditions. Photo by Dan Smith; courtesy South Carolina State Museum, Columbia.*

in contrast, may have been too friendly, leaving some attendees unsatisfied, their grasp of folk art still unclear. This introductory essay offers an opportunity to clarify the issues beyond what can be said in *Shaping Traditions* itself.

The American art world "discovered" folk art when dealers and collectors saw affinities between modern "fine" art and the work of artists with no academic training. In 1929 Edith Halpert opened her American Folk Art Gallery in New York City, with wealthy collector Abby Aldrich Rockefeller becoming one of her best customers. Holger Cahill curated Rockefeller's collection for the seminal 1932 exhibit *American Folk Art:*

The Art of the Common Man. The word *folk* was being used in the old Germanic sense, as in Volkswagen: the artistic vehicles of the masses with no formal art education. Such a large umbrella covers several varieties of art without acknowledging their different sources. Another problem with this usage is that it depends on a contrast with "fine" art, erroneously suggesting that folk art is of a single style recognizable by its lack of sophistication.

American folklorists, who had not yet learned to apply principles of folklore study to tangible traditions, continued to research folk songs and tales, leaving discussions of folk art to the art world. That was until 1968, when Henry Glassie, then a Young Turk, fired the opening shot in a war of words that still rages. "The serious student of material culture," he complained, "is . . . anguished by the way the term 'folk art' is popularly used. . . . A big piece of 'folk art' is not folk because . . . it is not traditional; such would be the daubings of untutored geniuses."[14]

Glassie was arguing that the adjective *folk* should have the same consistent meaning when applied to visual art as to song, story, dance, and custom. To folklorists, such a meaning hinges on informal learning from others in one's community, the handing on of traditions from generation to generation. Artists lacking either academic *or* folk training are being mislabeled, in Glassie's view, as folk artists. He didn't suggest an alternative name, but the useful phrase "self-taught" has since been coined.

The folkloristic side of this debate stresses the importance of asking in what tradition, if any, an artist is working. Folk artists refine old designs to satisfy community tastes, drawing their inspiration from the groups to which they belong. Self-taught artists, on the other hand, are driven by an intensely personal inner vision. The label *folk* is not a value judgment, yet it has a very real impact on the market value of an artwork. Applying this term to often eccentric self-taught artists does both groups a disservice by clouding their sources of inspiration and distracting attention from deserving traditionally trained artists who may be less colorful.

The art establishment has yet to embrace this view, probably because collectors, dealers, and museums have too much invested in what they honorifically call folk art to reconsider the term seriously. Still, recent exhibit titles reveal that art museums have become more cautious about applying the label *folk* to artists who have no traditional training, this caution likely a response to the semantic concerns raised by folklorists.[15]

This is a lengthy, but hopefully helpful, explanation of why work by self-taught artists such as the Reverend Howard Finster of northwest Georgia (who is often referred to as a folk artist) is not displayed in *Shap-*

ing Traditions. Self-taught artists tend to work in the media of painting and sculpture, while true folk artists normally create works that are inherently functional in what are generally thought of as crafts media.

In the old southern folk culture, however, the words *art* and *craft* are alien, and the artificial separation of beauty and utility made by elite Western society does not apply. A folk potter like Lanier Meaders referred to himself simply as a potter (or often "jug maker" in nineteenth-century censuses), an artisan in a particular medium who makes things that people use and that can also give them pleasure. Take, for example, the tradition of the face jug, in which artistry is combined with a useful form. A group of recently made examples in the exhibition's opening section, including a two-faced or "politician" jug by Lanier and a one-inch miniature by Chester Hewell (both from northeast Georgia pottery families), also illustrates that while folk arts are traditionally learned and community-shared, they allow for individual creativity.

The second section of *Shaping Traditions* explores traditions that are distinctly southern and how they came about.[16] Direct exploitation of natural resources by an agrarian society accounts for many regionalisms. Some southern traditions arose in response to the physical environment (e.g., the warm climate's effect on vernacular architecture), while others were shaped by historical forces, such as the South's early population mix. Isolation from change, a conservative mind-set, and economic conditions after the Civil War contributed to the retention of traditions once common in the Northeast, such as grits (their Yankee equivalents—hasty pudding and mush—having passed out of fashion).

The South's agrarian way of life was supported by a variety of hand-crafting traditions, many of which are still active. Folk crafts constitute the largest section of the exhibition, and the largest subsection under this heading is pottery. Because folk pottery reveals so much about the foodways, aesthetics, kinship and demographic patterns, preindustrial technology, and economy of the region, it is not only explored in depth here but runs as a connecting thread through the exhibition.

A model and video of the Meaders Pottery and re-created shop corner with potter's wheel and other equipment illustrate the folk process for converting raw clay into fired wares. Southern stoneware glazes are examined, especially the alkaline glazes that are strikingly similar to those of the Far East. A large selection of wares shows potters' migrations within the region and stylistic traits that arose in a dozen "jug-towns" under the influence of dominant families or "clay clans." One

of these pottery centers, active through the 1920s, was located at Howell's Mills, less than three miles from the Atlanta History Center. This part of the exhibition represents the first permanent display of folk pottery from the lower Southeast available to a growing group of collectors and researchers.

Wood crafts follow, starting with a re-created chair maker's shop and related carpentry tools. Following a precedent set by the 1983 Atlanta Historical Society exhibition, *Neat Pieces,* examples of "plain-style" furniture are arranged in bedroom and dining settings that emphasize their uses. The leisure-time art of wood carving or whittling is illustrated by African American walking sticks and mountain miniatures of covered wagons.

Baskets that once served the purpose of carrying and storing dry goods are now used as home decor. To represent the thousand-year-old southeastern Indian tradition of rivercane basketry we chose Lucille Lossiah, a North Carolina Cherokee and the youngest folk artist featured in *Shaping Traditions.* When it became clear that obtaining a set of baskets by a distinguished elder was not possible, I consulted Betty DuPree, manager of Qualla Arts and Crafts Mutual (the Cherokee crafts cooperative), and basketry scholar Sarah Hill. We agreed that spotlighting a promising young maker such as Lucille could give encouragement not only to her but to others hesitant to embrace this difficult art.

Textile traditions are presented next. Through the middle of the nineteenth century, virtually every southern farm woman was experienced in the complex skills of home cloth production, from dyeing and spinning fiber into yarn to weaving on the barn-frame loom. That these mother-to-daughter skills persisted even later in the mountains is shown by members of north Georgia's Collins family, who continued to weave traditionally through the 1940s outside the market stimulus of the Appalachian handcraft revival.

While most traditional weaving eventually died out with the affordability of factory-made fabrics, quilting has remained a vital folk art to the present. Using a state-of-the-art sliding rack system designed for the exhibition, the range of southern quilt types is illustrated by examples from the early nineteenth to twentieth centuries. With so many fine quilters currently at work in the region, selecting one to exemplify the tradition seemed like an exercise in futility. We therefore chose famed historical quilter Harriet Powers of Athens, Georgia, known for two remarkable story quilts illustrating Bible scenes and local events. Her quilts reside at

the Boston Museum of Fine Arts and Smithsonian Institution; she and her quilts are represented photographically in the exhibition.

The last crafts examined are those of metalworking. Foremost among these is blacksmithing, a once common skill. A contemporary gate, one of several major commissions for *Shaping Traditions,* was ordered from the Charleston, South Carolina, workshop of Philip Simmons, African American master of ornamental iron and the subject of a book by one of our advisers, folklorist John Vlach. Because Philip prefers to start with design suggestions from his customers, this gate, which incorporates the Atlanta History Center logo, was a collaboration among AHC staff, Philip as supervisor, and his two younger relatives who "banged iron." It is thus an apprentice piece that exemplifies the passing of an artistic torch to the next generation.

Folk crafts served southerners' survival needs, but oral, musical, and customary traditions have enriched their leisure time and spiritual life. In the fourth section of the exhibition, two listening enclosures allow visitors to experience some of the South's best traditional storytelling, singing, and instrumental music. Examples include a Cherokee creation myth, an Appalachian "Jack" tale and ghost legend, the "Tar Baby" story as told in the African American oral tradition, Okefenokee Swamp tall tales, children's game songs, performances by Georgia blues artists Blind Willie McTell and Gertrude "Ma" Rainey, ballads or story-songs, a Creek Indian stomp-dance chant, and hymns, spirituals, gospel songs, and chanted preaching.

Carl Stepp's mountain farmstead miniature and a selection of handmade stringed instruments suggest the former self-reliance of many southerners. The isolation caused by the frontier pattern of dispersed settlement was relieved by the custom of community work gatherings, which turned burdensome agricultural tasks such as corn shucking into social occasions. Plantations were another source of distinctly southern lore. Animal tales brought from Africa provided continuity for enslaved African Americans, for whom the trickster protagonist, Brer Rabbit, may have symbolized the triumph of wits over power. In the 1880s these folktales were popularized in Joel Chandler Harris's Uncle Remus books.[17] The living traditions of singing from shape-note hymnals and the folk drama *Heaven Bound,* performed annually at Atlanta's Big Bethel African Methodist Episcopal Church, exemplify the role of religion in southern life.

The final section of *Shaping Traditions* examines the impact of mod-

ernization on the region's folk culture. The older rural society was transformed in the twentieth century by increasing occupational alternatives to farming and a breakdown in the isolation that had fostered dependence on folk traditions. As Georgia mountain ballad singer Lillie West reflected in 1968, "The biggest change began with the coming of the automobile. Everyone's in too big a hurry now, they don't have time for their neighbors."[18] Electricity—and with it the refrigerator, light bulbs, air-conditioning, and television—altered traditional patterns of work and leisure. Real estate development of the folklore-rich mountains and coast has disrupted established communities while creating new economic opportunities.

Ballad singer Lillie Mulkey West of Blairsville, Georgia, reflecting on changes she'd seen in mountain life, 1968. *Photo by John Burrison.*

Some rural-based folk arts survived, but often under very different circumstances. A handcraft revival opened up outside markets to replace declining local ones, while introducing new and sometimes exotic ideas. Ironically, urban collectors have supported the continuation of such folk crafts as pottery and basketry that once served the needs of a farming society.

In the last three decades, immigrants have dramatically internationalized the urban South. Atlanta has large Asian, Latin American, and West Indian populations that maintain traditions from their homelands to help ease the adjustment and preserve their identity. These newly transplanted folk arts are evolving and promise to be part of future southern folk culture. Their portrayal in this exhibition is meant to be only suggestive, with plans to change periodically the groups represented.

Enough time has elapsed since *Shaping Traditions* opened for critical appraisals to begin to appear. In an otherwise positive journal review, the exhibition's second section was problematic to Peggy Bulger, now director of the American Folklife Center and president of the American Folklore Society:

> Less successful is the answer to the question, "What is 'Southern' about Southern folk arts?" The history center venue for this exhibit has shaped much of its character and this section, with a "living off the land" theme, perpetuates the notion of a stereotypical South defined by agriculture and slavery . . . an image that the exhibit tries unsuccessfully to dispel at the tail end . . . where one is introduced to video segments and artifacts representing the South's newer immigrant populations.[19]

The issue raised by this critique calls for a response. Not all folklorists share my historical orientation to folk traditions, and I am fortunate to

be associated with a museum that supports this perspective. While dirt farming may not be a glamorous image or one with which many residents now identify, it was undeniably central to the southern experience from early settlement through the early twentieth century. Even southern towns and cities were tied to the farming economy by serving as market centers for cash crops, and earlier industry drew heavily on the rural population for its labor pool (e.g., Atlanta's Cabbagetown and Whittier Mill textile villages).[20] The immigrant groups whose traditions Peggy would have liked to see more strongly represented constitute only 3 percent of Georgia's current citizenry.

For these reasons, *Shaping Traditions* emphasizes the rural society that is still a viable (but increasingly less visible) element of southern life, hopefully in a nonstereotypical way that reveals the society's richness and complexity. Farming folk generated the bulk of the South's material culture and in my opinion were the group most responsible for shaping traditions that express what's special about the region. But Peggy is right to point out that this is just one folklorist's view (with input from History Center staff and an advisory committee, to be sure) of a complex subject, and other slants could be presented.

Given the early upland Georgia and pottery thrusts of my collecting, expanding representation of the African American, Native American, and recent immigrant populations became a later priority. But there is still much to do in this regard, and a summative evaluation currently under way is likely to strengthen *Shaping Traditions* by providing a rationale and recommendations for further acquisition.

One of my few disappointments with the exhibition also serves to illustrate the workings of our advisory committee, which overall was extremely helpful. I had planned to include a section spelling out the ethnic backgrounds of southern folk arts, illustrated by Native American, African, British Isles, and European contributions. But the committee insisted that this point had been made in previous exhibits (including *Handed On*). I argued that this would still be news to much of our audience, but I was overruled. Now, observing how docents who guide school groups through *Shaping Traditions* latch onto ethnicity issues, I wish we could have been more explicit (the story is there but requires some digging, which may not be a bad thing after all).

The docents report that youngsters do find the exhibition engaging, with something of interest to everyone. This had been a planning consideration (as it should be for any exhibit seen by a youthful audience).

The videos, listening enclosures, touchable objects, and models have a particular appeal to children; so does the last case containing paper airplanes, illustrating a material tradition to which urbanites can relate. Children mention these elements most frequently in the visitors' comment book at the gallery's end (one of the museum's chief assessment instruments).

It is the public encounter with actual objects that museums (as distinguished from other communication vehicles) can do best. Since folklore is about the role of tradition in people's lives, one of the greatest challenges in all my exhibition work has been to bring out the people behind the objects. In addition to the videos, sound recordings, and photographs, regular programming helps make *Shaping Traditions* a "living" exhibition. Two events are now scheduled annually to support and expand on it. The fall Folk Arts Fair presents older traditions of the region, while the spring International Folk Arts Fair highlights newer groups in metropolitan Atlanta. These festivals combine performances and demonstrations by folk artists with lectures, film showings, and sale of appropriate foods and crafts.

Refinement of these programs and development of others will surely figure in the future of *Shaping Traditions.* The museum and folklore fields are already taking notice of the exhibition as a possible model for other installations. Museums have the prestige to empower deserving but undervalued aspects of our culture, and it would be gratifying to see *Shaping Traditions* support a trend toward long-term display of folk arts in the United States.[21]

NOTES

1. Pamela Blume Leonard, "Handmade Objects Remnants of Region's Histories, Hearts," *Atlanta Journal/Constitution,* June 7, 1996, sec. P, p. 19.

2. A new self-consciousness about the role and inherent biases of museums in presenting cultures can be seen in a growing number of publications from the Smithsonian Institution Press of Washington, D.C. These include Ivan Karp and Steven D. Lavine, eds., *Exhibiting Cultures: The Poetics and Politics of Museum Display* (1991); Susan M. Pearce, *Museums, Objects, and Collections: A Cultural Study* (1993); Stephen E. Weil, *A Cabinet of Curiosities: Inquiries into Museums and Their Prospects* (1995); Amy Henderson and Adrienne L. Kaeppler, eds., *Exhibiting Dilemmas: Issues of Representation at the Smithsonian* (1996); and Richard Kurin, *Reflections of a Culture Broker: A View from the Smithsonian* (1997).

3. The remainder of this introduction is revised from John A. Burrison, "The Journey to *Handed On* (and Beyond): A Personal History of the Folklife Collection," *Atlanta History* 37 (Fall 1993): 65–74; idem, "The Shape of *Shaping Traditions: Folk Arts in a Changing South*," *Atlanta History* 40 (Spring–Summer 1996): 51–60.

4. Henry C. Mercer, *Ancient Carpenters' Tools* (Doylestown, Pa.: Bucks County Historical Society, 1951), 19 (actually a different tool than the one found).

5. Henry Glassie, *Pattern in the Material Folk Culture of the Eastern United States* (Philadelphia: University of Pennsylvania Press, 1968), 237–38.

6. George Mitchell, *In Celebration of a Legacy: The Traditional Arts of the Lower Chattahoochee Valley* (Columbus, Ga.: Columbus Museum of Arts and Sciences, 1981). For a folk-cultural subregion Georgia shares with two adjacent states, see Jerrilyn McGregory, *Wiregrass Country* (Jackson: University Press of Mississippi, 1997).

7. This meeting is described in John A. Burrison, *Brothers in Clay: The Story of Georgia Folk Pottery* (Athens: University of Georgia Press, 1983; paperback ed. with new preface, 1995), xxvii–xxxi.

8. Stanley South, "A Comment on Alkaline Glazed Stoneware," in *The Conference on Historic Site Archaeology Papers 1970*, ed. Stanley South (Columbia: Institute of Archaeology and Anthropology, University of South Carolina, 1971), 178–79.

9. For a detailed description of this exhibition in catalog form, see John A. Burrison, *Handed On: Folk Crafts in Southern Life* (Atlanta: Atlanta Historical Society, 1993).

10. John A. Burrison, "Fiddlers in the Alley: Atlanta as an Early Country Music Center," and Pete Lowry, "Atlanta Black Sound: A Survey of Black Music from Atlanta during the Twentieth Century," *Atlanta History* 21 (Summer 1977): 59–113; Wayne W. Daniel, *Pickin' on Peachtree: A History of Country Music in Atlanta* (Urbana: University of Illinois Press, 1990); Bruce Bastin, *Red River Blues: The Blues Tradition in the Southeast* (Urbana: University of Illinois Press, 1986), chs. 6–8.

11. Availability of commercial sound recordings is always in flux, but two main sources for folk releases used in *Shaping Traditions* are the Library of Congress, Public Services Office, M/B/RS Division, Washington, D.C. 20540-4690, ph. (202) 707-5510 (Folklore Archives, which can help locate particular selections of their own and other labels), and Smithsonian/Folkways Recordings, 955 L'Enfant Plaza, Suite 2600, MRC 914, Washington, D.C. 20560, ph. (202) 287-3262.

12. For featured artists Lanier Meaders of Mossy Creek, Georgia, and Philip Simmons of Charleston, South Carolina, see Steve Siporin, *American Folk Mas-*

ters: The National Heritage Fellows (New York: Harry N. Abrams, 1992), 98–103, 116–19.

13. "Missing Pieces or Missing the Point?: The Georgia Forum on Folk Art," *Art Papers* 18 (September–October 1994): 8–9. The forum was reviewed by Henry Willett in *Journal of American Folklore* 108 (Summer 1995): 361–62.

14. Glassie, *Pattern in the Material Folk Culture of the Eastern United States,* 28–30.

15. The best book-length folkloristic statements on folk art are Henry Glassie, *The Spirit of Folk Art: The Girard Collection at the Museum of International Folk Art* (New York: Harry N. Abrams, 1989), and John Michael Vlach and Simon J. Bronner, eds., *Folk Art and Art Worlds* (Ann Arbor, Mich.: UMI Research Press, 1986). A model study is Glassie's *Turkish Traditional Art Today* (Bloomington: Indiana University Press, 1993). The art world's interest in folk art is surveyed by Beatrix T. Rumford, "Uncommon Art of the Common People: A Review of Trends in the Collecting and Exhibiting of American Folk Art," in *Perspectives on American Folk Art,* ed. Ian M. G. Quimby and Scott T. Swank (New York: W. W. Norton, 1980), 13–53.

16. For another discussion, see John A. Burrison, "South," in *American Folklore: An Encyclopedia,* ed. Jan Harold Brunvand (New York: Garland Publishing, 1996), 678–80.

17. Florence E. Baer, *Sources and Analogues of the Uncle Remus Tales,* Folklore Fellows Communications no. 228 (Helsinki: Academia Scientiarum Fennica, 1980).

18. Lillie Mulkey West of Blairsville, Union County, Georgia, interview by author, August 29, 1968.

19. *Journal of American Folklore* 110 (Summer 1997): 317–18. Her review concludes, "This collection and the scholarship that informs it makes this a world-class exhibit and truly imparts to the visitor a sense of what it means to be a folklorist: both passionate and reflective at once. Also, this collection celebrates and makes comprehensible the world of the traditional artist, who is based simultaneously in family, community, and region. We are fortunate [to have] *Shaping Traditions* as a permanent display for our field."

20. For an indication of the continuing as well as historical role of agriculture in Georgia, see Fred Brown and Sherri M. L. Smith, *The Best of Georgia Farms Cookbook and Tour Book* (Atlanta: CI Publishing and Georgia Department of Agriculture, 1998).

21. What follows is a revision of the exhibition script, consisting of the text for section and subsection introductory panels (with selected illustrations), followed by a full catalog of the objects. For the most part, vocabulary and sentence structure suitable for a general audience have been retained; in keeping with the informal nature of the subject, given names are used, and titles are avoided where

possible. Changes include correction of errors, addition of new or more detailed information, and stylistic improvements benefiting from the passage of time since the opening. To optimize narrative continuity, the sequence of sections and objects reflects my original conception, not always realized owing to constraints in the exhibition space and design. The objects in the catalog section are numbered consecutively, and the object numbers are included in corresponding text sections and photograph captions. Textiles selected as alternates for rotation (a conservation practice allowing fabrics to "rest") are included in the catalog section. When artists' names are not given, they are not known. Construction materials are given when known and not obvious.

What's *Folk* about Folk Arts?

In the past, unwritten traditions governed the conduct of many Americans, and the folk stream of our culture was prominent. Then, formal learning and popular culture pushed folk traditions to the edge of most people's behavior. The study of folklore can reveal the lives of tradition-oriented people who were often omitted from history books because they left behind few written records.

Folk arts are the artistic expressions of folklore. Stored in the memory and communicated by word of mouth or body action, folk arts change as they are passed from one person to the next. Such fluidity makes folk arts different from academic knowledge and mass culture that are disseminated in fixed forms.

Some people think folklore is limited to stories or songs; others refer to self-taught artists with no traditional training as folk artists. This section introduces some basic principles to clarify such confusion.

FOLK ARTS ARE LEARNED TRADITIONALLY

(CATALOG NOS. 2–4)

Folk arts are learned through informal contact, face to face. Learning to cook by watching an older family member in the kitchen and learning games from other children in the playground are familiar examples of folk, or traditional, communication. Playing a musical instrument also can be a folk art; folk musicians normally learn by ear and observation rather than written notation and formal instruction.

FOLK ARTS ARE COMMUNITY-SHARED

(CATALOG NOS. 5–16)

Folk arts are community resources, supporting group values while serving individual members' needs. Folk arts belong to groups as small as families or neighborhoods and as large as occupations or regions. Although the art establishment uses the term *folk art* to describe the per-

sonal visions of self-taught painters and sculptors, such artists do not work within a community tradition, and so folklorists do not consider their work to be truly "folk."

Face to Face

Face jugs are a folk-art expression shared within the community of southern folk potters. The origins of southern face jugs are obscure; dating from the mid-1800s, they do not closely resemble anthropomorphic vessels of other, possibly influential, cultures, such as Native American effigy pots, ancestral "spirit" pots of West Africa, English Toby jugs, or German bellarmines. Southern face jugs of the twentieth century embody a humorous "aesthetic of the ugly" and have become highly collectible. This regional tradition is kept alive by members of pottery families, who have the creative freedom to interpret the form in their own ways, resulting in variation typical of folk arts.

Folk arts are learned traditionally. The first display case in *Shaping Traditions* includes a print of Henry Tanner's painting *The Banjo Lesson* and two small, hand-made instruments from Georgia on which children learned to play folk music.

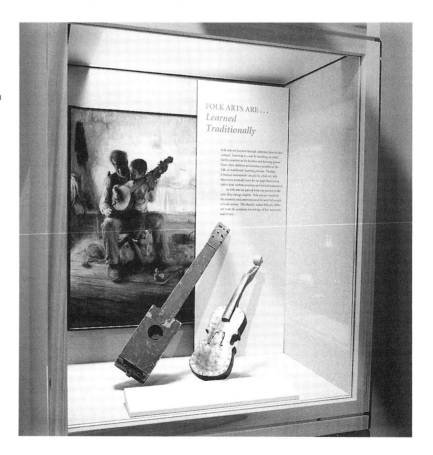

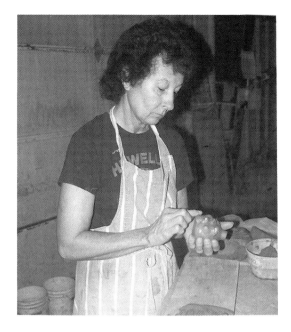

Left: Potter Grace Hewell of Gillsville, Georgia, sculpting one of her small face jugs as part of a family tradition, 1994. *Photo by John Burrison.*

Below: Recent face jugs representing a tradition shared by the community of southern folk potters and the variation resulting from individual interpretation. *Top, l–r:* Cat. nos. 7, 8, 15, 16, 10, and 9; *bottom, l–r:* Cat. nos. 6, 5, 11, 14, 12, and 13.

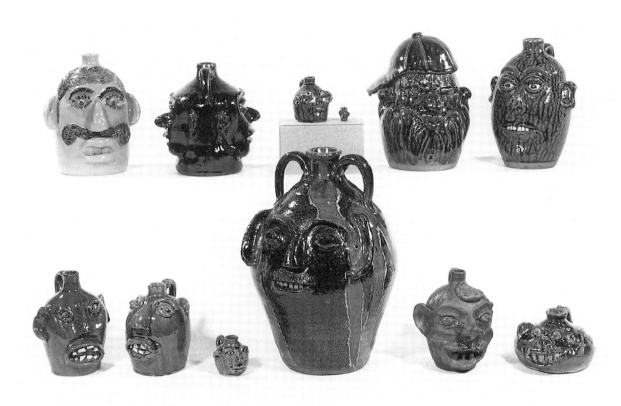

Rick Stewart of Sneedville, Tennessee, learning from his grandfather Alex Stewart an Appalachian coopering tradition probably brought from Ulster by Scots-Irish ancestors, ca. 1980. Rick is finishing a noggin like the one he later made for the folklife collection. *Courtesy Tennessee Valley Authority.*

FOLK ARTISTS BRING THE PAST INTO THE PRESENT

(CATALOG NOS. 17–19)

Folk artists draw their inspiration from their communities' earlier work. Since a folk artist is a human link in a chain that can be quite long, active folk arts are truly living history.

Using Their Noggins

The noggin is an eating vessel with one of the staves (the curved wooden slats held together with bands) extended as a handle. In the 1700s, Scots-Irish immigrants from Ulster brought the form and technology to the Appalachian Mountains. This coopering tradition can be traced back two thousand years to the Irish Iron Age. Noggins are still being made in both Ireland and Appalachia.

FOLK ARTS ARE FLEXIBLE

(CATALOG NOS. 20–22)

Although folk arts connect us to the past, they stay fresh and useful by adapting to change. Newcomers to the South, from the first European settlers to recent Asian immigrants, have adjusted their traditions to their new environment.

Tradition in a Basket

Among the Southeast Asians who have been settling in the Atlanta area since the 1970s are the Hmong, a Laotian ethnic group. My Lor Her learned basket making from her family in Laos, where the Hmong make

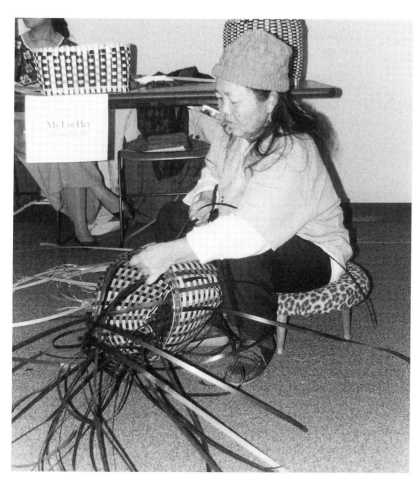

Hmong basket maker My Lor Her of Decatur, Georgia, demonstrating at the Atlanta History Center, 1994. In Georgia, colored plastic strips replace the bamboo of her Laotian homeland. *Photo by John Burrison.*

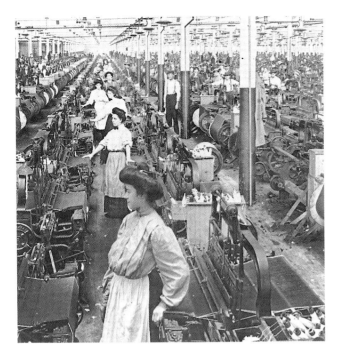

Left: The weaving room at White Oak Mill, Greensboro, North Carolina, showing the industrial approach to weaving in which power looms are run by semiskilled workers, 1909. *Courtesy Robert M. Vogel.*

Below: The Weavers, Land of the Sky, illustrating the traditional handcrafting approach to weaving in the North Carolina mountains, early 1900s. *Photo by H. Taylor Rogers, Asheville, N.C.; courtesy Museum of American Textile History, Lowell, Mass.*

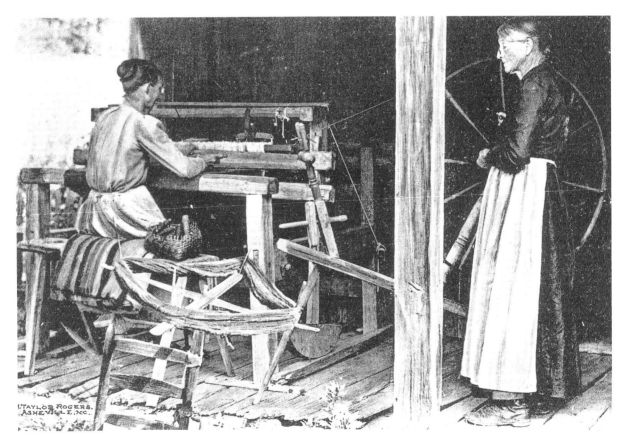

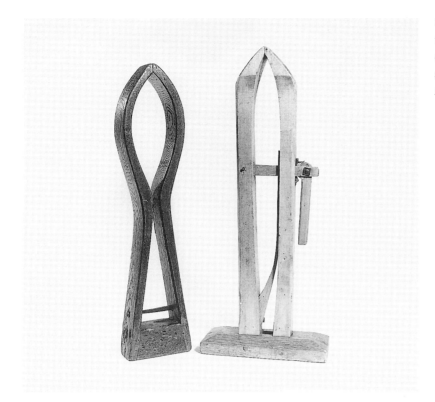

Nineteenth-century leather-stitching vises from North Carolina and Alabama, exhibiting the sculptural elegance of sensitively interpreted functional designs. *L–r:* Cat. nos. 23 and 24.

baskets of bamboo. That type of bamboo doesn't grow in Georgia, so she substituted plastic strips. The shapes and basic technique of her baskets are like those of Laos, but the new materials create stronger and more artistic products. The colors echo those in Hmong needlework, a folk art My Lor also practices.

FOLK OBJECTS CAN BE BOTH USEFUL AND BEAUTIFUL

(CATALOG NOS. 23–28)

In preindustrial societies such as the rural South, art was not separate from everyday experience. People combined beauty and utility in the things they made and used, enhancing the quality of their daily lives.

While most folk objects are made to perform a task, they can also be decorated. Even when they are not, they are governed by aesthetic principles and quality standards. Designs refined over generations and skillfully interpreted can result in objects that are at once functional and pleasing to the eye.

FOLK OBJECTS ARE HANDMADE—IN AN INHERITED TRADITION

(CATALOG NOS. 29–33)

Folk objects are produced by hand rather than machine. Clues about construction can help distinguish handmade from factory-made objects. Handcrafting leaves telltale signs of the human touch, while industrial machinery creates uniformity.

Although all folk objects are made by hand, some handmade things are not folk. This is because, in addition to being handmade, folk objects must also be traditional. Handmade items that are *not* folk include objects made in school art classes and works by self-taught artists. In neither case was the art learned informally from other members of a community.

What's *Southern* about Southern Folk Arts?

Unlike the academic and popular streams of American culture that are widely disseminated by print or electronic media and mass-production technology, the folk stream of culture can best reveal the localized concerns of a region or smaller group. However, not all the traditions practiced in the South are exclusive to the region. So which are truly southern, and why?

Dialect and foodways are the South's most obvious identity markers, but lesser-known traditions also contribute to its "personality." As with people, much of this regional personality results from a combination of heredity (cultural rather than genetic, of course) and environment.

The farming society that characterized the South for much of its history was responsible for many folk arts that distinguish the region from more urban and industrial parts of the country. Maintaining this rural society so late kept alive preindustrial traditions, such as folk pottery, that died out in other regions.

LIVING OFF THE LAND: A SOUTHERN WAY OF LIFE

I saw an honest farmer, his back was bending low.
Picking out his cotton, he couldn't hardly go.

.

"Goodbye, boll weevil, you know you've ruint my home.
You know you've got my cotton, and the merchant's got my corn."

—"The Honest Farmer," as recorded by north Georgian
Fiddlin' John Carson, 1925

Until the early to middle twentieth century, life in the South depended heavily on natural resources. Folk knowledge developed over generations allowed southerners to make a living from the soil, woods, and waters.

The South's longer growing season helped make agriculture central to its economy. Cash crops dominated this economy, giving rise to a plantation system dependent on slave labor. Relatively few southerners were the planter-aristocrats of popular fiction, however; many were middle-class or small farmers who raised crops and livestock for their own use as much as for market. They lived on isolated farms rather than in village clusters, contributing to greater reliance on the family and on inherited folk wisdom.

As recently as 1950, nearly a third of Georgia's population lived on farms. Agriculture remains the state's leading industry, but the small family farm is becoming obsolete. Some traditions stemming from older rural life, such as barbecue and grits, are still distinctive features of contemporary southern culture.

The Cotton Kingdom

(CATALOG NOS. 34–41)

After his 1793 stay on a Georgia plantation, New Englander Eli Whitney patented the cotton gin to separate the seeds from the fiber. This made possible large-scale growing of upland cotton, giving the plantation system and slave trade a big boost. Soon the South was bowing to King Cotton, which continued to rule the economy after the Civil War.

In the financial panic of 1892, the price of cotton dropped from one dollar to nine cents a pound. Production in Georgia fell from two million bales in 1918 to one-fourth of that by 1923 as boll weevils destroyed much of the crop. Many farmers abandoned the countryside for other work; others diversified with the "four p's" (poultry, peaches, pecans, and peanuts). Today, cotton is making a comeback in the South.

Corn Culture

(CATALOG NOS. 42–54)

Maize was a Native American gift to colonial settlers, who, to acknowledge its importance as a food crop, gave it the English generic name for cereal plants: corn. Corn is still a major bread grain in the South, cooked in a skillet or mold. Its popularity, once owing to affordability over wheat flour, is now more a matter of taste.

Scots-Irish settlers in Appalachia adapted their Ulster distilling skills to create "liquid corn," an important source of cash income for mountain farmers. Illegal moonshine and licensed bourbon became legendary southern products.

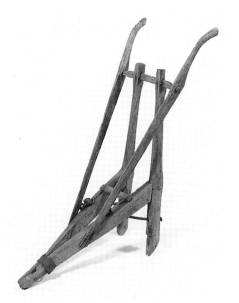

Left: Double-foot plow (Cat. no. 37) by William Brown of Pike County, Georgia, 1870s.

Below: Part of the "Living off the Land" section of *Shaping Traditions,* illustrating agricultural traditions.

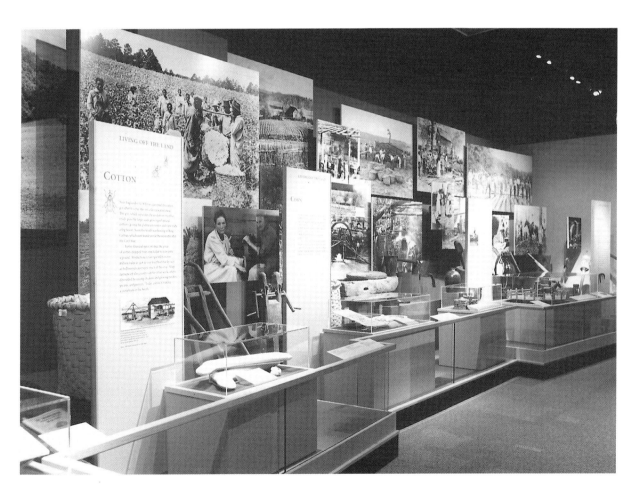

Right: Mr. and Mrs. Mallie Hutchinson of Abbeville County, South Carolina, making hominy in 1937. The pottery churn (foreground) held homemade lye, which, when boiled with water in the kettle, caused the hand-shelled corn kernels to burst their hulls and swell. The lye would be washed from the hominy before cooking. *Courtesy Bandon and Katherine Hutchinson.*

Below: Two field sleds sheltered by a log barn in Rabun County, Georgia, 1970. Like the quern for hand-milling corn, they represent the retention by southern farmers of a prehistoric trait from the British Isles. Such sleds survived because they continued to make sense for hauling produce and fertilizer in rugged terrain. *Photo by John Burrison.*

Raising Cane—and Other Farm Products

(CATALOG NOS. 55–66)

Tobacco, another Native American contribution, was the main cash crop of colonial Virginia and Maryland. Slaves from rice-growing areas of West Africa were brought to work on the low-country rice plantations of South Carolina and Georgia. Louisiana was known for its sugar making, but elsewhere in the lowland South sugarcane was converted into homemade syrup; sorghum was introduced for upland syrup making in the 1850s.

Pork was the southern meat of choice until the rise of the poultry industry in the 1920s. "Everything but the squeal" of the hog was used at butchering time in the fall; barbecuing and ham curing became fine arts. In south Georgia and Florida, where large herds of cattle were raised, a cowboy culture developed.

"Barning," or preparing tobacco for flue curing in a log tobacco barn, Nash County, North Carolina, 1926. *Courtesy North Carolina Division of Archives and History, Raleigh.*

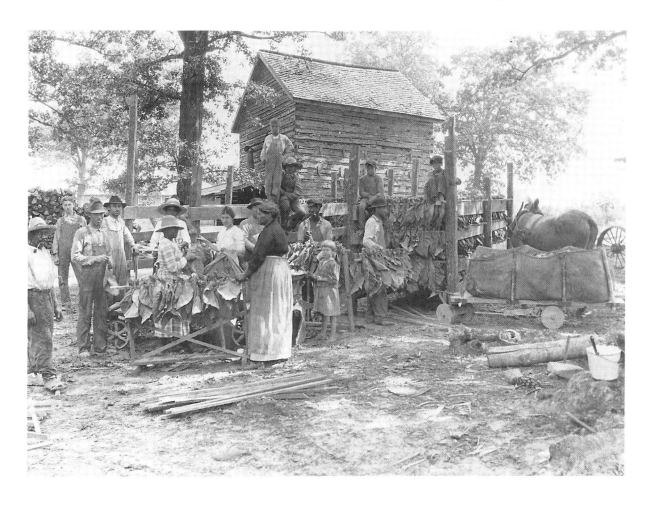

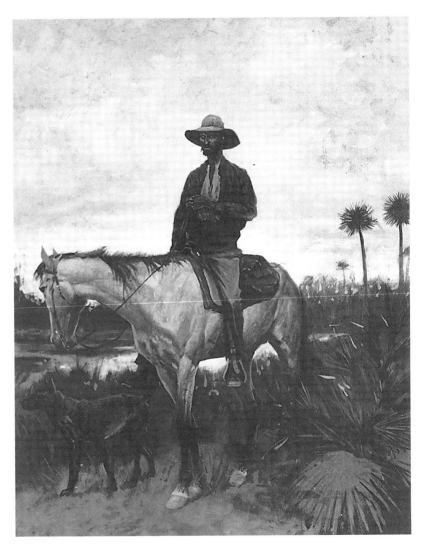

Above: Model sorghum-syrup mill and evaporator (Cat. nos. 61 and 62) by Carl Stepp of McCaysville, Georgia, 1970.

Right: A Cracker Cowboy (Bone Mizell of Arcadia, Florida), an 1895 painting by Frederic Remington representing the cattle culture of Florida and south Georgia. *Courtesy "21" Club, New York City.*

Timbering

(CATALOG NOS. 67–76)

Ain't gonna live in the country,
Ain't gonna live in the town;
Gonna wait right here 'til the river rises
And run my timber down.

> —"The Rafthand Song," as sung by
> James Kelton Rolison, Ohoopee,
> Toombs County, Georgia, 1972

The South's timber resources have supported the making of folk baskets, tools, furniture, musical instruments, and buildings. Logging, still a major industry in parts of the region, once was served by a rafting subculture that floated the logs downriver to the coast.

"Naval stores" extracted from pine trees were the South's third-largest export in the 1850s, earning North Carolina its nickname as the Tar Heel State. Distilling turpentine from the resin of longleaf pines was a labor-intensive folk industry. In the 1870s, turpentine villages spread through south Georgia's piney woods, but they have now all but vanished with competition from nonresin substitutes.

Hunting

(CATALOG NOS. 77–83)

An' I have a deer dog now, he is so good after deer 'til I have t' peg up one side of 'is nose t' keep 'im [from] runnin' two deer at the same time.—Lem Griffis, Fargo, Clinch County, Georgia, 1966, from John A. Burrison, ed., *Storytellers: Folktales and Legends from the South*

In the 1700s, southeastern Indians hunted deer in large numbers for their hides, which they traded for European goods. Such game as deer, wild turkeys, waterfowl, squirrels, and rabbits were important sources of meat for early settlers. To support hunting, the folk arts of rifle making and decoy carving developed in parts of the South. Hunting later became a ritual of male bonding and a favorite outdoor recreation.

Winnowing rice with a coiled "fanner" basket (rice-hulling mortar and pestle at right), Sapelo Island, Georgia, 1890s. This technology was introduced to coastal plantations by slaves from rice-growing areas of West Africa and survived among black low-country farmers into the twentieth century. *Courtesy Georgia Department of Archives and History.*

Mountain gunsmith Ambrose Loving (also spelled Lawing) of Flag Pond, Tennessee, ca. 1915. *Photo by John C. Campbell; courtesy Southern Historical Collection, University of North Carolina Library, Chapel Hill.*

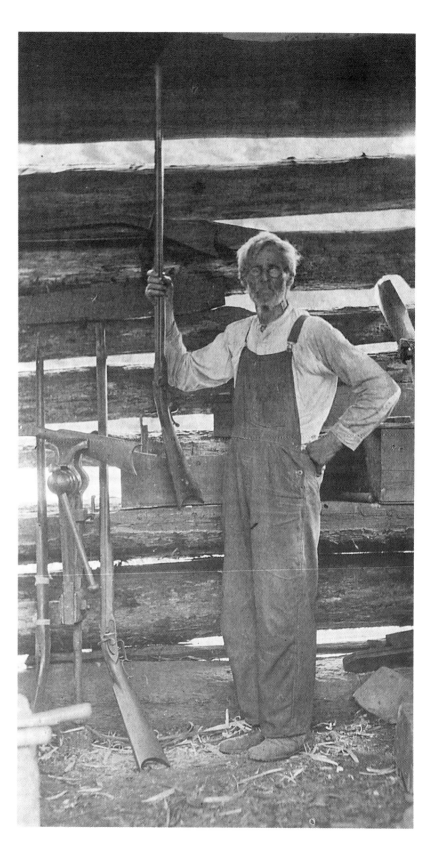

Lean and Mean: Mountain Rifles

(CATALOG NOS. 84–88)

Muzzle-loading hunting rifles of Appalachia reflect the dour practicality of Scots-Irish settlers. These rifles usually lack the decorative carving and inlays of brass or silver found on Pennsylvania and Piedmont North Carolina long rifles. They have a lean stock of black walnut, with iron rather than brass furniture (the trigger guard and butt plate). They also have the double set triggers and long tang (a strap attaching the rear of the barrel to the stock) typical of southern rifles. These mountain rifles continued to be made as a southern folk craft even after the appearance of breechloaders firing self-contained cartridges.

Mountain rifle (Cat. no. 85) by John Nelson of Ball Ground, Georgia, 1871. The double set triggers and iron trigger guard can be seen; view of top shows the signature, date, and long (two-screw) barrel tang.

Fishing

(CATALOG NOS. 89–99)

Looked down the river about one o'clock,
Spied this catfish swimming around.
I got so hungry, didn't know what to do,
I'm gonna get me a catfish too.

 —"Fishing Blues," as recorded by Henry
 "Ragtime Texas" Thomas, 1929

Fish have always added variety to the southerner's diet. Now, fishing is enjoyed mainly as a hobby. Some traditional fishing techniques, such as basketry traps and "gigs" (spears), are ancient. Along the south Atlantic and gulf coasts, communities grew up around the commercial fishing of shrimp, oysters, mullet, and menhaden (an inedible fish used for oil and fertilizer). Mussels were caught along some inland waterways for the shell-button industry.

Above: Fishing with a cast net on Johns Island, South Carolina, early 1960s. Such purse nets, which draw closed when pulled in, are native to Africa and Asia and probably represent an African survival on the south Atlantic coast. *Photo by A. R. Yellin.*

Right: Model shrimp boat (Cat. no. 98) by Dennis Wallace of Townsend, Georgia, 1994. Such models have become traditional among retired boatbuilders and fishermen as a source of income and occupational identity.

Nature's Pharmacy: Folk Medicine

(CATALOG NOS. 100–104)

People, y'know, didn't have a chance of runnin' after doctors back
in these mountain areas. . . . Where I was raised, it was twelve miles
by horseback to th' nearest doctor.—Harriet Echols, Macon County,
North Carolina, late 1960s, as quoted in Eliot Wigginton, ed., *The
Foxfire Book*

Herb gardens and woods have provided southerners with an abundant
source of medicine for common ailments. Plant lore was practiced by
family elders and handed on from generation to generation. Knowledge
of which plants were useful for what problems came from Native Ameri-
cans, the Old World, or trial and error.

SOUTHERN SPECIALTIES

Beyond an agrarian lifestyle, other factors were responsible for the de-
velopment of traditions unique to or concentrated in the South. These
include the physical environment (climate, terrain, and available re-
sources) and historical forces.

Buildings and Bonnets: Influences of Climate

(CATALOG NOS. 105–8)

Southern folk architecture and clothing illustrate responses to the physi-
cal environment. Folk dwellings were designed for comfort in a warm
climate. The gallery porch served as a shaded warm-weather living space.
In the Deep South, buildings often are raised on piers, allowing air to
circulate under the floor to cool the house and reduce rot, mildew, and
vermin. Outside end chimneys localized the heat when used for cooking.
For the same reason, some houses also had a separate kitchen.

Except in the "sunny South" (and among "plain" sects such as the
Amish), bonnets had passed out of fashion by the late 1800s. With their
protective visors and capes, bonnets helped keep southern white women
from tanning or getting "red necks," once a sign of low social status. Al-
though no longer a common sight, some southern women still garden in
bonnets.

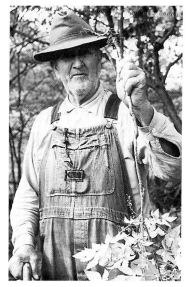

Harley Carpenter holding a yellow-root
plant he has just pulled from a stream
bank near his mountain home, ca. 1970.
He mixed the root with cherry bark and
whiskey for a blood tonic. *Courtesy The
Foxfire Fund, Mountain City, Ga.*

Right: Mrs. George Maney of Homer, Georgia, hoeing her garden in a new sunbonnet, 1970. *Photo by John Burrison.*

Below: The Cornelius Lynch House, an 1848 log "dogtrot" from rural Stewart County, Georgia, moved ca. 1970 to Lumpkin, the county seat. Later additions hide the basic structure of many surviving dogtrot houses, but this example clearly shows the doors facing each other across the breezeway. Gallery porches, pier-and-sill foundations, outside chimneys, and detached kitchens helped keep such houses cool in the southern climate. *Photo by John Burrison.*

Snakes as a Symbol

(CATALOG NOS. 109–13)

While not uniquely southern, snakes appear often in the region's folk art, interpreted in wood, clay, and iron. Representing Satan as tempter, the snake is a powerful Bible Belt symbol and is featured in worship services of the serpent-handling wing of the Church of God, a Pentecostal sect.

Pottery Grave Markers: A Response to History?

(CATALOG NOS. 114–17)

Regional folk arts also could be shaped by historical forces. Fired-clay markers in cemeteries associated with some pottery centers from Virginia to Texas have death dates mostly ranging from the 1870s to early 1900s. This suggests that they arose in response to economic conditions after the Civil War, when stone markers would have been prohibitive for many.

Some pottery markers were designed as tombstones, others to hold flowers. They were not always inscribed and glazed and show great variety in decoration and forming; they could be thrown on the potter's wheel, slab-built, or molded.

Wheel-thrown, salt-glazed stoneware grave markers in the Laney family cemetery, Union County, North Carolina, attributed to a potter of the Gay family, 1885–90. *Photo by John Burrison.*

SOUTHERN BLENDINGS

Early population groups—Native Americans and settlers from the Old World—made important contributions to southern folk culture. In the Southeast, the most significant Old World source areas were Britain, West Africa, Ulster in Ireland, and central Europe. Florida, South Carolina, and Alabama also had Spanish and French influences. As these foundation groups interacted, their diverse traditions mingled into a folk-cultural "stew" with a regional flavor all its own but with some original ingredients still identifiable. Social scientists call this process creolization.

From the Southern Stewpot: Gumbo

(CATALOG NOS. 118–24)

The lowland southern soup known as gumbo reflects the early mixing of African, European, and Indian traditions to create a uniquely southern product. Gumbo gets its name from the Tshiluba word for okra, one of the soup's ingredients, which was brought from Africa via the slave trade. Two other thickeners further reflect the ethnic diversity of southern Louisiana. Roux—flour browned in oil—is French, while filé—powdered sassafras leaves—is Native American. Spices, aromatic vegetables, and fish or meat complete the dish, which is usually served over rice.

Creolization (blending of cultures) in southern folklife is illustrated by the soup known as gumbo, which combines Native American, African, and French ingredients.

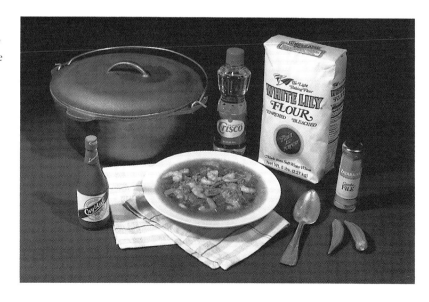

Color-Woven Baskets

(CATALOG NOS. 125–28)

The southern folk craft most influenced by Native Americans is basketry. In the 1700s, Indians traded rivercane baskets, dyed and woven in intricate patterns, to whites, probably inspiring later Anglo-American baskets with dyed splints. Some Indian basket makers, in turn, adopted European-style handled baskets.

Coat of Many Colors

(CATALOG NOS. 129–30)

Southeastern Indians adopted European-style coats, shirts, pants, and dresses while retaining their native turbans, moccasins, and sashes. By the nineteenth century, many Indians were wearing clothes that combined both native and European influences.

Florida's Seminole Indians have developed a distinctive clothing tradition that reflects this mix. Facilitated by sewing machines, they borrowed the piecing and strip techniques of southern quilts to create intricate patchwork decoration.

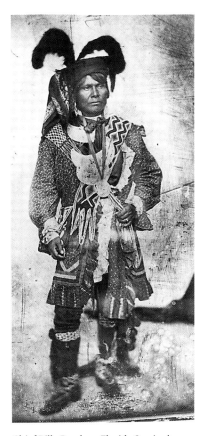

Chief Billy Bowlegs, Florida Seminole Indian leader, wearing a "long coat," 1852. It combines a frontier-era European design, southern textile techniques, and Native American aesthetics into a distinctly southeastern Indian style. *Courtesy Manatee County Historical Society.*

SECTION THREE

A Handmade Life: Folk Arts at Home

In the antebellum rural South, many material goods were handmade at home or by community specialists. Nearly all farm women sewed for their families, and most farm men had woodworking skills. Some, such as potters, practiced specialized trades. Whites normally learned these skills from family members, while enslaved African Americans were trained to produce much of what was needed on plantations.

As the North became industrialized, the South maintained its reliance on handcrafting. By 1860 this pattern was changing, with some industry in the region and increased access to imported goods. The Civil War, however, caused southern factories to shift to military production, and the Union blockade of the coast encouraged a return to the handmade life. Dependence on these survival skills was reinforced by the hard times following the war, especially in more remote sections such as the mountains.

Handcrafting was further stimulated in the twentieth century with the creation of outside markets. While no longer central to the lives of most southerners, these arts have gained a new value and appreciation as they decorate the homes of city dwellers and suburbanites across the nation.

Model of a typical southern folk pottery operation (Cat. no. 131). The main features are the workshop, wood-fired crossdraft kiln with shelter, mule-powered clay mill, and hand-turned mill for alkaline glaze (at rear of shop).

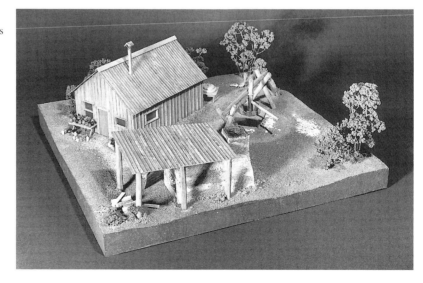

MADE OF MUD: POTTERY

[Pottery] was number one. Just about everything else at one time in this part of the country depended upon it. . . . You know, necessity rules everything.—Lanier Meaders, Mossy Creek, White County, Georgia, 1968, quoted in John A. Burrison, *Brothers in Clay: The Story of Georgia Folk Pottery*

Before refrigerators and inexpensive glass, metal, and plastic containers, vessels of clay were essential for storing food and drink. Whiskey, cane syrup, lard, milk, fruit, vegetables, and meat were all kept in pottery. Folk potters supplemented their farming incomes by supplying the needs of their communities.

Demand for folk pottery declined in the early 1900s. Rather than abandon clay work, some potters turned to unglazed planters or colorful art wares. Others, such as Lanier Meaders, kept up the older tradition and sparked a new interest in southern folk pottery. Georgia, North Carolina, and Alabama are the only states in the country where Euro-American folk pottery is still made.

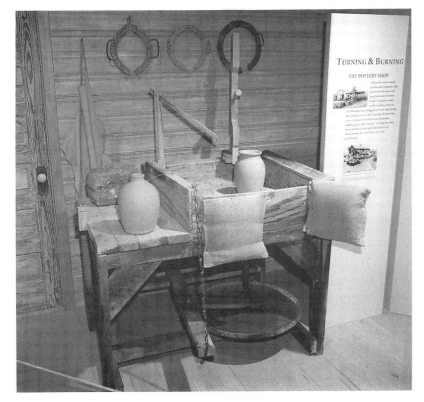

Pottery shop corner re-created in *Shaping Traditions*, featuring a Meaders family treadle wheel (Cat. no. 132). This type of wheel, with a foot bar linked to a crank-shaft, originated in eighteenth-century England.

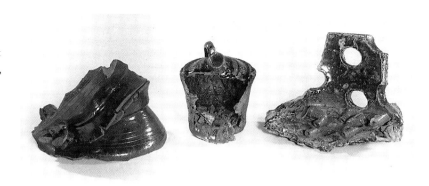

Ruined wares from the waster dumps of southern pottery shops, illustrating the loss from wood-fired crossdraft kilns that can be hard to control. *L–r:* Cat. nos. 154, 155, and 151.

Turning and Burning: The Pottery Shop

(CATALOG NOS. 131–55)

Historically, folk potters were professional craftsmen who invested in shops and equipment to create wares for sale. A few southern potters still maintain elements of the nineteenth-century technology by digging their own clay, mixing it in a mule-powered mill, "turning" (throwing) it on a foot-powered wheel, using homemade alkaline glazes, and "burning" (firing) their wares in a wood-fueled kiln.

Southern Stoneware Glazes

A glaze is a glassy coating that seals a pot and adds to its beauty. Glazes can help identify American pottery of different regions and eras. Colonial potters made earthenware, a porous, red-clay pottery glazed with lead (later found to be poisonous). By the early 1800s, stoneware was becoming the dominant type of American folk pottery. This harder ceramic product is made of a purer (light gray or tan) clay that is fired at a higher temperature and is coated with a nontoxic glaze.

Salt Glaze

(CATALOG NOS. 156–57)

German potters of the 1400s discovered that throwing salt into the kiln at the height of firing creates a coating of glass on stoneware. This European technique, with associated blue cobalt-oxide decoration, was brought to the Mid-Atlantic region in the early 1700s. In the lower South, salt-glazed stoneware was made only sporadically, and seldom was cobalt decorated. Firing in the wood-fueled, rectangular kilns of the region often gave this glaze an irregular surface, with drippings from the kiln bricks and salt or fly-ash puddling.

Potter Cleater "C. J." Meaders sifting ashes for his drippy-textured alkaline glaze, Cleveland, Georgia, 1988. The ashes then would be mixed with water, clay, and silica into a solution for coating the unfired pots. *Photo by John Burrison.*

Alkaline Glazes

(CATALOG NOS. 158–74)

Unknown elsewhere in the United States, alkaline stoneware glazes were spreading through the lower South by the 1820s. These green or brown glazes depend on wood ashes or lime to help melt other readily available ingredients (typically, clay and sand). An iron-bearing mineral that colored the glazes sometimes was added.

These alkaline glazes are strikingly similar to those of the Far East. A French missionary's account of Chinese ash and lime glazes was published in 1735. Brothers Abner and John Landrum, stoneware pioneers of South Carolina's Edgefield District, may have read that description about 1810 and tried the glazes in place of salt, which would have been hard to come by in the backcountry. Potters associated with the Landrums took the alkaline glazes as far as Texas.

Lower Southeast pottery centers, located mostly in the Piedmont (the darker shaded area), where good clay is concentrated. The arrows show movements of some potters in the region, including those who spread the alkaline-glazed stoneware tradition from South Carolina's Edgefield District. *Map design by Staples & Charles Ltd.*

Albany Slip

(CATALOG NOS. 175–76)

After the Civil War when trade with the North was resumed, some southern potters adopted Albany slip, a natural clay glaze from New York State. This smooth, brown glaze is easier to prepare and clean than alkaline glazes. Albany slip was sometimes given a regional treatment by salt-glazing over it, creating a patchy tan or green coloring; as a precedent, German and English stoneware potters often salt-glazed over an iron wash.

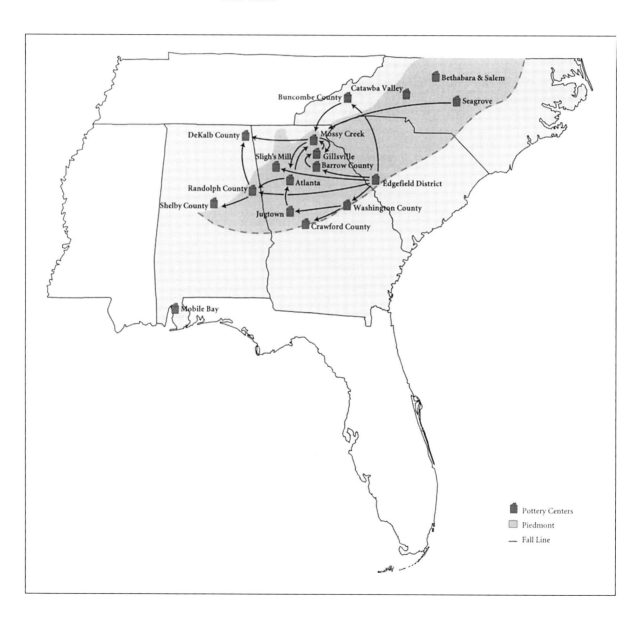

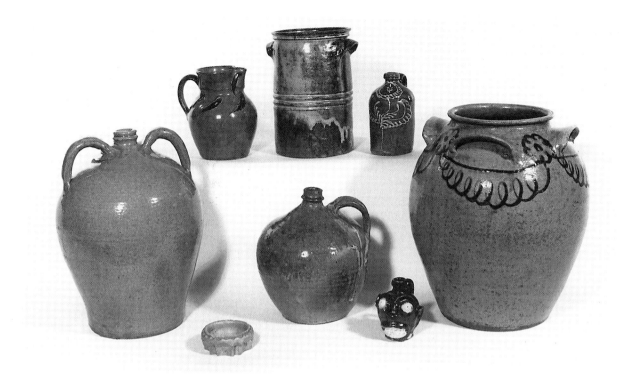

Bristol Glaze

(CATALOG NO. 177)

Another smooth—white or clear—stoneware finish called Bristol glaze, developed in England in 1835, was adopted in the United States in the late 1800s. In the South, it was used mainly in Mississippi, Texas, and more industrial operations in Georgia.

Jugtowns: Piedmont Pottery Centers

Southeastern folk potters clustered in "jugtowns" in the Piedmont and along its lower edge, the Fall Line, where stoneware clay is concentrated. Each center developed recognizable stylistic traits influenced by pioneer pottery families, or "clay clans." Typical wares of each center can be identified by examining the markings, glazes, forms, and handle and neck treatments.

Just as potters migrating from the Carolinas contributed to Georgia's stoneware tradition, movement within Georgia carried ideas from one center to another. Only those centers for which good examples could be acquired are represented here.

Alkaline-glazed stonewares of antebellum South Carolina, most from the old Edgefield District. *Clockwise from left:* Cat. nos. 179, 183, 185, 181, 182, 184, 187, and 178.

Edgefield District, South Carolina

(CATALOG NOS. 178–87)

The old Edgefield District of west-central South Carolina (now Edgefield and parts of Aiken, Greenwood, Saluda, and McCormick Counties) was the likely birthplace of southern alkaline glazes. Brothers Abner and John Landrum were running shops here by 1817. Edgefield-trained potters spread the regional stoneware tradition through the lower South.

For greater appeal to customers, some Edgefield wares were decorated with iron (dark brown) and kaolin (white) slips, or liquid clays (a technique elsewhere associated with earthenware). This combination of slip decoration and alkaline-glazed stoneware is unique in world ceramics. Edgefield shops depended on African American labor. The most famous slave potter, known as Dave, made large storage jars decorated with poetry. Other slave potters made face vessels.

Wheel-thrown pottery figurals, a nineteenth-century Jugtown (Upson and Pike Counties), Georgia, tradition still practiced by Marie Rogers. *L–r:* Cat. nos. 206 and 213.

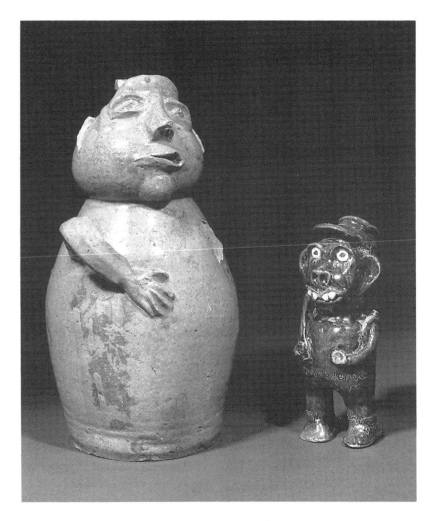

(CATALOG NOS. 188–89)

Before the Civil War, black stoneware potters were concentrated in Edge-field District, where shops were run with slave labor as full-time busi-nesses. (One usually became a folk potter elsewhere by being born or marrying into an Anglo-southern pottery family.) Later African Ameri-can folk potters include Rich Williams, who owned a shop in Greenville County, South Carolina, and Bob Cantrell, a hired turner at Daddy Bill Dorsey's shop in White County, Georgia. There are no black folk potters known to be working in the South today.

Dave, Slave Potter-Poet

The enslaved African American potter we know the most about is Dave (1800–187?). He learned the craft in the Edgefield District shop of either Abner or John Landrum and began signing his wares in 1840 on the plantation of Lewis Miles (whose successive wives were daughters of the Landrum brothers). Recent research points to Dave taking the surname of Drake, an early owner and potter, after emancipation.

Some Dave jars are among the largest pieces of folk pottery made in the United States. Their decoration is also remarkable: poetry incised in the damp clay. Dave may have learned to write while working at the *Edgefield Hive,* a newspaper published by Abner Landrum. One rhyme mentions his slave status: "Dave belongs to Mr. Miles / Where the oven bakes & the pot biles." Another is more poignant: "I wonder where is all my relations / Friendship to all—and every nation."

Washington County, Georgia

(CATALOG NOS. 190–95)

Northern Washington County was Georgia's earliest pottery center, with two stoneware potters operating in 1820. They were Cyrus Cogburn and Abraham Massey, associates of the Landrums back in Edgefield District, South Carolina. They brought the recently developed alkaline glazes to middle Georgia. The type seen on Washington County wares is a lime glaze that included clay and sand; when underfired it is muddy looking and rough textured.

Crawford County, Georgia

(CATALOG NOS. 196–205)

A pottery shop was operating in eastern Crawford County in 1829. It was owned by James Long or John Becham, who both migrated from Wash-ington County. Whiskey jugs, made for licensed distillers in nearby Ma-

con until Georgia's 1907 prohibition, became this center's chief product. Both lime and ash types of alkaline glaze were used. These were often colored with "paint rock" or limonite nodules. Until recently, local Lizella clay was machine-formed into orchid pots by the Merritt family, one of the old clay clans.

Jugtown, Georgia

(CATALOG NOS. 206–13)

There were seven communities in the South called Jugtown, a sign of the importance of pottery making in the region. Georgia's Jugtown, at the juncture of Upson and Pike Counties, was not an official map name, so the nearest post offices—Meansville, Delray, and Kenzie—were used on stamps to mark wares. The Bishops and Browns were early pottery families here, the Browns likely coming from Washington County. By the late 1800s, alkaline glazes were abandoned in favor of salt glaze and Albany slip.

Atlanta, Georgia

(CATALOG NOS. 214–23)

By 1864, potter Bowling Brown had moved with several relatives from Jugtown to Howell's Mills, northwest of Atlanta. A new center grew around the present intersection of Howell Mill Road and Northside Parkway near West Paces Ferry Road (less than three miles from the Atlanta History Center). There were seven shops, the last closing about 1930. Fulton County potters specialized in whiskey jugs for licensed distillers, using mainly salt glaze and Albany slip.

Barrow County and Gillsville, Georgia

(CATALOG NOS. 224–30)

By 1847, Edgefield-trained Charles H. Ferguson had set up a "jug factory" (as shown on early maps) near Statham in present-day Barrow County. He began a fifty-potter dynasty that, through marriage, included the DeLay, Archer, Dial, Robertson, and Hewell families. During the Civil War, alkaline-glazed tablewares were made to replace factory-made wares kept out by the Union blockade. Later wares were salt-glazed over Albany slip.

In the late 1800s, Gillsville, at the juncture of Hall, Banks, and Jackson Counties, blossomed as a pottery center, fed by migrants from Mossy Creek to the north and Barrow County to the south. Albany slip soon became the chief glaze. Gillsville is now Georgia's center for unglazed garden pottery, produced by the Hewells and Cravens.

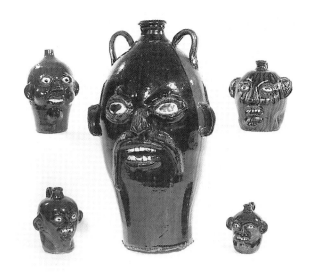

Left: Recent alkaline-glazed face jugs by the Hewells of Gillsville, Georgia. *Clockwise from lower left:* Cat. nos. 239, 241, 237 (*Big John,* twenty-six inches tall), 240, and 238.

Below: Hewell family potters at their wood-burning kiln, Gillsville, Georgia, 1993. *L–r:* Chester; his wife, Sandra; their sons, Nathaniel and Matthew; and Chester's parents, Grace and Harold. *Photo by William F. Hull, Atlanta History Center.*

THE HEWELL FAMILY

(CATALOG NOS. 231–42)

The Hewells illustrate the adaptability of the southern pottery tradition as the market changed in the twentieth century. The first known potter of this family was Nathaniel Hewell of Barrow County. His son, Eli, came to Gillsville with associated potters about 1890. With the decline in demand for food-related wares in the 1940s, the Hewells shifted to unglazed garden pottery.

Sensing a growing collectors' market in 1983, the Hewells revived their tradition of alkaline-glazed stoneware with which they had begun. They again make face jugs, as their ancestors did in the early 1900s. With three generations working together, this is truly a family business. As Harold Hewell puts it, "We must have been born with clay in our veins."

Mossy Creek, Georgia

(CATALOG NOS. 243–50)

This foothills farming settlement in southern White County was Georgia's largest pottery center, home to some eighty potters since the 1820s. The pioneer potters came from North Carolina. The Meaders family entered the craft late but carries it on today. Both ash and lime alkaline glazes have been used; varying the silica additive created "iron-sand" and "flint" subtypes.

THE MEADERS FAMILY

(CATALOG NOS. 251–61)

The Meaders Pottery was launched in 1893 by John Milton Meaders, who saw the success of his folk-potter neighbors at Mossy Creek and thought this would be a good trade for his six sons. He hired Marion Davidson and Williams Dorsey to work in the new log shop and teach his older boys. The youngest son, Cheever, learned from his brothers, taking over the shop in 1920. As local demand for household wares dropped, crafts enthusiasts became Cheever's main customers. In the 1950s his wife, Arie, began making decorative wares for those seeking a more artistic product.

In 1921 Cleater Meaders, one of Cheever's brothers, opened a shop in Cleveland, the White County seat. This shop closed in 1938, but his son, Cleater ("C. J."), later returned to the craft and built a wood-burning tunnel kiln at his summer home outside Cleveland, where he and his wife, Billie, make runny-textured ash-glazed wares. Their son, Clete (the third Cleater Meaders), mixes clay with a mule at his own pottery at Hoschton, Jackson County.

1. The snake motif in southern folk art. *L–r:* Cat. nos. 449, 110, 113, and 450.

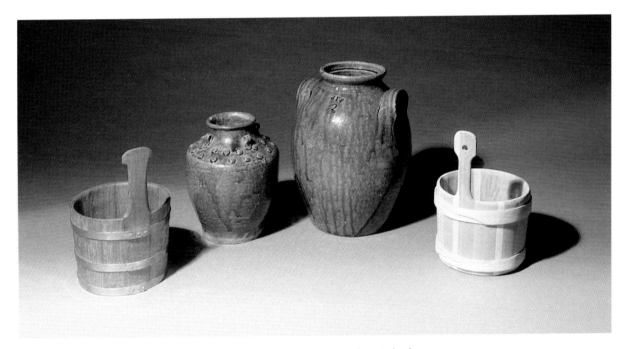

2. Some Old World sources for southern folk arts: coopered wooden noggins from Ireland and Tennessee; ash-glazed stoneware jars from China and North Carolina (alkaline glazes seem to have come indirectly from Asia via print). *L–r:* Cat. nos. 17, 163, 162, and 18.

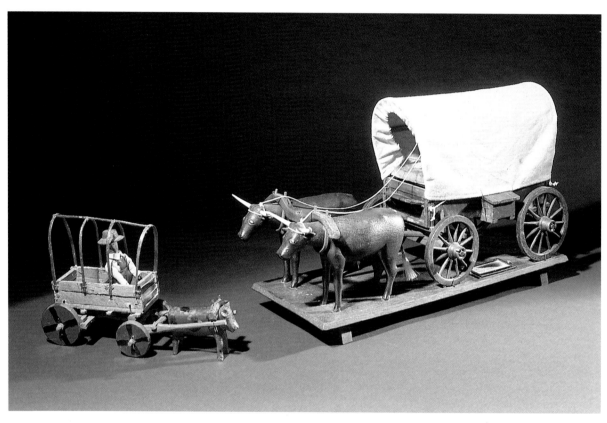

3. North Georgia miniature covered wagons pulled by oxen, showing two different approaches to a traditional Appalachian woodcarving subject. *L–r:* Cat. nos. 367 and 368.

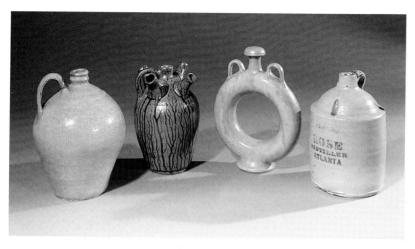

4. Some Georgia jug forms. *L–r:* whiskey jug (Cat. no. 191) with bulbous shape and sharp neck collar typical of the antebellum period; "flower jug" or quintal (Cat. no. 261), a European-derived form for cut flowers; ring jug (Cat. no. 212), a European-based canteen form; and whiskey jug (Cat. no. 219) in later cylindrical "stacker" shape.

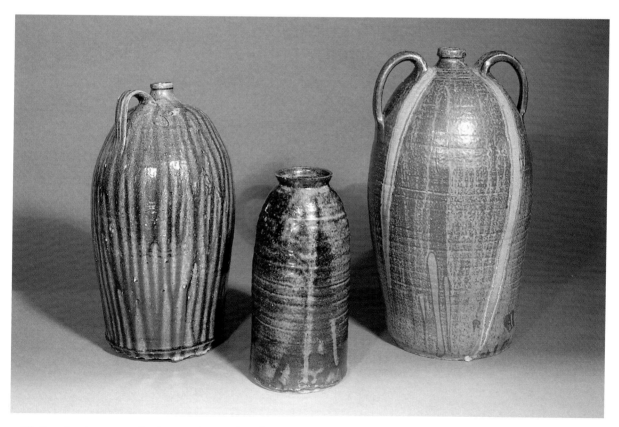

5. Alkaline-glazed stonewares by the second generation of potters at Mossy Creek, Georgia. *L–r:* Cat. nos. 248, 247, and 243.

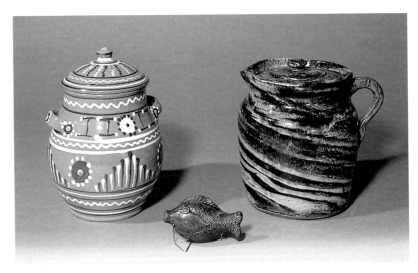

6. North Carolina decorative pottery. *L–r:* Cat. nos. 269, 268, and 276.

7. Stonewares from North Carolina's two largest pottery centers, the Catawba Valley and Seagrove area. *L–r:* Cat. nos. 274, 275, 273, 271, and 272.

8. Alabama stonewares. *L–r:* Cat. nos. 282, 284, 283, 281, 278, and 280.

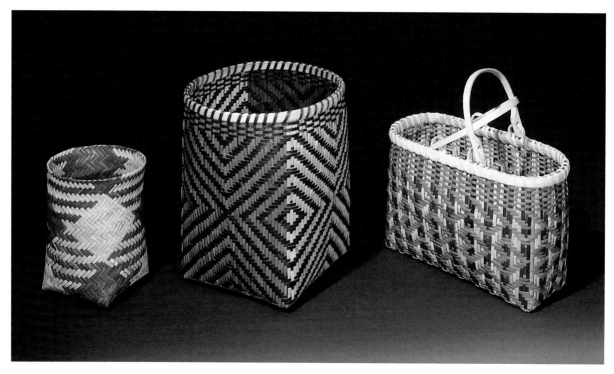

9. Baskets of natural-dyed rivercane by Lucille Lossiah of Cherokee, North Carolina, 1994–95. *L–r:* Cat. nos. 372, 373, and 374.

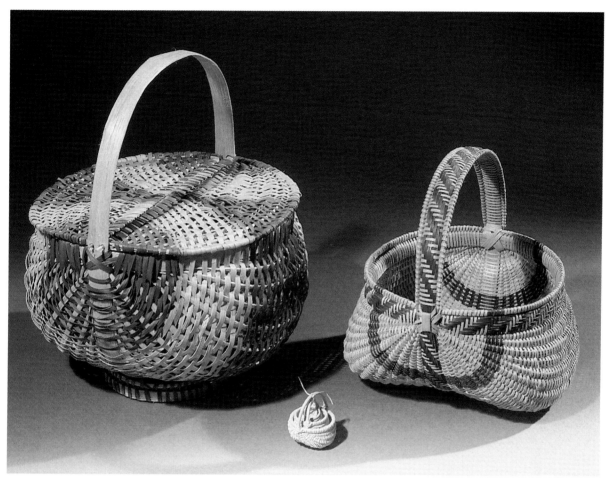

10. Decorative white-oak rib baskets recently made in Tennessee and North Carolina.
L–r: Cat. nos. 127, 381–83, and 126.

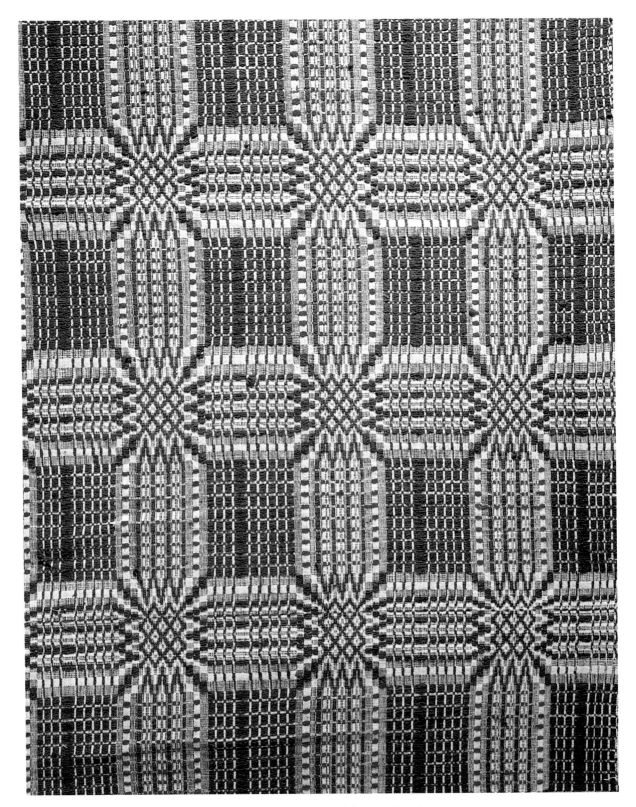

11. Detail of "Habersham Burr" coverlet (Cat. no. 410) by Ethel Collins of Choestoe, Georgia, 1920.

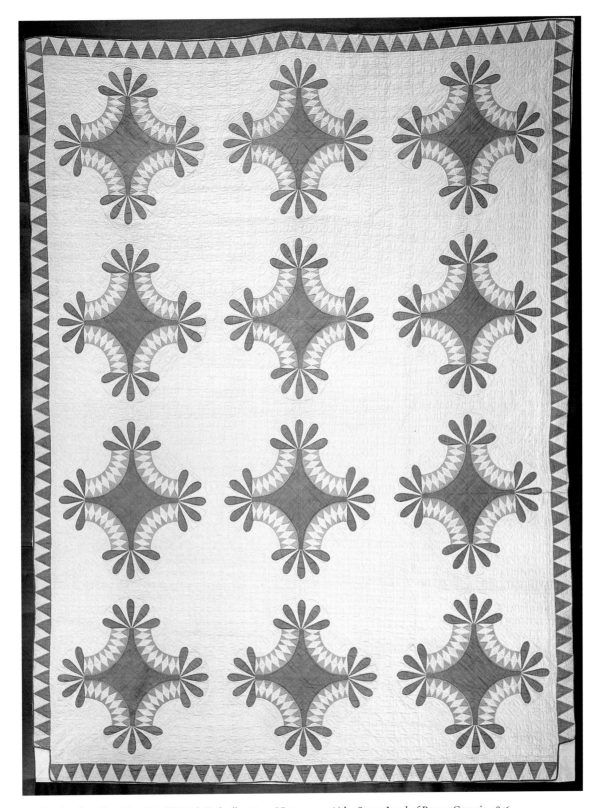

12. Pieced and appliquéd quilt in "Whig's Defeat" pattern (Cat. no. 430A) by Susan Loyd of Rome, Georgia, 1856.

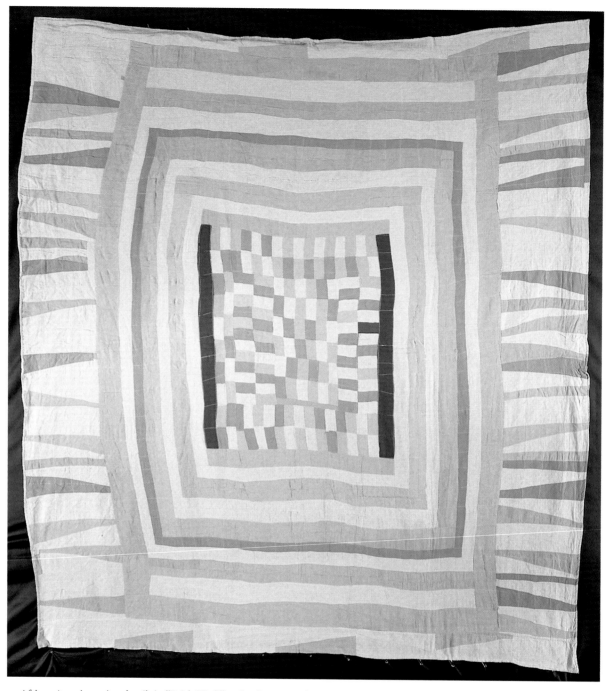

13. African American pieced quilt in "Brick Work" and strip pattern (Cat. no. 433A) by Annie Howard
of Madison, Georgia, 1957.

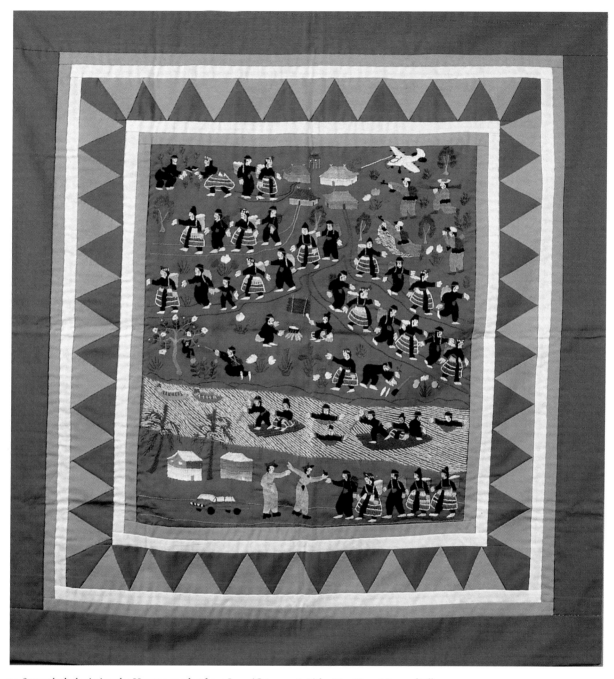

14. Story cloth depicting the Hmong exodus from Laos (Cat. no. 587A) by May Tong Moua of Lilburn, Georgia, a recently transplanted Asian tradition, 1991.

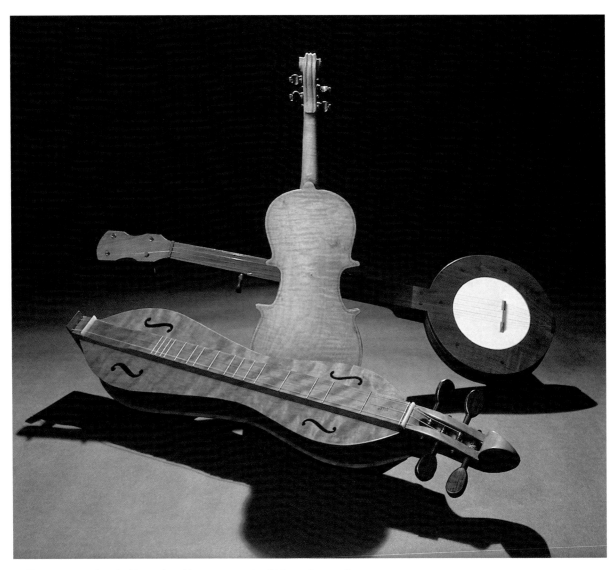

15. Contemporary Appalachian stringed instruments using high-quality woods.
Front to back: Cat. nos. 524, 514, and 520.

16. Animal woodcarvings from Appalachia exemplifying the decorative thrust of the handcraft revival.
Clockwise from left: Cat. nos. 543, 544, 545, 546, and 542.

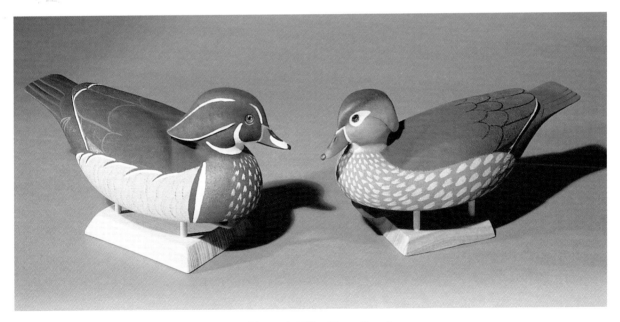

17. Drake and hen wood-duck decoys (Cat. nos. 572-73) by Ernie Mills of Perry, Georgia,
a recently transplanted Mid-Atlantic tradition, 1990 and 1993.

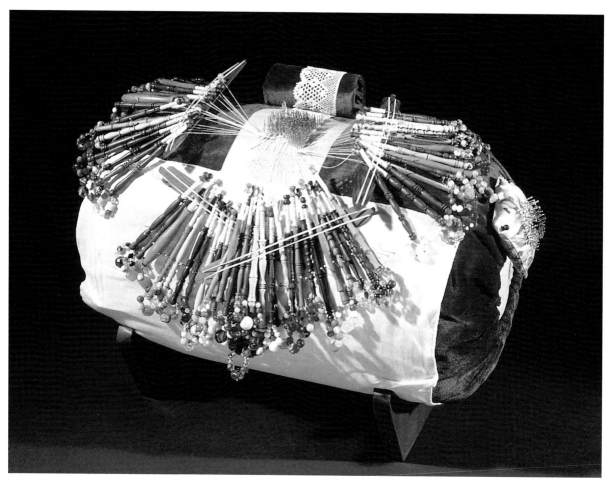

18. Bobbin lace in process with pillow and bobbins (Cat. nos. 581–84) by Betty and Mak Kemp
of Powder Springs, Georgia, a recently transplanted English tradition, 1994.

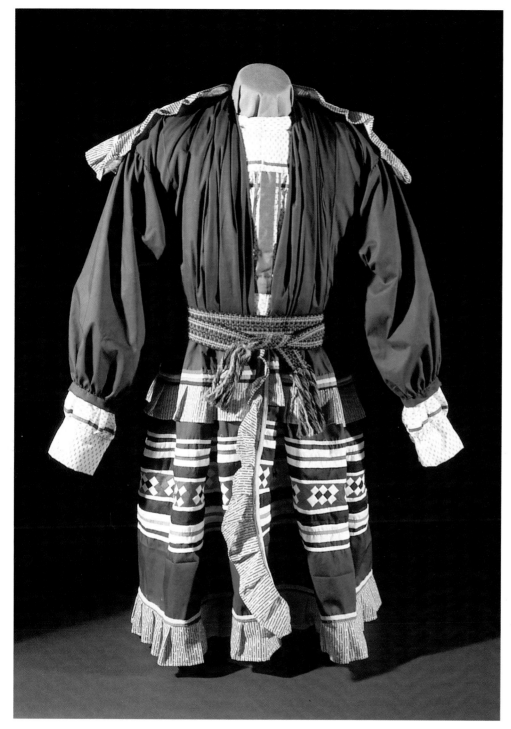

19. Seminole patchwork "long coat" (Cat. nos. 129–30) by Mary Frances Johns of Okeechobee, Florida, 1995. A European coat pattern of the frontier era is combined with southern quilting techniques in this distinctly Native American man's ceremonial dance costume.

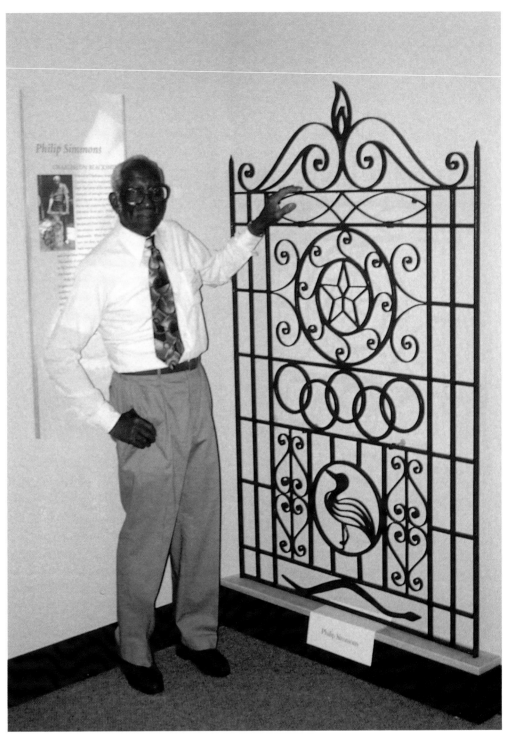

20. Charleston, South Carolina, blacksmith Philip Simmons with his workshop's Atlanta History Center Gate (Cat. no. 451) at the opening of *Shaping Traditions*, 1996. *Photo by John Burrison.*

Lanier Meaders, Artist in Clay

(CATALOG NOS. 262–67)

The career of Quillian Lanier Meaders (1917–98) illustrates a folk artist's creative growth. Returning to Mossy Creek after military service in World War II, Lanier worked at other jobs while helping his father, Cheever, at the old-fashioned shop on weekends. After Cheever's death in 1967, Lanier took over the Meaders Pottery.

Face jugs became Lanier's specialty. Cheever had made only a small number of them, but Lanier produced roughly ten thousand, no two exactly alike. His creativity revitalized this form and made him famous. In 1983 Lanier was awarded a National Heritage Fellowship by the National Endowment for the Arts. Poor health forced him to retire from active

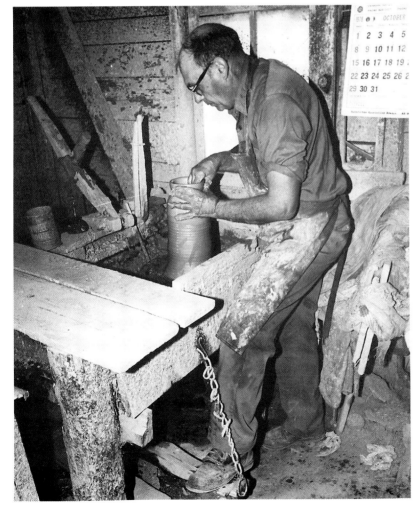

Lanier Meaders of Mossy Creek, Georgia, at his potter's wheel, 1978. *Photo by John Burrison.*

63

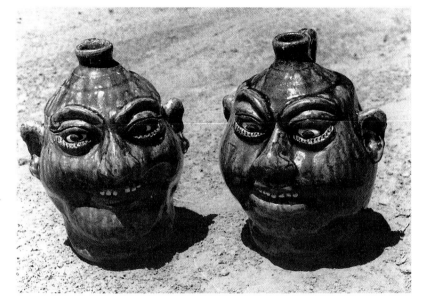

Right: Ash-glazed face jugs by Lanier Meaders, 1988. Made toward the end of his career, each is individualized. *Photo by John Burrison.*

Below: Burlon Craig of Vale, North Carolina, wood-firing his rectangular "ground-hog" kiln, 1977. *Photo by John Burrison.*

potting in the early 1990s, and he died a few months after his eightieth-birthday party, given by his potter friends the Hewells. But Lanier Meaders remains a role model for others who learned from him or who benefit from the interest in southern folk pottery he helped to create.

North Carolina

(CATALOG NOS. 268–77)

Pottery traditions typical of both the upper and lower South came together in North Carolina. Starting in the 1750s, Moravian potters at Bethabara and Salem (now Winston-Salem) made plain and fancy earthenwares in a central European tradition. The state's two largest centers also were in the Piedmont. One, near Seagrove in Randolph, Moore, and Chatham Counties, produced earthenware and salt-glazed stoneware. The Jugtown Pottery was established here by Jacques and Juliana Busbee in 1921, and the area is now home to eighty shops (only a few of them traditional). The second center, located farther west in the Catawba Valley on the Lincoln and Catawba county line, is known for its ash-glazed stoneware.

Chair maker's shop re-created in *Shaping Traditions*, including a pole lathe by Walter Shelnut of White Creek, Georgia (Cat. no. 309).

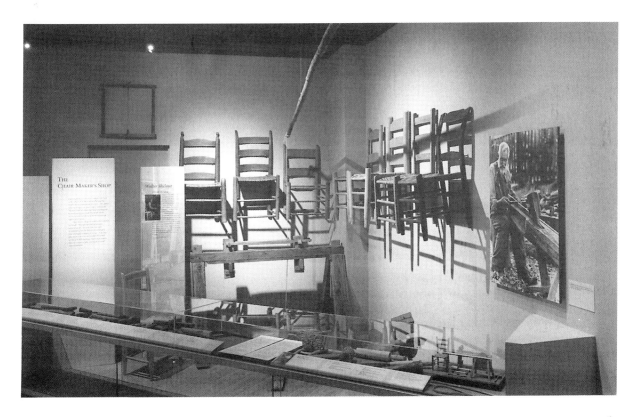

65

Alabama

(CATALOG NOS. 278–85)

Potters from places as diverse as the Carolinas, Georgia, Ohio, and France contributed to Alabama ceramics. Centers were located at Rock Mills and Bacon Level in Randolph County, at Sterrett in Shelby County (Alabama's Jugtown), on Sand Mountain in DeKalb County, and on Mobile Bay in Baldwin County.

WITH THE GRAIN: WOODWORK

[Plantation carpenters] constructed the wash-stands, clothes-presses, sofas, tables, etc. with which our house is furnished, and they are very neat pieces of workmanship—neither veneered or polished indeed, nor of very costly materials . . . but all the better adapted therefore to the house itself.—Frances Anne "Fanny" Kemble, *Journal of a Residence on a Georgian Plantation in 1838–1839*

The South's early settlers found themselves in a heavily forested wilderness. Although much of the timber eventually was cleared for planting, stands of trees were kept as a resource. Most young men learned basic woodworking skills from their elders. Some developed these skills to become professional carpenters.

The Chair Maker's Shop

(CATALOG NOS. 286–308)

Chairs with horizontal slats to support the back arose in seventeenth-century Europe and became the South's most common item of folk furniture. The earliest type has straight rear posts topped with finials. The later mule-ear chair, with backward-curving rear posts that aid in leaning against porch walls, may have been inspired by northern Hitchcock-type chairs.

Chair makers' shops equipped with a few basic carpentry tools once dotted the southern landscape. Some makers made do without a lathe, shaping their posts with a drawknife. The pole lathe was used in Appalachia into the twentieth century, unchanged from its origins in medieval Europe. A springy pole tied to a foot treadle supplied the power for this primitive machine.

Rocking chair made in the early 1920s by Jason Reid of Choestoe, Georgia, as a wedding gift for his son Ed. A fancy mule-ear with split banisters below the scalloped upper slat, its maple posts and arms were turned on Jason's great-wheel lathe. *Photo by John Burrison.*

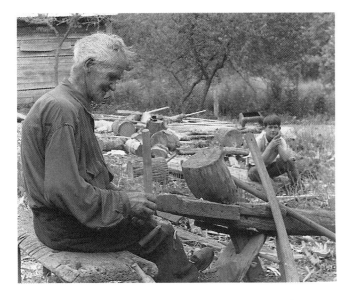

Chair maker Lon Reid (son of Jason) of Choestoe, Georgia, 1969. Lacking a lathe, he used a drawknife and shaving horse to shape all his chair parts. *Photo by John Burrison.*

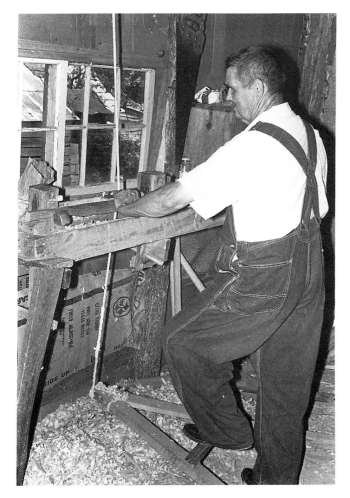

Walter Shelnut of White Creek, Georgia, turning a chair post on his pole lathe, 1975. Above his head (and out of view) was the horizontal pine pole that acted as a spring to ready the post for the next cut of the chisel; a downward push of the foot treadle created a full rotation for the cut. *Photo by Kirk Elifson.*

Walter Shelnut, Chair Maker

(CATALOG NOS. 309–16)

A farmer in the White Creek community of White County, Georgia, Walter Shelnut (1905–78) was one of the last traditional woodworkers in the nation to use a medieval-style pole lathe. His father and grandfather also were chair makers in White County.

Having inherited a variety of hand skills, Walter preferred to make things he needed—from farm buildings to most of his equipment—rather than buy them. When asked why he didn't use power tools, he replied, "Hit'd take a whole heap of money." He made about a dozen chairs a year in his converted chicken-house shop during late fall and winter, after his crops were "laid by" and when the timber wasn't so sappy.

Interior of the Walker sisters' log home showing handmade beds with quilts and a coverlet, Sevier County, Tennessee, 1936. *Photo by E. E. Exline; courtesy Great Smoky Mountains National Park.*

68

Furniture, Southern Style

(CATALOG NOS. 317–62)

Southern cabinetmakers developed furniture designs to suit the region. Paralleling the pier-and-sill building foundation, sugar chests, hunt boards, and some pie safes had tall legs to protect food from the vermin that thrive in the warm climate. Yellow pine was often used in case furniture because it was plentiful and inexpensive; the humble pine could be disguised with paint.

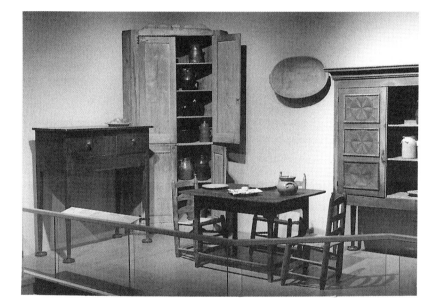

Dining furniture in *Shaping Traditions.*

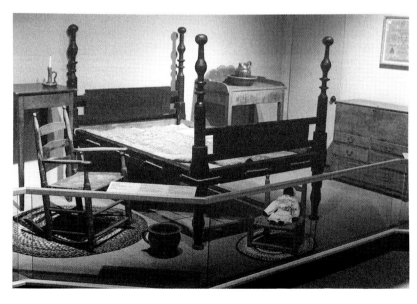

Bedroom furniture in *Shaping Traditions.*

Cities such as Charleston and Savannah produced furniture in a more academic style, modeled on that of the North and England. Backcountry furniture makers tended to work in a vernacular, or "plain," style. Their products nevertheless could contain echoes of formal furniture along with decorative features of local "schools." Georgia furniture, mostly of the nineteenth century, is shown here with other appropriate folk artifacts in dining room and bedroom settings that suggest their uses.

Wood Carving

(CATALOG NOS. 363–68)

Southern boys customarily received a pocketknife as a gift and were taught to use it by an older family member. Whittling was a leisure-time activity and a way to practice woodworking skills.

African American canes with human and reptile carvings may be echoes of West African ceremonial staffs. Covered wagons, a nostalgic symbol of the changes brought about by the automobile, became a traditional subject for mountain whittlers.

Right: African American walking stick (Cat. no. 363) from Millen, Georgia, featuring a full-figure carving of a woman, early 1900s.

Far right: Arthur "Pete" Dilbert, stick carver of Savannah, Georgia, 1994. *Photo by Susan Levitas; courtesy Georgia Council for the Arts Folklife Program.*

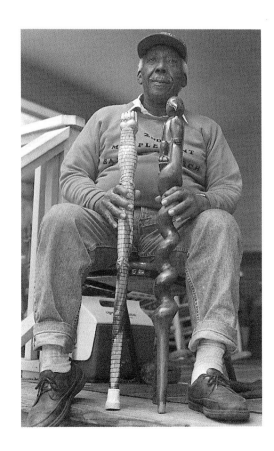

Woven of Wood: Baskets

Lightweight containers woven of plant materials were essential on southern farms for harvesting, carrying, and storing dry goods. Now, baskets are collected by city dwellers seeking to re-create the "country look" in their home decor.

Baskets reflect the South's ethnic diversity. Each early population group—Native American, European, and African—has made its contribution to a set of distinctive regional basketry traditions.

Rivercane

(CATALOG NOS. 369–71)

Rivercane appears to be the South's oldest basket material. There is archaeological evidence of its use in woven mats and baskets by Native Americans of the Mississippian period—before contact with Europeans—and speculation that this use goes back more than a thousand years. Rivercane baskets woven in elaborate colored patterns were traded to European settlers in the 1700s, and this decorative tradition probably inspired later color-woven baskets in Appalachia.

Rivercane basketry is still a living tradition among some southern Indian groups—notably the Cherokee of North Carolina, the Chitimacha of Louisiana, and the Choctaw of Mississippi—as stimulated by the handcraft revival and a tourist market.

Lucille Lossiah, Cherokee Basket Maker

(CATALOG NOS. 372–75)

Lucille Lossiah (born 1957) is a younger folk artist who shows every promise of mastering a difficult craft. She is concerned that the next generation of her people continues this ancient art, which has become an emblem of Cherokee identity.

Lucille learned the basics from her mother and grandmother in the Painttown community of Swain County, North Carolina. She has developed her skills by demonstrating in the summers with older basket makers at the Oconaluftee Indian Village, an outdoor museum at Cherokee, North Carolina. She makes the highly prized double-weave rivercane baskets, with continuously woven outer and inner walls, as well as white-oak-split baskets with maple curls, a technique the Cherokee borrowed from northern tribes.

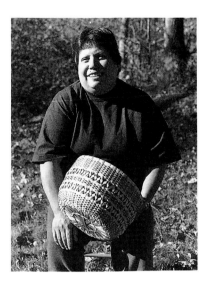

Basket maker Lucille Lossiah of Cherokee, North Carolina, the youngest folk artist featured in *Shaping Traditions*. Although she often works in the older medium of rivercane, she is shown here with a white-oak basket decorated with maple curls, 1995. *Photo by William F. Hull, Atlanta History Center.*

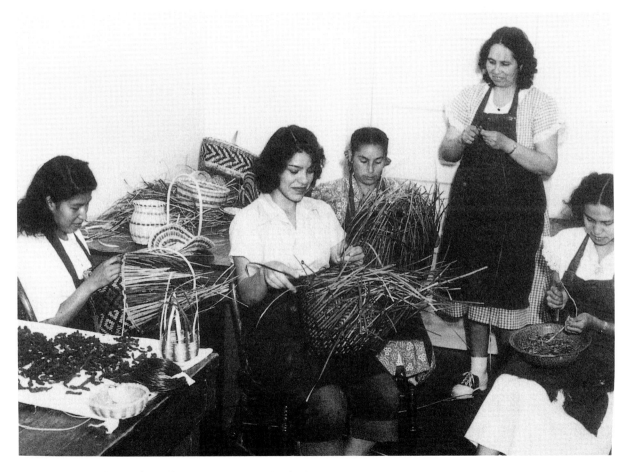

Lottie Stamper teaching basket making at the Cherokee School, Cherokee, North Carolina, ca. 1950. This institutional approach to keeping the tradition alive was part of the handcraft revival. *Photo by Vivienne Roberts; courtesy Museum of the Cherokee Indian.*

White Oak

(CATALOG NOS. 376–88)

Handled baskets of split hardwood are a tradition brought from Europe. The most European form is the rib or bow basket with its curved bottom, still made in Appalachia and middle Tennessee. Flat-bottomed forms probably represent a Native American influence. White oak is now the South's most common basket material, shared by Cherokee, white, and black makers.

THE REEVES FAMILY

(CATALOG NOS. 389–93)

The Reeves family, living near Greenville in Meriwether County, Georgia, can trace their basket making back to antebellum times. The family's earliest known maker was Allen Reeves Sr., who was born into slavery about 1850. At that time, slaves wove large baskets for field hands to collect cotton and corn. Allen's grandson, John Reeves Sr., started making baskets for sale with his wife, Lucile, in the early 1980s when he couldn't find other work. Since then, most of their children have taken up the craft, and now some of the grandchildren are learning. About a dozen members of the family make white-oak-split baskets in a variety of functional shapes, sometimes decorated with Rit, a commercial dye. Much of their business comes from craft shows.

Softer Materials

(CATALOG NOS. 394–99)

Typically, men have worked with harder materials, such as splits from quartered white-oak saplings, while women tend to weave more pliable materials. This gender distinction, however, is not hard and fast—some women also work in white oak, and, regardless of material, women are the basket makers among the Cherokee.

Baskets of willow (and smaller-gauge plant material such as honeysuckle vine) are a European-derived tradition. Enslaved Africans introduced coiled-grass basketry to the south Atlantic coast, where it became part of the rice-growing culture. Possibly inspired by African American coiled baskets, pine-needle baskets were developed in the 1860s by Mrs. M. J. McAfee of West Point, Georgia; they were adopted by Seminole Indians and women's clubs in the early 1900s.

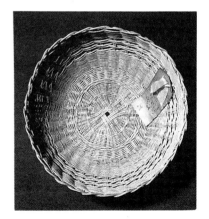

Interior of honeysuckle-vine roll basket (Cat. no. 394) by Flora Dysart of Rydal, Georgia, 1956. Such work is a refined extension of the European tradition of willow baskets.

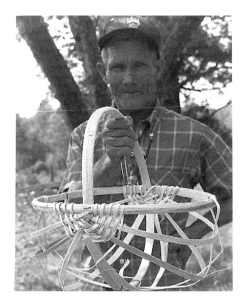

Milburn Richardson of Acworth, Georgia, 1970. He holds the skeleton of a white-oak bow basket, which he started as two hoops joined at a right angle. He had just begun to flesh out the added ribs with woven splits. *Photo by John Burrison.*

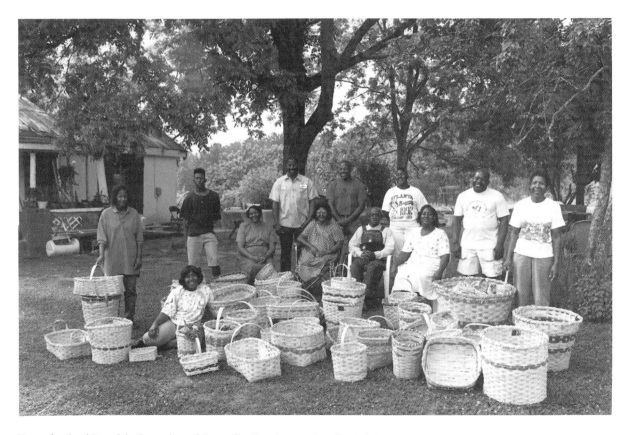

Reeves family white-oak basket makers of Greenville, Georgia, 1993. *L–r:* Bessie, Mary, Tommy, Sarah, Randy, Lucile, Charles, John Sr., Rebecca, Catherine, Tom, and Louise. *Photo by William F. Hull, Atlanta History Center.*

WARP AND WEFT: TEXTILES

Hurrah! Hurrah!
For the Sunny South so dear!
Three cheers for the homespun dress
The southern ladies wear.

Now northern goods are out of date,
And since Old Abe's blockade,
We southern girls can be content
With goods that's southern made.

> —"The Homespun Dress,"
> a Confederate folk song

In the South, textiles were the woman's domain; unlike the North, there were few professional male weavers. Weaving, quilting and other needle-work, crocheting, knitting, tatting, and rug making served household needs as well as an artistic outlet; rarely was such work sold. In *Handi-crafts of the Southern Highlands,* Allen Eaton quotes Kentucky mountain weaver "Aunt Sal" Creech as saying, "Weaving, hit's the prettiest work I ever done. It's asettin' and trampin' the treadles and watchin' the pretty blossoms come out and smile at ye in the kiverlet [coverlet]."

Field to Fabric: Spinning and Weaving

(CATALOG NOS. 400–409)

Through the mid-1800s, many southern farms and plantations were self-contained "factories" for the hand production of cloth. Tench Coxe's *Statement of the Arts and Manufactures of the United States of America, for the year 1810* reported 20,058 spinning wheels and 13,290 looms in Georgia. Flax and cotton plants, along with sheep, supplied fibers for the spinning wheel. Dyestuffs were also taken from nature, mostly from plants.

Weavers worked at a barn-frame loom. Preparing the yarn and setting up the warp (the parallel foundation threads) took more time than the weaving itself, which involved throwing one or more shuttles filled with weft thread from side to side to interlace with the warp, creating the "web." Foot treadles controlled the pattern, raising and lowering the two to four heddles through which the warp was threaded. The resulting fab-ric was used for clothing or bedcovers.

THE COLLINS FAMILY, MOUNTAIN WEAVERS

(CATALOG NOS. 410–27)

With the availability of affordable factory-made cloth, home production became rare by 1900. The Collins family of Choestoe, south of Blairsville in Union County, Georgia, made traditional textiles to a surprisingly late date. Although Francis "Bud" Collins and his wife, Georgianne, were in some ways progressive farmers, their daughters maintained these hand skills until 1950.

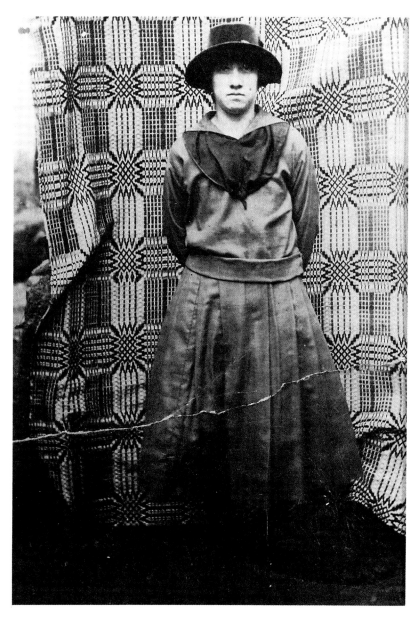

Above: Francis "Bud" Collins of Choestoe, Georgia, ca. 1938. He wears the homespun suit (Cat. nos. 425–27) woven and tailored by daughters Ethel and Avery. *Courtesy Ethelene Dyer Jones.*

Right: Weaver Ethel Collins of Choestoe, Georgia, posed at age sixteen with her first coverlet, in the "Habersham Burr" pattern (Cat. no. 410), 1920. *Courtesy Mr. and Mrs. Blueford Dyer.*

Georgianne had learned to weave from her mother by the age of twelve. When she married Bud at fifteen, she brought with her four bedspreads she had made. Their six daughters all learned to spin and weave. The older girls gave up the craft after leaving home, but Avery and Ethel, the youngest, remained spinsters both literally and figuratively (Ethel married late in life). They never sold their creations but regularly won prizes for them at the Southeastern Fair in Atlanta.

Stitches in Time: Quilting

(CATALOG NOS. 428–34)

Born of the need to keep warm in bed while beautifying the home with color, quilts are, as quilters like to explain, a "cloth sandwich." Between the lining and patterned top is an insulating layer of batting. In the South, this filling normally was carded cotton. The three layers are stitched together so the batting doesn't shift and bunch up.

The first southern quilts had whole-cloth tops decorated only by elaborate stitching. Later, colored designs were cut and sewn, or appliquéd, onto a solid top. Both types had European origins. An American contribution is repeated-block construction, with a series of squares joined to form the top. The blocks could be pieced together from smaller bits of material of different shapes and colors. Piecing also was used for the Victorian crazy quilt and African American strip quilt, which both have irregular pieces for a spontaneous effect very different from the symmetry of repeated-block quilts.

Harriet Powers, Story Quilter

(CATALOG NO. 435)

A former slave who lived near Athens in Clarke County, Georgia, Harriet Powers (1837–1911) is famous for two surviving quilts. Both are appliquéd with scenes from the Bible and local history. An Athens artist, Jennie Smith, bought the first quilt after seeing it at a fair in 1886 and later lent it for the 1895 Cotton States and International Exposition in Atlanta. Atlanta University faculty wives saw it there and in 1898 commissioned the second, more elaborate quilt as a gift for a former trustee.

Vivid church sermons inspired Powers's fascination with the Bible. She regarded meteorological events as religious portents. Scholars compare her appliquéd figures to tapestries of similar style by the Fon people of Benin and the Ewe, Fanti, and Ashanti of Ghana. Was she carrying on a West African design tradition or creating personal statements within the

Right: Mrs. Martin showing some of her quilts to neighborhood children in Jackson, Mississippi, 1976. *Photo © 1998 Roland L. Freeman.*

Below: Pearl Martin quilting with the Betty's Creek Women's Club, Rabun County, Georgia, 1969. *Photo by John Burrison.*

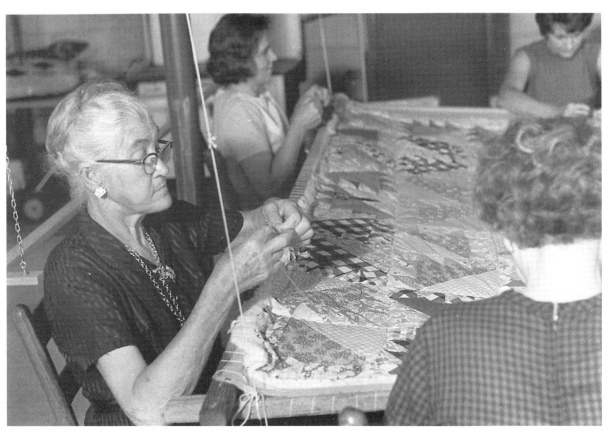

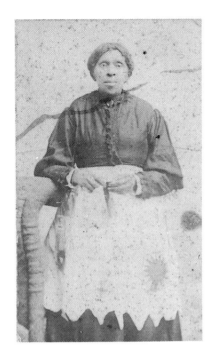

Left: Quilter Harriet Powers of Athens, Georgia, late 1800s. *Courtesy Museum of Fine Arts, Boston.*

Below: Harriet Powers's second story quilt (Cat. no. 435), 1898. *Courtesy Museum of Fine Arts, Boston.*

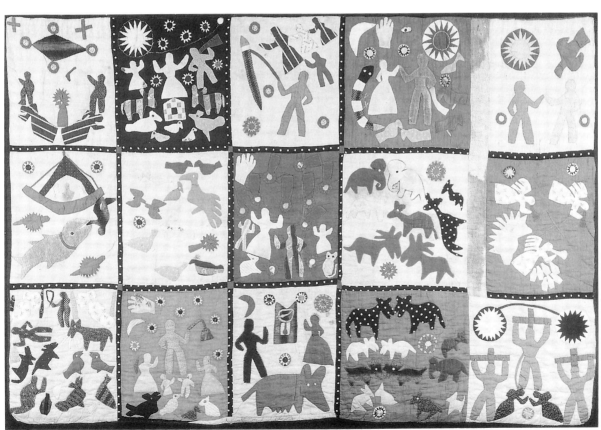

regional quilt tradition? Without being able to trace the thread of her needlework skills, we may never know.

ANVIL SPARKS: METALWORK

(CATALOG NOS. 436–50)

Even when a man could not make what he needed at home, somebody in the settlement made it for him. The blacksmith, Alf Ridings, could make just about any tool needed on the farm.
—Jess Hudgins of Ball Ground, Cherokee County, Georgia, ca. 1960, quoted in Floyd C. and Charles Hubert Watkins, *Yesterday in the Hills*

Ironworking once was a common skill. Many farms and plantations had blacksmith shops where equipment could be repaired and basic necessities forged. Each community also had its professional smith, who earned his living making tools and shoeing horses.

The industrial technology of casting molten iron in molds was developed in England in the 1700s. Southern iron foundries served the Confederate cause during the Civil War, but small-scale ironworking continued to be done by hand. With the introduction of the "horseless

Hand-forged iron tools from north Georgia. All but the drawknives are attributed to Fannin County blacksmith John Pickelsimer. *Top to bottom:* Cat. nos. 294, 293, 445, 446, 438, and 287.

Implements of copper, tin, pewter, and silver, ranging from the eighteenth to twentieth centuries. *Clockwise from left:* Cat. nos. 453, 548, 452, 454, and 455–60.

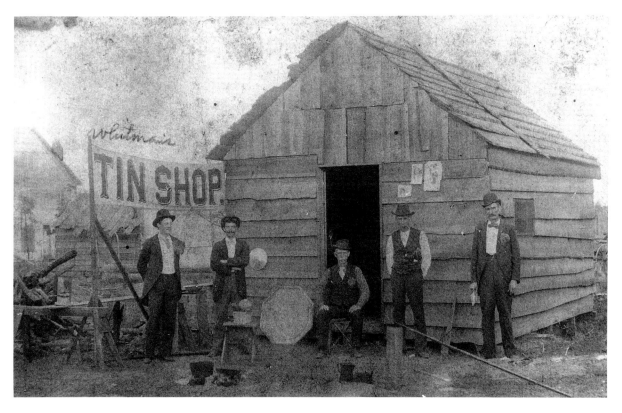

Whitman's Tin Shop, Fitzgerald, Georgia, ca. 1895. *Courtesy Georgia Department of Archives and History.*

Mountain gunsmith James Gillespie of Blairsville, Georgia, ca. 1875. *Courtesy Edward S. Mauney.*

George Gillespie (James's shoemaker son) of Blairsville, Georgia, with a Henderson County, North Carolina, rifle by his uncle, Harvey Gillespie, 1936. *Photo by Edward S. Mauney.*

carriage," many blacksmiths became automobile mechanics or turned to ornamental ironwork.

Philip Simmons, Charleston Blacksmith

(CATALOG NO. 451)

Visitors to Charleston, South Carolina, may be surprised to learn that some of the outstanding examples of wrought iron that grace the old city are not antiques but the recent creations of African American blacksmith Philip Simmons (born 1912). As a boy, Philip apprenticed locally with Peter Simmons (no relation), son of an enslaved smith. When Philip took over the shop, he shoed horses, built wagons and vegetable carts, and forged boat fittings and dock equipment. This variety of work gave him the versatility to fill orders for ornamental wrought iron that began in 1939.

Philip has produced hundreds of gates, fences, and window grills, many for architectural restorations sparked by the Historic Charleston Foundation. Though faithful to the spirit of old local ironwork, he adopted such modern tools as the acetylene torch and arc welder. A 1982 National Heritage Fellow, Philip no longer "bangs iron" but continues to design orders and supervise his fabricators.

Copper, Tin, and Silver

(CATALOG NOS. 452–60)

Metal crafts other than ironworking were practiced in Georgia. Copper stills were needed for moonshine and turpentine. Common household wares were made of tin and pewter, while silversmiths catered to wealthier customers. There were even a few goldsmiths, located in the mountains around Dahlonega during America's first gold rush, which began in 1829.

THE GILLESPIE FAMILY, MOUNTAIN GUNSMITHS

(CATALOG NOS. 461–95)

The Gillespies practiced the Appalachian craft of rifle making into the late nineteenth century. Matthew Gillespie and his two brothers learned the trade from their father, John, who came to Transylvania County, North Carolina, about 1795. After visiting the ironworks of Phillip Sitton in adjoining Henderson County, Matthew settled there, marrying Sitton's daughter. Their five sons all became gunsmiths.

By 1840 the eldest son, John, had moved to Union County, Georgia, and his brother James soon joined him. The 1850 census lists them together as gunsmiths. After marrying, each operated his own shop, with James staying in the Blairsville area and John moving to Young Harris in adjacent Towns County. They were among Georgia's last traditional rifle makers, but in recent years hobbyists have revived the art.

Feeding the Soul: Beyond Subsistence

Folk crafts, although incorporating artistry, historically were about supplying southerners with the necessities of life. Oral, musical, and customary folklore, in contrast, served to enrich leisure time and spiritual life. These intangible traditions now can be "captured" and preserved through electronic recording.

LEISURE-TIME STORIES, SONGS, AND MUSIC
(CATALOG NOS. 496–97)

Reach over in the corner, Mama,

And hand me my travelin' shoes;

You know by now that I've got them Statesboro blues.

Mama, sister got 'em, brother got 'em, friend got 'em.

Woke up in the mornin', we had the Statesboro blues;

Looked over in the corner: Grandma and Grandpa had 'em too.

—"Statesboro Blues," as recorded by Georgian
Blind Willie McTell, 1928

The front porch and shade tree in summer, the hearth in winter, fiddlers' conventions, "juke joints," and the "liars' bench" of general stores were important recreational settings (in the days before television) for southerners to make music, sing songs, and tell stories often shaped by frontier and plantation experiences.

Southern folk music was recorded commercially in the 1920s, leading to the later styles of country and rhythm and blues. It is not unusual today for folk performers to communicate to large audiences from the stage and through electronic media. The forms endure, however, because they continue to entertain and express the values of the communities that created them.

Brer Rabbit's Journey

(CATALOG NOS. 498–503)

The trickster, a universal folktale character, delights audiences with his rule breaking. The South's best-known trickster is Brer Rabbit, popularized in Joel Chandler Harris's Uncle Remus books. Harris had heard slaves tell these animal stories on the Turnwold Plantation near Eatonton in Putnam County, Georgia. As a literary artist he created a nostalgic plantation setting to frame the tales and brought African American folklore to public attention.

Many African Americans took exception to the stereotyped portrayal of Uncle Remus in Walt Disney's 1946 film *Song of the South.* Novelist Alice Walker's Eatonton family had once enjoyed the Brother Rabbit stories that were part of their folk heritage. But after seeing the film, she writes, "We no longer listened to [the tales]. They were killed for us." Julius Lester's recent rewriting of the Uncle Remus tales for modern readers returns Brer Rabbit to a place of honor for African Americans.

Brer Rabbit's journey from African American folktales to popular literature and film.

Right: "Dough face" (Cat. no. 496), or homemade mask for the southern Christmas custom of "sernatin'," re-created by Maebelle White of Alto, Georgia, 1975.

Below: A corn shucking on the London farm, Dahlonega, Georgia, ca. 1890. *Courtesy Georgia Department of Archives and History.*

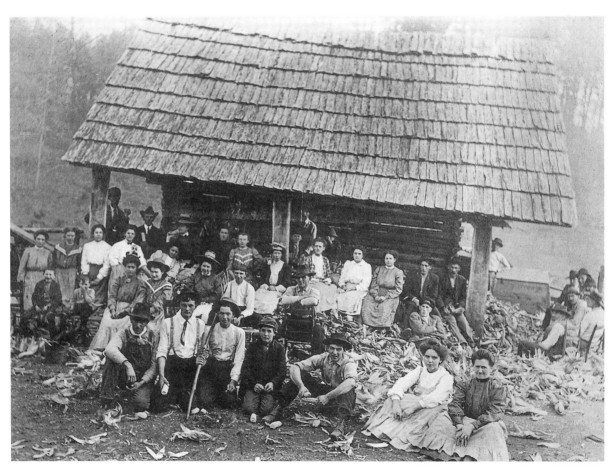

A Passel of Shuckers: Community Workings

(CATALOG NOS. 504–8)

Americans used to help each other in community gatherings, or "bees," that turned hard work into fun. These get-togethers were especially popular in the South, where families were isolated from each other by frontier settlement patterns. Corn shuckings and log rollings (removing trees to clear new land) were favorite social occasions that often ended with a square dance.

Corn shuckings took place after the autumn harvest. The ears were stripped of their shucks so the corn could be shelled for milling. The shucks were used primarily as winter fodder for livestock, stored in the loft of the corncrib. African American shuckings became a competitive art form. On each half of the divided corn pile stood a "general" who urged his team on with improvised, call-and-response songs such as:

Leader: Fall out here and shuck this corn,

Chorus: Oh-oh, ho!

Leader: Biggest pile since I was born,

Chorus: Oh-oh, ho!

A family birthday gathering for James Allen Stanfield, Tatnall County, Georgia, 1921. *Courtesy Georgia Department of Archives and History.*

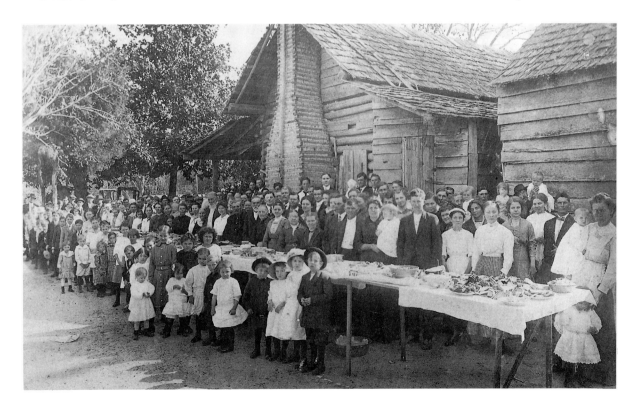

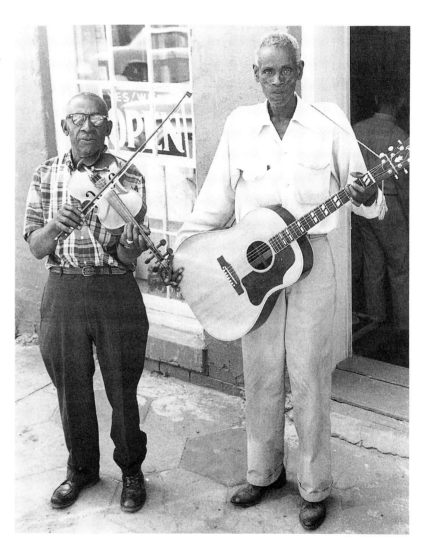

"Beating straws" on the fiddle strings to accentuate a melody's rhythm for dancing, Appalachia, ca. 1915. *Photo by John C. Campbell; courtesy Southern Historical Collection, University of North Carolina Library, Chapel Hill.*

Fiddler Elbert Freeman and guitarist Nathaniel Ford of Monticello, Georgia, 1967. Their composition, "Worried Blues," can be heard in the exhibition's "Leisure-Time Stories, Songs, and Music" listening booth. *Photo by John Burrison.*

Heart Strings: Musical Instruments

(CATALOG NOS. 509–24)

Music to accompany dancing and singing or just for listening has always been a favorite southern folk expression. In the past, instruments often were built from whatever was available. Today's makers, concentrated in Appalachia, are more conscious of their instruments' sound and appearance.

The South's dominant folk instrument is the fiddle, brought with associated tunes from the British Isles. Thomas Jefferson, himself a fiddler, wrote of his plantation slaves in *Notes on Virginia* (1781), "The instrument proper to them is the Banjer, which they brought hither from Africa." The banjo later was adopted by upland whites. The Appalachian dulcimer evolved from the *Scheitholt*, a type of German zither, brought to Pennsylvania and later taken into the mountains.

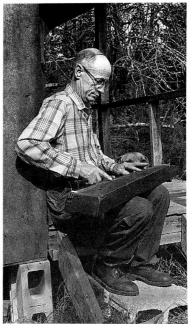

Above: Ernest Hodges of Murrayville, Georgia, playing an old Appalachian dulcimer found in north Georgia, 1968. Its tapered, straight-sided form closely resembles the Pennsylvania German *Scheitholt*, forerunner of the dulcimer. *Photo by John Burrison.*

Left: Banjoist Mrs. J. W. Matthews with her brother and his wife, Mr. and Mrs. Brooks, who hold a homemade cornshuck mop and sedge broom, Bartow County, Georgia, 1966. *Photo by John Burrison.*

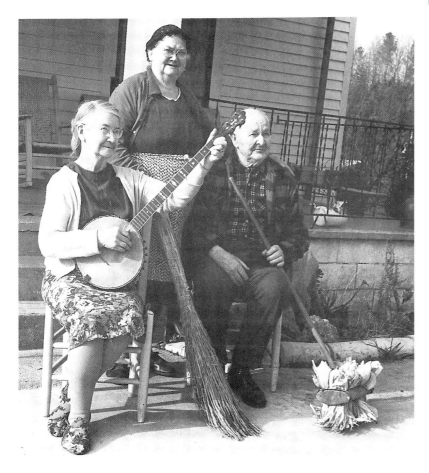

FEEL THE SPIRIT: RELIGIOUS EXPRESSION

(CATALOG NO. 525)

Well, what a time, what a time we're living in,
What a time, what a time we're living in;
There is hate on every hand, not many love their fellow man,
What a time, what a time we're living in.

Oh, there'll be peace, there'll be peace after awhile,
There'll be peace, there'll be peace after awhile;
Lion'll lay down by the lamb, we shall be led by a child,
There'll be peace, there'll be peace after awhile.

—"What a Time We're Living In," as sung by the
Reverend Robert Akers, Galax, Virginia, 1978

Life's railway: customary objects that once marked the spiritual journey of southern Protestants from birth to death.

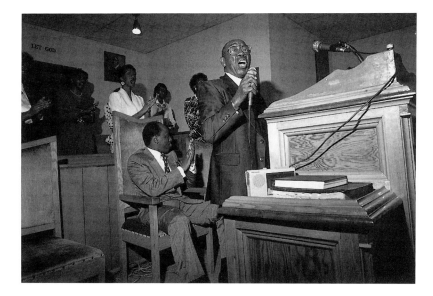

The Reverend C. J. Johnson of Atlanta leading his congregation in song, 1989. Their performance of "You'd Better Run to the City of Refuge" is included in the exhibition's "Feel the Spirit" listening booth. *Photo by Philip Mosier; courtesy Georgia Council for the Arts Folklife Program.*

Until recently, religion in the lower Southeast was relatively homogeneous, being predominantly Protestant with a fundamentalist and evangelical inclination. Even today, worship services in some churches maintain in their singing and preaching the emotional fervor of the eighteenth century's Great Awakening and the later Camp Meeting Revival. Most early religious refugees to the region were from Protestant sects such as the French Huguenots and central European Salzburgers and Moravians.

Charleston, Savannah, and Atlanta have had long-standing Jewish communities, but outside such cities Jews and Catholics were very much in the minority. Although newcomers from other regions and countries are now bringing greater religious diversity, the South (along with the rural Midwest) remains America's Bible Belt.

Singing His Praise: Shape-Note Hymnals

(CATALOG NOS. 526–31)

American spirituals arose in the early 1800s in the religious fervor of camp meetings. They were spread with earlier hymns by traveling singing-school teachers, who gave musical notes different shapes to aid learning. Hymnals were printed with the harmonies arranged in notations with four or seven shapes.

The Sacred Harp, compiled in 1844 by west Georgians Benjamin F.

Right: Religious sign on a north Georgia bridge abutment, 1969. *Photo by John Burrison.*

Below: "Decorated" African American grave, Georgia Sea Islands, 1933. The custom of placing on the grave durable objects owned by the deceased probably harks back to Africa. *Courtesy Library of Congress, Washington, D.C.*

White and Elisha J. King, is still used for all-day singings. Hugh McGraw of Bremen, Georgia, a 1982 National Heritage Fellow, has taught this tradition all over the country. His African American counterpart, 1983 National Heritage Fellow Dewey Williams of Ozark, Alabama, revived the use of Judge Jackson's *Colored Sacred Harp* (1934).

Heaven Bound: Atlanta Folk Drama

(CATALOG NOS. 532–34)

Heaven Bound, one of America's few true folk plays, was born in crisis. In 1923, a fire destroyed Atlanta's Big Bethel African Methodist Episcopal Church on Auburn Avenue. *Heaven Bound* was created by choir members Lula Byrd Jones and Nellie Lindley Davis as a fund-raiser to rebuild the church. First performed in 1930, the play became an annual institution and continues today.

In place of a script, a narrative scroll reading provides continuity between songs of the choirs and the cast members. In the play, pilgrims on their way to heaven are tempted by Satan. Some resist and are greeted at the Pearly Gates by Saint Peter and the angels (the choir), while others weaken and are cast into hell.

Life's Railway: Arrival and Departure Signs

(CATALOG NOS. 535–41)

Southern Protestants have marked the joining and passing of church members with symbolic ceremonies and objects. River baptizing and grave decorating are two such religious customs.

Revitalization and Change: Folk Arts in the Modern South

This final section of *Shaping Traditions* addresses the question "How have folk arts been affected by the South's modernization?" Surprisingly, some of the old agrarian-based arts have survived sweeping changes and even have been revitalized, although under very different circumstances. At the same time, new arrivals to the region are transplanting traditions from elsewhere that are taking root and contributing to the future of southern folk arts.

THE RESHAPING OF OLDER NATIVE CRAFTS

The spread of textile mills in the 1880s marked the beginning of a more diversified economy for the South. Steady wages meant more cash to buy factory-made goods and less need for handcrafting. But strategies for maintaining the old rural arts were developed, and, as in the past, folk traditions served as "cultural shock absorbers" to help southerners accommodate change.

The Handcraft Revival: Is It Still "Folk"?

(CATALOG NOS. 542–51)

Social reformers and entrepreneurs who recognized the economic potential of southern crafts began a revival in the 1890s that created teaching programs and outside markets for crafts that otherwise might have died out. In the process, the decorative value of the crafts came to be emphasized.

The revival was focused in Appalachia. The Southern Highland Handicraft Guild, established in 1930, held its first Craftsman's Fair in 1945 and was a major force in the movement. Participants often learned their skills in a classroom setting. While their work may not be considered "folk," the revival generated its own traditions and helped create a climate that supports the present generation of southern folk artists.

Sweetgrass Baskets and Tourism

(CATALOG NOS. 552–60)

The handcraft revival was concentrated in Appalachia, but its influence spread all the way to the coast. In 1904, Penn School on St. Helena Island, South Carolina, opened its Native Island Basketry Department to teach the African American tradition of coiled-grass basket making. In 1916, Charleston merchant Clarence Legerton launched his Sea Grass Basket Company to market the work of nearby Mt. Pleasant basket "sewers." In the 1930s, the makers began to sell their baskets themselves from stands along Highway 17. Tourism sparked creativity, and new designs and techniques (such as adding pine needles for color) were developed.

Coastal development threatened the availability of sweetgrass, an ocean dune plant and the chief material of coiled baskets. A 1988 conference led to planting experiments that should ensure the vitality of this three-hundred-year-old folk art.

Alfred Graham teaching a coiled-grass basketry class at Penn School as part of the handcraft revival, St. Helena Island, South Carolina, 1905. *Courtesy Southern Historical Collection, University of North Carolina Library, Chapel Hill, with permission of Penn Community Services, Inc.*

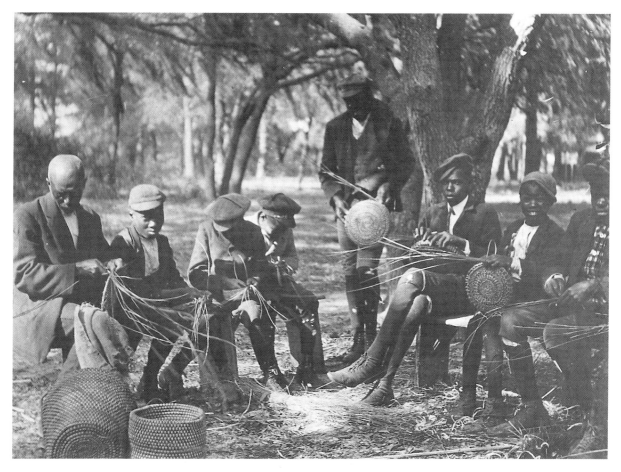

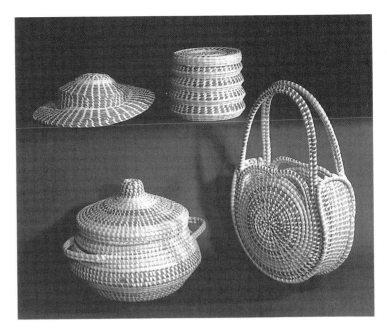

Right: Contemporary expressions of the three-hundred-year-old African American coiled-grass basketry tradition, Mt. Pleasant and Charleston, South Carolina, illustrating creative responses to a tourist market. *Clockwise from lower left:* Cat. nos. 555, 559, 556, and 558.

Below: Elizabeth Mazyck at her basket stand on U.S. Highway 17, Mt. Pleasant, South Carolina, 1994. *Photo by Dale Rosengarten.*

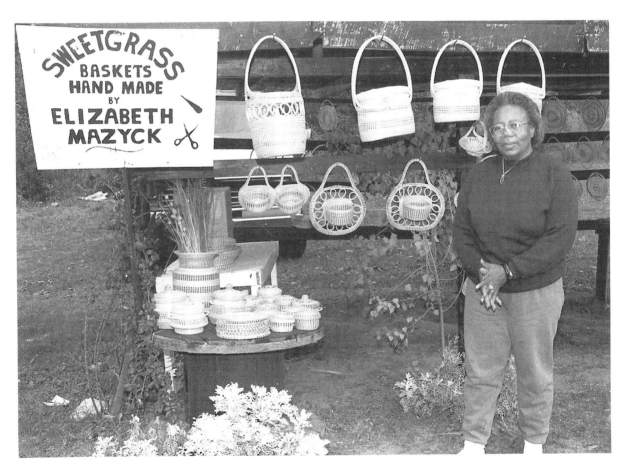

SWEETGRASS BASKETS HAND MADE BY ELIZABETH MAZYCK

Folk Pottery Gets Respect

(CATALOG NOS. 561–65)

An urban collectors' market has developed for wares once meant to be used on the farm. This recent appreciation of southern folk pottery is fueled by books, exhibits, and even a Southern Folk Pottery Collectors Society. Pottery once priced at a few cents a gallon is now valued at hundreds or even thousands of dollars.

Outside interest in their work encourages potters with a traditional background to carry on a craft that otherwise might have died out as local demand dried up. This new respect has made some potters self-conscious about their place in history, leading them to revive earlier designs and methods.

Quilting: A Folk Art Popularized

(CATALOG NOS. 566–68)

A common notion about historical quilters is that they typically used only leftover scraps to patch together their creations. In fact, both in the past and present, many have purchased material for the purpose, approaching quilting as an art form. Quilting also was and still is an opportunity for friends to get together, and when given as a gift the finished product serves to bind relationships further. These aesthetic and social reasons help explain quilting's continuing popularity today.

Some of today's quilters have not learned the art in a traditional, face-to-face way but instead teach themselves with the aid of publications or attend classes that encourage original designs. Many quilters still learn from others, sharing patterns and techniques in an ongoing folk tradition. This is often done, however, at regularly scheduled meetings in a more institutional setting such as a club.

THE NEW SOUTHERNERS: RECENT TRADITIONS

(CATALOG NOS. 569–71)

Early settlement groups laid the foundation for southern society before the close of the frontier, but the folk-cultural "stew" is still cooking and changing flavor as new ingredients are added. In recent years, the Sun Belt's climate and economic growth have spurred relocation from other

Right: Potter Ben Owen III of Seagrove, North Carolina, 1995. His Asian-inspired wares represent a mixture of local tradition and outside influences typical of the handcraft revival. *Photo by Jill Beute, Atlanta History Center.*

Below: Recent north Georgia stonewares illustrating the contemporary southern folk potter's historical awareness and orientation to a collectors' market. *L–r:* Cat. nos. 564, 563, and 562.

regions and countries. Since the 1960s, immigrant groups—especially Asians, Latin Americans, and West Indians in Atlanta—have made southern cities more cosmopolitan, most visibly through their public festivals and restaurants.

A small sampling of Atlanta immigrant traditions is presented here. There are many other such groups living in the metropolitan area; they will be featured on a rotating basis.

Ernie Mills, Mid-Atlantic Decoy Carver

(CATALOG NOS. 572–80)

Ernie Mills (born 1934) is one of the few traditional decoy carvers ever to work in Georgia. His North Carolina grandfather made decoys for his own use. So did Ernie's father, who relocated to the Mid-Atlantic, where Ernie carved his first decoy at the age of nine.

In 1978 Ernie moved from Delaware to Perry in Houston County, Georgia. After retiring from an airline job in 1981, he turned his decoy

Olympic quilters at the State Capitol, Atlanta, Georgia, 1995. They created quilted wall hangings as gifts for the teams participating in the 1996 Centennial Olympic Games in Georgia. *Photo by William C. L. Weinraub; courtesy Georgia Quilt Project.*

pastime into a career and today receives more orders than he can fill. Ernie has adapted to Georgia by using local woods and emphasizing birds most often hunted in the state. The Georgia Folklife Program is supporting an apprenticeship that will help him pass on his carving tradition.

Betty Kemp, English Lace Maker

(CATALOG NOS. 581–84)

A native of Bristol, England, Betty Kemp (born 1923) studied the intricate art of bobbin lace making with Penny Kemp-Jones, who in the 1960s led an English lace-making revival. Kemp-Jones, in turn, had learned from her grandmother in Buckinghamshire, once an important lace-making county to which Flemish and French refugees had brought the cottage industry in the 1500s.

In 1967 Betty and her husband, Mak, came to Georgia, where the nearest equivalents to lace making were crocheting and tatting. She began demonstrating at Powers Crossroads Country Fair and soon was teaching and organizing the Atlanta Chapter of International Old Lacers, Inc. Mak, a woodworker (who died in 1998), supported her art by making bobbins. Betty, who does not sell her work, loves lace making for the challenge in each new piece and because of the friends she has made through her teaching and associations.

Flowers and Guns: Hmong Needlework

(CATALOG NOS. 585–88)

Among the Hmong, a mountain people of Southeast Asia, young women traditionally have learned to produce elaborate textile pieces. Hmong fled to refugee camps in Thailand with the 1970s Communist takeover of Laos, and many have since been resettled. Georgia's Hmong population, numbering one thousand in 1992, is concentrated in DeKalb and Gwinnett Counties, east of Atlanta.

Some Hmong women in Georgia continue their textile art. They still sew personal clothing and gifts, but now their needles have become an important source of income, creating two types of wall hangings to sell. *Pa Ndau,* or flower cloths, display geometric designs in reverse appliqué. Story cloths depict a village scene or folktale in embroidery. The popularity of these textiles is encouraging Hmong women to experi-

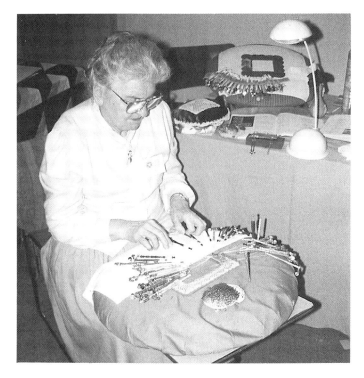

Betty Kemp of Powder Springs, Georgia, demonstrating her English lace-making tradition at the Atlanta History Center, 1994. *Photo by John Burrison.*

Hmong textile artist May Yang Moua of Decatur, Georgia, with her flower cloths, 1988. *Photo by Elizabeth Turk; courtesy Georgia Council for the Arts Folklife Program.*

ment. Some now make such items as Christmas-tree ornaments to suit American tastes.

Cuban and Mexican American Religious Expressions

(CATALOG NOS. 589–90)

Atlanta's Spanish-speaking Catholics, numbering more than 112,000 in 1995, honor the patron saints of their homelands in public and private ceremonies. Cuban Americans gather for a special mass and procession to pay homage to the Virgin of Charity, the patron saint of Cuba.

Home altars are private settings for religious expression. Typically assembled with saints' images, candles, flowers, and personal mementos, they become intimate statements of spiritual devotion as well as folk art. Mexican home altars often honor the Virgin of Guadalupe, the patron saint of Mexico.

Celebration and Outreach

Some ethnic celebrations take place quietly at home, perhaps with holiday food and decoration. Other events are more public. In Atlanta, these include Greek Independence Day at the Hellenic Center, the Caribbean Carnival parade on Peachtree Street, and the Saint Patrick's Day Parade.

Immigrants continue their homeland celebrations for several reasons.

Cuban American procession for the Virgin of Charity, Cathedral of Christ the King, Atlanta, Georgia, 1995. *Photo by William F. Hull, Atlanta History Center.*

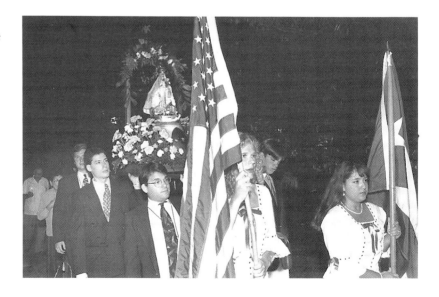

Lourdes Chavez working on her Mexican American home altar (Cat. no. 590), Atlanta, Georgia, 1995. *Photo by Elizabeth Turk, Atlanta History Center.*

Such events bring them together with those they may rarely see, reinforcing a sense of community. Festivals are also a way to share their heritage with outsiders in the hope of becoming better accepted by the larger society.

Greek Dance in Atlanta

(CATALOG NOS. 591–92)

Dating from the early 1900s, Atlanta's Greek community had grown to about 8,700 by 1992. Today, members of Atlanta's Troupe Hellas perform dances from their ancestral homeland, acting out stories of Greek warriors, fishermen, and mountain villagers. Few of the young participants have firsthand experience of Greek folklife, but by learning and performing dances from all parts of Greece, they express their identities as Greek Americans.

Atlanta's Caribbean Carnival

(CATALOG NO. 593)

Carnival, which features roving bands of costumed dancers, is a major Caribbean celebration just before Lent. In 1989, Atlanta's Caribbean populations, now numbering about thirty thousand, began hosting the Atlanta Peach Carnival, which includes a parade and costume competition. Participating bands—local and nonlocal—consist of immigrants from the Bahamas, Guyana, Barbados, Jamaica, Trinidad, and Tobago.

Right: Troupe Hellas Greek Folkloric Society performing at the Atlanta Greek Festival, 1995. *Photo by William F. Hull, Atlanta History Center.*

Below: Atlanta Caribbean Association participating in the Peach Carnival parade, 1993. *Photo by Lee Wilson, Atlanta History Center.*

The Atlanta parade takes place on Memorial Day weekend; there are similar parades at other times elsewhere in North America. This allows people to visit distant friends and family by circulating from carnival to carnival throughout the year.

WE ARE ALL FOLK ARTISTS

(CATALOG NOS. 594–608)

What is the place of folk arts in the modern South? Even in a society dominated by the mass media and mass-produced goods, many feel a need for face-to-face traditions. The childhood learning of arts such as paper airplanes and Halloween jack-o'-lanterns, urban legends that "happened to a friend of a friend," and jokes about current events fill a void in our lives.

Recent folklore springs from urban and suburban experience. Many traditions now practiced in the South say more about the mobile national culture than about the region. Folk arts may no longer be as central as they were in the rural South, but they will always be with us in some form.

Catalog

1. Maul, hardwood

Hickory Flat, Cherokee County, Ga., early 1900s

This implement, used with a wedge to split wood, was salvaged from an abandoned farm as the first object acquired for the Burrison Folklife Collection in 1966.

2. *The Banjo Lesson* (reproduction print)

HENRY OSSAWA TANNER

Philadelphia, Pa., 1893

This painting illustrates the folk learning process. Courtesy Hampton University Museum, Hampton, Va.

3. Child's learning guitar, grain-painted cigar box

Cobb County, Ga., early 1900s

4. Child's learning fiddle, sheet iron and wood

Elbert County, Ga., early 1900s

5. Face jug, secret-formula glaze

DAVIS BROWN

Arden, Buncombe County, N.C., ca. 1966

6. Face jug, secret-formula glaze

JAVAN BROWN

Skyland, Buncombe County, N.C., 1975

7. Face jug, Bristol glaze and Albany slip

JERRY AND SANDRA BROWN

Hamilton, Marion County, Ala., 1992

The Browns, an eighth-generation southern pottery family, have made face jugs since at least the early 1900s. Davis and Javan were brothers who moved to North Carolina from Atlanta; Jerry is a next-generation cousin whose potter father, Horace, had moved to Alabama from Atlanta.

8. Two-faced "politician" jug, ash glaze

LANIER MEADERS

Mossy Creek, White County, Ga., 1975

9. Face jug, ash glaze

CLEATER "C. J." AND BILLIE MEADERS

Warner Robins, Houston County, and Cleveland, White County, Ga., 1995

10. Head, wheel-thrown and altered, ash glaze

CLETE MEADERS

Hoschton, Jackson County, Ga., 1995

11. Face jug, ash glaze

ANITA MEADERS

Mossy Creek, White County, Ga., 1995

Face jugs brought fame to Lanier Meaders, who revitalized the form. He learned to make them from his father, Cheever, who had seen those by the Browns and Hewells. C. J. is Lanier's cousin; Anita is the wife of David Meaders, Lanier's nephew; and Clete is the son of C. J. and Billie Meaders.

12. Face jug, Albany-slip glaze

D. X. GORDY

Westville Pottery, Stewart County, Ga., ca. 1970

13. Face buggy jug, mock Albany-slip glaze

MARIE ROGERS

Meansville, Pike County, Ga., 1994

D. X.'s father, W. T. B. Gordy, learned to make pottery from his uncles, the Bishops, at Jugtown in west-central Georgia. Marie is the widow of Horace Rogers, another Jugtown-trained potter.

14. Face jug, ash glaze, melted-glass decoration

BURLON CRAIG

Vale, Lincoln County, N.C., 1980

Craig learned to make face jugs from neighbor potters Harvey Reinhardt and Auby Hilton in the Catawba Valley. Through later contact, he borrowed ideas from Georgia potter Lanier Meaders (two-face jugs and wig-stand heads) and influenced the work of the Hewells (melted-glass decoration).

15. Face jug, ash glaze

GRACE HEWELL

Gillsville, Hall County, Ga., 1994

16. Miniature face jug, ash glaze

CHESTER HEWELL

Gillsville, Hall County, Ga., 1992

The Hewells' face jug tradition goes back to the early 1900s. Chester is Grace's son. He revived the family face jug tradition in 1975, inspired by Lanier Meaders's success with the form.

17. Noggin, Indonesian teak with brass bands

NED GAVIN

Ballinagh, County Cavan, Ire., 1986

One of Ireland's last rural coopers, Gavin now uses materials that appeal to well-to-do customers. Originally, the staves would have been oak and the bands, wood or iron.

18. Noggin, red cedar with oak bands

RICK STEWART

Sneedville, Hancock County, Tenn., 1989

In Appalachia, Rick studied coopering with his grandfather, Alex Stewart, who inherited the craft from his Scots-Irish ancestors.

19. Noggin, walnut with oak bands

Nantahala, Swain County, N.C., ca. 1800

This is an early example of the Ulster coopering tradition as transplanted in Appalachia.

20–22. Baskets, plastic and wire

MY LOR HER

Decatur, DeKalb County, Ga., 1992

23–24. Leather-stitching vises, hardwood

(dark) N.C., early 1800s; (light) Scottsboro, Jackson County, Ala., mid-1800s

These tools were used by cobblers and harness makers to bind together layers of leather.

25–26. Shoe lasts, hand-forged iron

North Ga., mid-/late 1800s

These forms were used to repair shoes made on wooden lasts.

27–28. Child's boots, leather

Gilmer or Fannin County, Ga., 1940s

These handmade boots, purchased at a general store, were shaped on a single straight wooden last by a mountain cobbler long after factories began making right and left shoes. The "uppers" are attached to the soles with tiny, hand-whittled hardwood pegs.

29. Ruined whiskey jug

JESSE B. LONG POTTERY

Crawford County, Ga., 1880s

This jug was found discarded in the waster dump of the shop site. The horizontal finger ridges inside reveal that it was thrown on a potter's wheel (the outside wall was smoothed with a hand-held rib). A factory-made pot would be smooth both inside and out.

30. Whiskey jug

Atlanta, Fulton County, Ga., ca. 1905

This jug was made for Atlanta's R. M. Rose Distillery. The outside bottom has a uniform ring where the moist clay was squeezed in a revolving mold on a jolly machine. The joint around the middle shows that the jug was molded in two sections.

31. Wheelwright's hub reamer (wooden handle missing)
Blairsville, Union County, Ga., mid-1800s
Identical to those of eighteenth-century Europe, this tool was used to enlarge the holes in wagon-wheel hubs. Hammer marks and uneven thickness and shape are evidence that it was fashioned by hand on a blacksmith's anvil.

32. Cooper's bunghole borer
Place unknown, mid-1800s
This tool was used by the Camp family of Winder, Georgia, to cut the hole needed to fill and drain barrels. It shows the uniformity of iron cast in a mold, confirmed by the raised number on one side indicating the hole diameter.

33. Bed coverlet
ELIZABETH DUNEGAN EDWARDS
Whitfield County, Ga., ca. 1870
Southern coverlets typically were handwoven as two or three panels that were then sewn together. The panel width was limited by loom width, which in turn was influenced by the span of the weaver's arms. A bedcover with no seams, in contrast, was made either on a factory loom with a mechanical fly shuttle or on a wider, northern professional handloom.

34. Miniature farming implements
CARL L. STEPP
McCaysville, Fannin County, Ga., 1969
In this "memory art," featuring a plow, spade, mattock, and hoe, the maker was recalling his boyhood on a mountain farm.

35. Grier's Almanac
Atlanta, Fulton County, Ga., 1995
Some southern farmers and gardeners still use *Grier's Almanac* (published since 1807) to support folk rules for planting by the signs of the zodiac and phases of the moon. Based on belief in the heavenly bodies' influence on the natural world, the system was created by astrologers more than three thousand years ago.

36. "Bull-tongue" plow, wood and iron
Lamar County, Ga., 1870s
Plows such as this one, owned by the Pippin family, prepared the soil for planting cotton and corn.

37. Double-foot plow (missing its blades), wood and iron
WILLIAM R. BROWN
Pike County, Ga., 1870s
Beautifully made with hand-forged iron fittings and pegged joints, this little plow shows traces of red paint.

38. Cotton basket, white-oak splits
R. L. RICHARDSON
Summerville, Chattooga County, Ga., 1967
Once made to collect cotton in the fields, such "hamper" baskets now are used mainly in yardwork for raked leaves.

39. Cotton gin, wood
Southern United States, 1800s
Such handmade gins probably were inspired by manufactured ones like those of Eli Whitney. Two operators, turning the rollers in opposite directions, separated the seeds from the fiber.

40–41. Stockings, cotton
MRS. HENRY CLAY HUGHES
Roswell, Fulton County, Ga., ca. 1915
These stockings illustrate the continued use by southerners of homegrown and homespun cotton for knitting after handweaving had largely died out.

42. Corn basket, white-oak splits
ROLLIN MCCUTCHEON
West Andrews, Williamsburg County, S.C., 1994
The African American maker refers to this as a corn basket.

43–45. Quern, or hand-turned corn mill, stone and wood (milking stool and bucket for catching the meal added)
Hampton, Hampton County, S.C., 1800s
The quern, like the field sled, is an ancient European survival among self-sufficient southern farmers, who thus avoided paying the toll of a professional miller. This example was used by the Freeman family.

46–47. Bag for stone-ground cornmeal, paper (with new cast-iron cornstick mold)

From Houston Mill, DeKalb County, Ga., early 1900s

Houston Mill operated on the present grounds of Emory University.

48–50. Breakfast plate with grits (reproduction) and bags of stone-ground grits

Grits—coarsely ground corn stirred into boiling water—are still a customary part of the southern breakfast, even in fast-food chain restaurants. They are usually served with eggs and ham and eaten like mashed potatoes, with butter or gravy. Their northern counterparts, hasty pudding (New England) and mush (Mid-Atlantic), were eaten with milk as a sweetened hot cereal and have largely passed out of fashion.

51. Model moonshine still, copper with cement-mortared stones

THEODORE "DOC" KING AND MELVIN BROWN

Blairsville, Union County, Ga., 1968

Between the furnace-encased copper cooking pot and water-cooled condenser is a "thumper" keg that eliminated the time-consuming second run to produce drinkable whiskey. The keg contained cornmeal "beer" through which steam from the pot bubbled with a rhythmic thumping to double the alcohol content. Doc King, a former "blockader," supported his family with such models and moonshining demonstrations at mountain fairs.

52. Moonshine still, copper

Chattanooga, Hamilton County, Tenn., ca. 1900

The condenser of this simple "fireplace" still is a double-walled ring that was water-cooled.

53. Whiskey jug, ash glaze

ATTRIBUTED TO WILEY MEADERS

Mossy Creek, White County, Ga., ca. 1910

This stoneware jug is typical of those used by north Georgia moonshiners until glass and metal containers became available.

54. Mason jar of "white lightnin'," or moonshine

Fannin County, Ga., 1973

Later moonshiners often used glass containers so their customers could see what they were buying.

55. Tobacco twist or "pigtail"

GROWN BY G. S. MCCLURE

Helen, White County, Ga., ca. 1965

The upper Savannah River valley and inland south Georgia have been the state's commercial tobacco-growing areas, but mountain farmers grew the plant on a smaller scale for their own use.

56–59. Rice-hulling mortar and pestles, wood

Sylvania, Screven County, Ga., 1800s

Steam-powered mills came to be built on larger plantations, but low-country African Americans continued to hull rice by hand in African-style log mortars. This one was used until the mid-1900s.

60. "Fanner," or rice-winnowing basket, bulrush bound with palmetto-butt strips

JANNIE COHEN

Hilton Head, Beaufort County, S.C., 1994

Such shallow coiled baskets were used to toss hulled rice in the air, the breeze carrying away the hulls and the cleaned rice dropping to a ground cloth.

61–62. Model sorghum-syrup mill and cooker

CARL L. STEPP

McCaysville, Fannin County, Ga., 1970

The sorghum, stripped of leaves and seed heads, is fed through the mill's rollers (mule-powered until recently). The resulting juice is then boiled. As the juice cooks, it is pushed around the baffles, and foam is skimmed off. The finished syrup is strained into a barrel.

63. Syrup jug, ash glaze

Catawba or Lincoln County, N.C., ca. 1880

Large, graceful vessels were made by southern potters to store cane syrup before glass and metal cans became widely available. Some potters widened the mouth for easier pour-

ing. The form can be traced to the English cider jar of the 1700s.

64. Mason jar of sorghum syrup

DUANE DYER

Blairsville, Union County, Ga., 1971

Along with honey, syrup was the only sweetener many southerners could afford before the 1900s; sugar, in the form of solid cones, was kept in a lockable chest as a precious commodity. The mountain town of Blairsville is a stronghold of sorghum-syrup production, hosting a fall festival in its honor.

65. Gambrel stick, wood

Georgia, ca. 1900

After they are killed, hogs are hung from such a stick through the exposed tendons of the back legs for butchering.

66. Bullwhip, leather with decoratively carved wood handle

Attributed to southwest Georgia's Wiregrass section, late 1800s

The sound of such whips, used to drive cattle to market, is one explanation for the name "cracker" given to southern poor whites. In reality, the word is of Irish origin (from *craic,* or amusing talk) and was applied by the English in the 1700s to the "vulgar braggarts" of the southern backcountry.

67. Sawmill dog, hand-forged iron

Maysville, Jackson County, Ga., late 1800s

Such staples were used for securing a log or board on a sawmill carriage.

68. Hewn log, half-dovetail notching

JOHN ROLLINS

Daves Creek, Forsyth County, Ga., ca. 1850

Sawmills were scarce on the frontier, so trees were used for the walls of buildings in a more natural state, notched at the ends to join the corners. Finno-Swedes and central Europeans brought horizontal-log construction to the New World. This segment came from a wall of the builder's ruined, one-room cabin.

69. Broadax, iron and wood

Union County, Ga., 1800s

Broadaxes were used to hew (flatten or square up) logs for buildings and railroad crossties. The handle is slightly bent to one side to avoid grazing the knuckles.

70. Maul or beetle, hardwood

ODIE BENNETT

Calhoun, Gordon County, Ga., early 1900s

Two-handed mauls such as this one were used with a wedge to split timber into fence rails and firewood and to quarter oak saplings to make splints for baskets and chair seats.

71. Frow, hand-forged iron blade

North Ga., ca. 1900

72. Frow maul, hardwood

Marietta, Cobb County, Ga., late 1800s

The frow and one-handed maul were used for splitting roof shingles and floorboards. With the frow blade down and the sharp lower edge laid just inside the flat face of a quartered oak log, the blade's upper edge was struck with the maul. A thin, flat section was cut along the grain; then the frow handle was turned sharply outward, splitting away the remaining board.

73. Turpentine hack

BLADE BY COUNCIL TOOL COMPANY

Wananish, Columbus County, N.C., early 1900s

BLACK-GUM STOCK HANDMADE AT PEAGLER CAMP

Homerville, Clinch County, Ga., 1940s–1950s

This tool was used for "chipping," or cutting a V-shaped face in a pine tree, from which the resin bled.

74. Turpentine scrape iron

BLADE BY TURPENTINE AND ROSIN FACTORS

Savannah, Chatham County, Ga., early 1900s

BLACK-GUM STOCK HANDMADE AT PEAGLER CAMP

Homerville, Clinch County, Ga., 1940s–1950s

This tool was designed to scrape dripping resin from the edge of a pine-tree face.

75. Turpentine cup, machine-molded earthenware

HERTY TURPENTINE CUP COMPANY

Soddy Daisy, Hamilton County, Tenn., early 1900s

Such cups were used for collecting pine resin to be distilled into turpentine and rosin. Destructive "boxing," or cutting of deep gashes, was replaced by the cup-and-gutter system developed by the University of Georgia's Charles Herty. Factory-made tools for turpentining are not folk, but their use became so. This cup was used at Peagler Camp, Homerville, Georgia.

76. Turpentine cup, tinned iron

Southern United States, mid-1900s

This later style of gum-collecting cup was used at Eli Vickers and Sons Naval Stores of Douglas, Georgia.

77. Hunting knife, bone handle and hand-forged iron blade

Chatsworth, Murray County, Ga., 1860s

78. Hunting knife, steel (from a circle-saw blade) and wood

Georgia, early 1900s

The bone-handled knife was used by the Plemons family.

79. Turkey caller, walnut

Georgia, 1800s

80. Turkey caller, maple

LON REID

Choestoe, Union County, Ga., 1969

With the walnut caller, the corrugated cylinder makes a gobbling sound when rolled in the grooves of the block. The handled maple caller produces a high-pitched cry when a piece of slate is rubbed across a tin strip set into the sound box.

81. Duck decoy, painted cork and yellow pine

LACEY NORWOOD

Savannah, Chatham County, Ga., 1920s

One of Georgia's few decoy makers, Norwood was a market hunter who took his boat up the Savannah River when he wasn't working as a "squinch" (bill collector) in Savannah. He obtained the cork from surplus life jackets.

82. Ring-necked duck decoy, painted cypress

ERNIE MILLS

Perry, Houston County, Ga., 1990

This service-grade decoy is hollowed to float properly and has a keel for larger bodies of water, such as southwest Georgia's Lake Seminole. The white paint on the decoy's sides was combed to "cut the shine."

83. Canada goose decoy, painted yellow pine and canvas-covered, wire-frame body

ATTRIBUTED TO NED BURGESS

Church Island, Currituck County, N.C., 1930s

In the Southeast, wildfowl decoys have been made mainly along the Chesapeake Bay and North Carolina coast. Burgess made decoys both for sale and for his own use. Between 1915 and 1948 he built hundreds of such lightweight working decoys meant to be "shot over."

84. Squirrel rifle, percussion, .36 caliber

MEIER(?) ENSLEY (FAINT SIGNATURE AND DATE ON BARREL TOP)

Probably Cohutta Springs, Murray County, Ga., 1882

The locks on many mountain rifles were factory-made and often imported from England. The gunsmiths also sometimes bought pre-made barrel blanks that they bored and rifled. Much of the handwork therefore went into the wooden stock and its metal "furniture."

85. Squirrel rifle, percussion, .38 caliber

JOHN DANIEL NELSON (SIGNED AND DATED ON BARREL TOP)

Ball Ground, Cherokee County, Ga., 1871

The maker settled at Nelson, near Ball Ground, after serving as a surgeon in the Confederate army. His blacksmith and gun shop was supplied with spring water via hand-bored wooden pipes.

86. Hog rifle, percussion, .41 caliber

ATTRIBUTED TO BRIGGS GARLAND

Dial, Fannin County, Ga., late 1800s

Hog rifles were meant for bigger game than squirrel rifles and took a larger bullet. The construction of this one is so spare that it lacks a butt plate.

87. Powder horn

Blue Ridge, Fannin County, Ga., mid-1800s

Powder horns carried black gunpowder for muzzle-loading rifles. The twist allowed them to fit snugly against the hunter's side. This example was owned by the Terrell family.

88. Hunting bag, leather

Blue Ridge, Fannin County, Ga., late 1800s

Lead balls (bullets) and cloth for patches were carried in such bags. Attached to this example, which belonged to the Sisson family, are cockspur and horn powder measures and a wooden tab with holes for patch-encased balls to speed up loading.

89. Cast net, nylon twine with cowhorn sleeve

FRANK HUNTER

St. Simons Island, Glynn County, Ga., 1979

African-style "purse" nets have been used since antebellum days in coastal Georgia and South Carolina. With the cord attached to the fisherman's wrist, the net is flung from shore or a boat into a school of fish or shrimp, drawing closed as it is pulled in.

90. Seine, cotton twine

Sutalee, Cherokee County, Ga., early 1900s

This net, used by the Gramling family, was stretched across a stream with its lower edge weighted by the chain and anchored at each end by the poles that were driven into the banks.

91. Net needle, dogwood

WILLIAM NELSON

Sugar Valley, Gordon County, Ga., early 1900s

Shuttles like this have been used all over the world since prehistoric times for making and repairing knotted fishnets.

92. Fish trap, white-oak splits

TOBE WELLS

Elberton, Elbert County, Ga., 1984

Basketry traps have both European and Native American precedents; this one was made by an African American basket maker. The trap was set facing upstream, and fish enter-ing the mouth were trapped by a circle of pointed splits woven inside. The trap was emptied by undoing the binding at the narrow end.

93. Sturgeon "gig," hand-forged iron

Montrose, Laurens County, Ga., late 1800s

94. Frog or fish "gig," recycled from an old file

Monticello, Jasper County, Ga., ca. 1900

Such fish spears hark back to the European Iron Age. They vary in size and shape depending on what fish is being sought. Boys often went gigging at night with lanterns, both for sport and for food.

95–97. Chain of mussel "drags," with punched shell and button

North Alabama, 1920s

Along Alabama's Tennessee River between Guntersville and Wheeler, a specialized fishing subculture served the preplastic button industry. Wire "drags," their ends "knobbed" by melting with an acetylene torch, were lowered from a flat-bottomed boat. As the knobs dragged bottom, mussels would clamp their shells onto them, mistaking them for food. They were then hauled up and the shells sold to small factories, where they were punched into buttons.

98. Model diesel-powered Desco shrimp trawler, painted basswood

DENNIS WALLACE

Townsend, McIntosh County, Ga., 1994

Model boats have become traditional among retired boatbuilders and fishermen as an expression of occupational identity and a way to gain income as pollution, overfishing, and regulations take their toll on commercial fishing.

99. Model Willie Harris–style bateau, painted cypress

CURTIS HARRIS

White Oak, Camden County, Ga., 1998–99

The bateau is a small low-country workboat used since the 1700s for fishing and wildfowl hunting. Its flat-bottomed, squared-bow form is related to such European watercraft as the English punt, while its three-plank construction may

derive from the Caribbean multiple-log canoe or pirogue. Curtis acquired the boatbuilding tradition from his famed grandfather, Willie Harris of Brunswick, Georgia, who refined the bateau design. This is his first model.

100. "Good for what ails you" medicine
BENNIE CAUDELL
Cleveland, White County, Ga., 1968
This family recipe of roots from bloodroot, lady's-slipper, burdock, granny graybeard, and jimsonweed, along with wild cherry bark and sulfur in whiskey is especially good for colds or rheumatism, according to Caudell. "That's an old Indian remedy—my grandmother's side; she was three-quarter Cherokee." His son recovered from influenza soon after drinking it.

101. Pokeberry wine
SHADE HINKLE
Jasper, Marion County, Tenn., 1966
Southerners cook the young leaves of pokeweed to eat as poke "sallet," pickle the stalks, and use the roots and berries for "rumatiz" medicine, which must be taken in small doses or it can be poisonous. The berries also were used to make dye and ink.

102. Yellow root, or yellow dock
Purchased at Municipal Market, Atlanta, Fulton County, Ga., 1990
Dried yellow roots are made into tea and used for a variety of ailments and as an energy booster. Mountaineers chew the fresh root, rich in tannic acid, to heal mouth and stomach ulcers.

103. Elixer dispenser, salt glaze
ATTRIBUTED TO CHARLES OR L. FARRELL CRAVEN
Moore or Chatham County, N.C., late 1930s
This stoneware container was made without a lid so the mixture of roots, rock candy, and whiskey could be shaken without spilling.

104. Ginseng digger, hand-forged iron blade
Gilmer County, Ga., ca. 1900
Ginseng, or "sang" as it is called in Appalachia, is highly valued as a medicinal plant in the Far East. Although mountaineers use it in home remedies, they also earn cash by digging the roots to sell for export.

105. Model "dogtrot" house
A distinctive Piedmont folk building type that appeared around 1800, the dogtrot house is so named because it has two main rooms separated by an open breezeway—a cool place for dogs (and people). It usually was built of horizontal logs with a wood-shingle roof, reflecting the South's abundance of timber. Model by Rebecca Fuller, RAF Models and Displays, Winston-Salem, N.C.

106. Bonnet, silk
Elbert County, Ga., mid-1800s
Bonnets were the height of fashion all over the country at the time this example was worn by Martha Washington Scales McBath.

107. Bonnet, cotton
IVEY BEAVER
Jesup, Wayne County, Ga., 1968
This example represents the ongoing tradition of bonnet making in the South.

108. Fan, guinea feathers, gimp, and wood
MRS. CASTALOW BURTON
Mount Airy, Habersham County, Ga., 1977
A southern tradition of handcrafted fans and fly whisks began in the antebellum period in lieu of air conditioners and window and door screens. The maker learned the folk art of guinea-feather fans from her mother-in-law.

109. Walking stick, red maple
JACK ALEXANDER
Clarkesville, Habersham County, Ga., 1994
Snakes often appear as a design motif on southern canes. On this example, the wood that overgrew an entwined, dead vine is carved and painted as a rattlesnake.

110. Rattlesnake dance mask, basswood

VIRGIL CROWE

Birdtown, Swain County, N.C., 1992

The Cherokee Indians, for whom killing rattlesnakes is taboo, once danced in such masks to show defiance and threaten war against their enemies.

111. Serving spoon, poplar

Georgia, early 1900s

The carved rattlesnake is highlighted in pencil.

112. Snake jug, "glass" glaze (ash glaze with powdered glass)

BURLON CRAIG

Vale, Lincoln County, N.C., early 1980s

There are earlier precedents for potters of the region decorating their jugs with applied-clay snakes.

113. Rattlesnake, ash-glazed stoneware

MICHAEL AND MELVIN CROCKER

Lula, Banks County, Ga., 1991

The Crocker brothers also make snake jugs. The scales on their realistic snakes are picked out with plastic drinking straws.

114. Child's headstone, salt glaze

Itawamba County, Miss., ca. 1880

This molded stoneware marker was found broken and discarded in the woods next to a cemetery and has been repaired (the area subsequently was flooded for the Tennessee-Tombigbee Dam). The type-impressed inscription was filled with cobalt blue.

115. Upper portion of tombstone base, salt glaze

Itawamba County, Miss., ca. 1880

Two-piece markers with slot-and-tab joints were patented by the Loyd family and sold by Mississippi and Alabama folk potters. The base was wheel-thrown and altered while damp to form the slot.

116. Grave planter, earthenware, combed and fluted decoration

ATTRIBUTED TO THE SHEPHERD FAMILY

Sligh's Mill, Paulding County, Ga., ca. 1900

This wheel-thrown, two-piece planter is restored from discarded fragments.

117. Grave marker, partial Albany-slip glaze

GERALD M. STEWART

Louisville, Winston County, Miss., 1972

Stewart was the last southern folk potter to make ceramic grave markers. He sold them in sets of four to mark the corners of burial plots. However, he made five per order in case one was damaged in firing; this example was the extra.

118–24. Bowl of gumbo (reproduction) with ingredients and cookpot

125. Basket, rivercane, bloodroot and walnut root dyes

ELNORA LITTLEJOHN

Cherokee, Swain County, N.C., ca. 1890

This typical older Cherokee basket is woven in a colored pattern.

126. Basket, white oak, blue dye

NELDA JOAN TODD

Woodbury, Cannon County, Tenn., 1992

The dyed stripes of this rib basket by an Anglo-American maker represent a later borrowing of the Native American decorative technique.

127. Picnic basket, white oak, bloodroot and walnut root dyes

DOLLY TAYLOR

Birdtown, Swain County, N.C., 1991

Such European-style handled rib baskets have been a specialty of the Cherokee maker's family for four generations, illustrating that influences went in both directions.

128. Basket, white-oak splits, blue and red dyes
CATHERINE REEVES JOHNSON
Greenville, Meriwether County, Ga., 1993
This basket by an African American maker shows another possible influence of the Native American decorative technique.

129–30. Seminole patchwork "long coat" over "everyday" shirt
MARY FRANCES JOHNS
Okeechobee, Okeechobee County, Fla., 1995
"Long coats" are now worn for special occasions, such as Green Corn ceremonial dances. The maker learned patchwork skills from her grandmother, mother, and mother-in-law on the Brighton Seminole Reservation at the northern edge of the Everglades.

131. Model of typical southern folk pottery operation, loosely based on the Meaders Pottery of Mossy Creek, White County, Ga., as it was in 1970
The aboveground "tunnel" kiln is typical of north Georgia; middle Georgia potters used an earth-enclosed "groundhog" type. Both kinds are wood-fueled, rectangular cross-draft kilns, with firebox and chimney at opposite ends (as distinct from the round updraft kilns once used in the North). The mule-powered clay mill and hand-turned mill for refining alkaline glazes also were typical of southern shops. Model by Rebecca Fuller, RAF Models and Displays, Winston-Salem, N.C.

132. Potter's wheel
CLEATER "C. J." MEADERS
Cleveland, White County, Ga., 1993
A few southern folk potters still use the treadle type of wheel (developed in late-1700s England), powered by a foot bar pushed from side to side. The standing position facilitates the "pulling up" of large pieces. This example, equipped with early-style wood headblock, height gauge for uniformity, and hinged lever to punch an initial opening in the clay, is new but incorporates the crankshaft and flywheel saved from Cheever Meaders's old wheel.

133. Unused clay block
Gillsville, Hall County, Ga., 1940s
This dried clay, still bearing the preparer's fingerprints, is from the abandoned log pottery shop of John F. Hewell.

134. Scales, wood and iron
CHEEVER MEADERS
Mossy Creek, White County, Ga., mid-1900s
Based on the steelyard for weighing cotton, such scales created uniform clay "balls" for pots of a given size and shape. The counterweight, consisting of plow points and other scrap metal, was shifted to the notch representing the intended gallonage on the wooden beam's upper edge, and then clay was added to or removed from the pan at the beam's butt end until the scales balanced.

135. Potter's apron, cotton
ADA HEWELL
Gillsville, Hall County, Ga., ca. 1950
This "work shirt," made from a feed sack, was used by Ada's husband, Maryland Hewell.

136. "Chip," or rib, steel
MARYLAND HEWELL
Gillsville, Hall County, Ga., ca. 1950
Ribs are used to shape and smooth the outside of pots; earlier examples usually were wooden.

137. Gauge, yellow pine
RAY HOLCOMB
Gillsville, Hall County, Ga., 1930s
Such gauges are still used at Hewell's Pottery to check and standardize the height of pots on the wheel.

138–40. Pot lifters, hand-forged iron
Used by Horace Rogers at Meansville, Pike County, Ga., Cheever Meaders at Mossy Creek, White County, Ga., and Maryland Hewell at Gillsville, Hall County, Ga., all early 1900s

141. Pot lifters, yellow pine and leather

CHEEVER MEADERS

Mossy Creek, White County, Ga., 1940s

Lifters clamp under and support a pot when removing it from the potter's wheel to avoid caving in the sides with the hands. They were made in graduated sets for pots of different sizes.

142. Potter's stamp, fired clay

WILLIAM THOMAS BELAH GORDY

Alvaton, Meriwether County, Ga., 1920s

Made in a hand-carved wooden mold, this stamp was used to mark wares of the Gordy shop, where a number of hired potters worked.

143. Kiln brick, handmade

CLEATER MEADERS SR.

Cleveland, White County, Ga., 1920s

144. Tripod stilt, wheel-thrown clay

FROM SHEPHERD POTTERY

Sligh's Mill, Paulding County, Ga., early 1900s

145. "Setter," or stilt, wheel-thrown clay

CHEEVER MEADERS

Mossy Creek, White County, Ga., ca. 1960

Cheever made such "setters" in the shape of hollow truncated cones to keep decorated wares—especially those of his wife, Arie—off the sandy kiln floor when firing.

146. Firing tester

LANIER MEADERS

Mossy Creek, White County, Ga., 1978

Lanier placed cones of thickened glaze, set in a clay base, at the chimney end of the kiln and observed them through a peephole; when they melt, or "slick over, it's time to quit burning." His father, Cheever Meaders, developed this technique after learning about scientific pyrometric cones.

147–48. Draw-trials (one underfired, the other with glaze fully melted)

CHESTER HEWELL

Gillsville, Hall County, Ga., 1995

Draw-trials are an older way of determining when to stop firing. Recycled from broken garden pots, these were pierced, glazed, and withdrawn with an iron hook from the chimney end of the kiln toward the end of firing until the ash glaze properly melted.

149. Jug-stacking dish, wheel-thrown clay

Jugtown, Upson or Pike County, Ga., ca. 1880

To conserve kiln space, jugs with salt or Albany-slip glazes were stacked in columns, using an upended walled dish (a type of kiln "furniture," or production piece) to support the jug above. This dish is stuck to the broken top of a salt-glazed whiskey jug and was discarded on the waster dump of an unidentified shop.

150. Pipe mold, lead and wood

ATTRIBUTED TO THE DORSEY FAMILY

Mossy Creek, White County, Ga., late 1800s

This two-piece mold was used to make smoking pipes. The bowls and neck collars were hollowed with separate reamers.

151–53. Pipe-sagger fragment and two smoking pipes, salt glaze

Columbia, Richland County, S.C., 1870s?

Saggers are clay boxes used for firing delicate wares; their perforated sides protected from flames but admitted the glazing vapor from salt thrown in the kiln. Salt glazing was rare in South Carolina, but alkaline glazes were also used at this shop, which has not been identified. The "elbow" pipes, which would have been fitted with homemade reed stems, are "wasters," or defective discards, warped or scarred where stuck to the sagger.

154. Churn wasters (upper fragments), Albany-slip glaze

SLIGH POTTERY

Sligh's Mill, Paulding County, Ga., ca. 1920

These two four-gallon churns were ruined by overfiring. Stacked mouth to mouth in the kiln, they were fused together and distorted by the excessive heat.

155. Jug waster, ash glaze

LANIER MEADERS

Mossy Creek, White County, Ga., 1974

This jug blew up from thermal shock when rainwater came down the kiln chimney toward the end of firing. Such accidents ruin wares, causing them to end up on the waster pile.

156. Crock, salt glaze, cobalt-oxide bluebird

ATTRIBUTED TO THE BRADY AND RYAN POTTERY

Ellenville, Ulster County, N.Y., 1880s

With its blue decoration, this is a typical example of northern stoneware. Because such wares were stacked in columns for firing, preventing the salt vapor from entering them, they were coated inside with Albany slip, a natural clay glaze from the Hudson River valley.

157. Whiskey jug, salt glaze (Albany slip inside)

ATTRIBUTED TO THE BROWN FAMILY

Atlanta, Fulton County, Ga., 1880s

The dark drips, caused by corrosion of the low ceiling bricks from hydrochloric acid as a by-product of salt glazing, and the melted ashes on the shoulder blown from the wood-fueled firebox, are marks of firing in a southern crossdraft kiln. Potter Javan Brown declared, "Most potters didn't care what their ware looked like, so long as it didn't leak."

158–59. Alkaline glaze ingredients: wood ashes and lime

Wood ashes are a key ingredient in one type of alkaline glaze. They are screened and mixed with water, clay, and sand according to a traditional recipe. Ash glaze tends to run when melting, creating a drippy texture (however, a later version substituting powdered glass for sand, "glass"

glaze, is smooth). Lime is the basis for the other type of alkaline glaze. Some potters made their own lime by burning limestone in their kilns. The resulting powder was slaked with water, producing a caustic base like the lye from wood ashes. Both alkaline substances work as a flux, or melter, but lime glaze normally is smoother.

160–61. Alkaline glaze ingredients: clay and sand

Clay contains silica, helping to make alkaline glazes glassy; additional silica is contributed by sand, quartz, or powdered glass. Clay also keeps the glaze solution in suspension for coating the unfired pots. It is the iron in this clay that gives the glaze its color. In a reduction, or smoky, firing atmosphere, alkaline glazes turn green; in an oxidation, or free-burning, atmosphere they become brown.

162. Jar, ash glaze

JAMES FRANKLIN SEAGLE

Vale, Lincoln County, N.C., 1860s

163. Jar, ash glaze

China, 1600s (Ming dynasty)

Alkaline stoneware glazes were first used during the Han dynasty, about the time of Christ. A published European report of Chinese alkaline glazes may have inspired development of similar glazes by South Carolina's Landrum brothers about 1810. These glazes soon spread to North Carolina and westward through Georgia.

164. Pitcher, ash glaze

MATTHEW HEWELL

Gillsville, Hall County, Ga., 1994

The runny texture of this glaze has a distinct tactile quality.

165. Coloring agent: "iron sand"

This iron-bearing sand was scraped off a dirt road in White County, Georgia, by Lanier Meaders, who learned of the site from his father, Cheever. This is the same location exploited by Isaac Craven in the late 1800s for his "iron sand" glaze.

166. Spittoon, "iron sand" glaze

ISAAC H. CRAVEN

Mossy Creek, White County, Ga., 1870s

Craven was known for this special subtype of ash glaze, in which iron-bearing sand replaced ordinary creek sand, darkening the glaze and producing the metallic sheen.

167. Mug, lead-glazed earthenware

Liverpool, Merseyside, Eng., early 1700s

The glaze on this English mug is colored with iron oxide, a technique that may have inspired some southern stoneware potters to add an iron-bearing mineral to their alkaline glazes.

168–73. Coloring agent: "Indian paint rocks" (with iron mortar and pestle)

Potters in Crawford County, Georgia, crushed such limonite nodules in a mortar and then added the resulting powder to their glaze solutions.

174. Jar, lime glaze

ATTRIBUTED TO THE LONG FAMILY

Crawford County, Ga., ca. 1860

The glaze is colored with "paint rock," a locally occurring iron ore in the form of limonite nodules.

175. Pitcher, Albany-slip glaze

EDWARD LESLIE STORK

Orange, Cherokee County, Ga., ca. 1915

A grandson of South Carolina stoneware pioneer Abner Landrum, Stork was trained in Columbia and worked at a number of Georgia shops before settling in Cherokee County. He also used Michigan slip, a clay glaze from the Great Lakes.

176. Jar, salt glaze over Albany slip

WILLIAM R. ADDINGTON

Gillsville, Jackson County, Ga., 1880s

Addington was trained at the Barrow County pottery center, where this distinctive double glaze came into use in the 1870s.

177. Creamer, Bristol glaze

JERRY BROWN

Hamilton, Marion County, Ala., 1986

This version of Bristol glaze combines zinc oxide (which makes it white and opaque) with feldspar (a silica source as well as flux or melter), whiting (a chalky flux similar to lime), and water.

178. Table salt, alkaline glaze

(Note: This generic term is used in object labels when the more particular ash or lime version has not been determined; all pottery is stoneware unless specified as earthenware.)

ATTRIBUTED TO THE ABNER LANDRUM SHOP

Pottersville, Edgefield County, S.C., ca. 1820

This rare, evidently molded form may have been an experiment to appeal to wealthy customers.

179. Syrup jug, lime glaze

ATTRIBUTED TO THE SHOP ESTABLISHED BY ABNER LANDRUM

Pottersville, Edgefield County, S.C., 1830s

Abner's shop changed ownership several times after he sold it in 1828 and was likely operated by Nathaniel Ramey when this piece was made. The double-collared neck and sturdy handles perched on the shoulder are typical Edgefield District jug features; early jugs and jars such as this tend to have a bulbous shape.

180. Whiskey jug, lime glaze

ATTRIBUTED TO BENJAMIN FRANKLIN LANDRUM

Aiken County, S.C., 1840s

B. F. was the son of pioneer potter John Landrum, brother of Abner.

181. Whiskey jug, alkaline glaze, kaolin-slip decoration

COLLIN RHODES SHOP

Aiken County, S.C., ca. 1850

Rhodes was the son-in-law of Amos Landrum, brother of Abner and John. This is the smallest size (one-quarter gallon) in his "flower-number" decorated series; the cylindrical shape is atypical for such early production.

182. Food-storage jar, alkaline glaze, iron-slip decoration

THOMAS CHANDLER

Kirksey's Crossroads, Greenwood County, S.C., ca. 1850

Virginia-born Chandler came to Edgefield District in the late 1830s, perhaps introducing slip decoration. His looping designs complement his classically proportioned forms.

183. Pitcher, lime glaze, two-color slip decoration

ATTRIBUTED TO THOMAS CHANDLER

Kirksey's Crossroads, Greenwood County, S.C., ca. 1850

On this example, a leaf motif was created with both iron and kaolin slips, the latter appearing greenish under the glaze.

184. Face jug, alkaline glaze darkened with iron-bearing mineral

SLAVE POTTER AT THOMAS DAVIES'S PALMETTO FIREBRICK WORKS

Bath, Aiken County, S.C., ca. 1862

Ceramics historian Edwin AtLee Barber wrote of these early southern face vessels in 1909, "The modelling reveals a trace of aboriginal art as formerly practised by the ancestors of the makers in the Dark Continent." "Spirit pots" in human form were kept at ancestral shrines in Nigeria and Cameroon, but English, German, southeastern Indian, and (as early as 1840) white Edgefield potters also made anthropomorphic wares, and African connections remain to be established. The meaning and use of the slave-made examples are unknown, but the angry faces with their bared kaolin teeth suggest protest against enslavement.

185. Churn, alkaline glaze

Edgefield District, S.C., mid-1800s

Because of the hard usage inherent in churning, surviving early pottery churns are uncommon. The deep midsection grooves on this small example, perhaps from Lewis Miles's Aiken County shop, are unusual. The cream-colored area may be due to naturally occurring rutile (titanium dioxide) in the clay where the glaze was thicker and didn't fully melt.

186. "Clabber bowl," or cream pot, alkaline glaze

Edgefield District, S.C., ca. 1860

The rim collar on this distinctive local form probably was intended to tie down a cloth cover.

187. Whiskey jug, ash glaze, melted-glass decoration

ATTRIBUTED TO THE THOMAS OWENBY SHOP

Cherokee County, S.C., 1846? (incised date unclear)

This early piece from near Gaffney in northern South Carolina illustrates that potters worked in the state outside Edgefield District, although less is known about them. The melted-glass drips from the handle, a technique mainly used in North Carolina, suggest ties with that adjoining state's stoneware tradition.

188. Meat jar, alkaline glaze

DAVE (SIGNED AND DATED)

Aiken County, S.C., April 12, 1858

The initials "L m" stand for Dave's master, Lewis Miles. The twenty-five tick marks on one shoulder signify the gallonage. The incised poem, "A very Large Jar which has 4 handles / Pack it full of fresh Meats—then light Candles," suggests that salted meat was meant to be sealed with melted wax or tallow. The jar was found being used as a planter under a tree on an east Georgia farm, where fallen branches had done some damage.

189. Storage jar, alkaline glaze

DAVE (SIGNED AND DATED)

Aiken County, S.C., July 4, 1859

The poem on this thirty-gallon jar reads, "The fourth of July is Surely come / to blow the fife and beat the drum," raising the issue of how the enslaved maker may have viewed Independence Day. The jar lost much of its glaze and suffered other damage sitting outside on an east Georgia farm.

190. Syrup jug, lime glaze

ATTRIBUTED TO THE CYRUS COGBURN SHOP

Washington County, Ga., 1820s

The overall shape and neck collaring betray the South Carolina background of middle Georgia's stoneware tradition.

Unlike the heavy Edgefield wares, the wall of this piece is impractically thin, with several holes knocked through.

191. Whiskey jug, lime glaze
ATTRIBUTED TO THE CYRUS COGBURN SHOP
Washington County, Ga., 1820s
Such Edgefield-style jugs were made in large numbers at the Cogburn shop, based on archaeological remains at the site. By 1850 Cogburn and his family had moved to Texas, where they continued to make pottery.

192. Storage jar, lime glaze
ATTRIBUTED TO ABRAHAM MASSEY ("M" IS CLEARLY THE SECOND INITIAL INCISED ON ONE SIDE)
Washington County, Ga., 1820s–1830s
This early jar has lug handles, such as those of Edgefield District, South Carolina.

193. Storage jar, lime glaze
Washington County, Ga., 1860s
By the 1860s, vertical loop handles for jars, placed just under the rim, were becoming the norm in Washington County. Note the handprint left in the glaze.

194. Pitcher, lime glaze
LUCIUS JORDAN
Washington County, Ga., 1870s
Jordan was the only local potter known to mark his wares regularly, incising "L J" or "J" in script.

195. Grave marker, wheel-thrown, partial lime glaze
ATTRIBUTED TO JOHN OR W. ANDREW REDFERN
Washington County, Ga., 1880s
Most surviving Washington County pottery grave markers lack inscriptions. This one was found in the woods next to a cemetery. The Redferns may have brought the tradition of wheel-thrown grave markers from North Carolina.

196. Storage jar, alkaline glaze
ATTRIBUTED TO THE LONG OR BECHAM FAMILY
Crawford County, Ga., 1840s
The "paint rock" particles in the glaze drifted toward the bottom when fired, creating a two-tone effect. As in Wash-

ington County, the earliest Crawford County jars have lug handles.

197. Storage jar, lime glaze with "paint rock" coloring
JESSE BRADFORD LONG (MARKED "JBL")
Crawford County, Ga., 1860s
As in Washington County, vertical loop handles on jars were becoming the norm by the 1860s but were placed further down the shoulder. Marking also was becoming common, with the potter's initials stamped in relief on the handle top.

198. Whiskey jug, lime glaze with "paint rock" coloring
WASHINGTON BECHAM (STAMPED "WB" ON HANDLE)
Crawford County, Ga., 1870s
Beehive-shaped jugs are a distinctive Crawford County form. Wash Becham's jugs typically have a flared mouth and wide upper handle embracing the neck.

199. Whiskey jug, lime glaze
JOHN C. AVERA (INSCRIBED "J. MARSHALL'S JUG / MADE AND WARRANTED BY J. C. AVERA / AUG THE 31ST 1871")
Crawford County, Ga., 1871
The incised decoration on this special two-gallon, beehive-shaped jug shows a hunter and two dogs chasing a fox. Working at Jesse Long's shop, Avera made this piece for John Marshall, a wealthy landowner who loved fox hunting.

200. Pitcher, alkaline glaze
ATTRIBUTED TO BILLY MERRITT
Crawford County, Ga., 1890–1910
Produced in a range of sizes, this distinctive flowerpot-like form made a useful kitchen utensil.

201. Milk pan, alkaline glaze with "paint rock" coloring
ATTRIBUTED TO THE BRYANT FAMILY ("BB" STAMPED ON HANDLE)
Crawford County, Ga., 1880s
This is another use of the collared flowerpot shape, with loop handles on either side of the pour spout.

202. Coffeepot, lime glaze
Crawford County, Ga., late 1800s
Coffeepots with either tubular or V-shaped spouts were a Crawford County specialty. "Coffee boilers" also were made by Washington County's Abraham Massey in 1820.

203. Bowl, lime glaze with "paint rock" coloring
Crawford County, Ga., 1880–1920
Bowls were an important Crawford County product, especially after the 1907 state prohibition crippled the legal market for whiskey jugs.

204. Grave marker, wheel-thrown, combed decoration
Crawford County, Ga., early 1900s
As in Washington County, surviving grave pots lack inscriptions. This was found in the woods near a cemetery.

205. Face jug, lime glaze
ATTRIBUTED TO EDDIE AVERETT
Crawford County, Ga., ca. 1920
Averett is the only Crawford County potter known to have made face jugs. According to his daughter, Lucile Wills, "Papa made face jugs for sale. . . . It tickled the men that bought them . . . to think they had something funny-looking to put their whiskey in. Others bought them for . . . home decorations. . . . My mama, Bertha Pender Averett, made the faces on the jugs. The teeth and eyes were made out of pieces of white china."

206. Figural jug, lime glaze
Jugtown, Upson/Pike Counties, Ga., 1870s
The missing arm held a pipe to the mouth. Figural jugs were later made by W. T. B. Gordy, who trained with the Bishops, and by his son, D. X. Gordy.

207. Churn, salt glaze with Albany slip inside and on lid
208. Pitcher, salt glaze with Albany slip inside
209. Lidded butter pot, salt glaze with Albany slip inside
All Jugtown, Upson/Pike Counties, Ga., 1880s
Salt glazing for stoneware seems to have been introduced to Georgia relatively late. The cylindrical butter-pot form harks back to 1600s England.

210. Buggy jug, Albany-slip glaze, combed decoration
WILLIAM THOMAS BELAH GORDY
Alvaton, Meriwether County, Ga., 1920s
With its low center of gravity, the squat form was designed to prevent tipping over when placed on the floor of a buggy. A jug this large (marked two and one-half gallons) may have been made as a hot-water foot warmer. The maker was trained at Jugtown but settled in nearby Meriwether County—first at Alvaton, then Primrose.

211. Ring jug, Albany-slip glaze
ATTRIBUTED TO S. RUFUS ROGERS
Jugtown, Upson/Pike Counties, Ga., 1920s
This European-derived form was meant to carry water to the fields and lie flat on a projection such as the hame knob of a mule's collar, but it later became a novelty item. Ring jugs are thrown on the wheel, beginning with a clay disk. A hole is scooped out of the center, creating a solid ring. Then walls are pulled up on each side and joined to hollow the ring.

212. Ring jug, "Mountain Gold" glaze
WILLIAM JOSEPH GORDY
Cartersville, Bartow County, Ga., 1991
Bill, son of W. T. B. Gordy, left his father's Alvaton shop to be a journeyman potter in North Carolina, where he learned glaze chemistry. In 1935 he established the Georgia Art Pottery at Cartersville, creating a line of refined stonewares, the shapes of which sometimes were drawn from his folk pottery background.

213. *Confederate Soldier,* Albany-slip and Gerstley borate glaze
MARIE GOODEN ROGERS
Meansville, Pike County, Ga., 1993
Marie is the widow of Jugtown potter Horace Rogers. Her whimsical work carries on local traditions like the figural jug, wheel-thrown in two sections. Note the ring jug over one shoulder, which she had heard was used as a canteen in the Confederate army.

214–15. Drainpipes, ash glaze

POSSIBLY ASBERRY T. DAVIDSON

Atlanta, Fulton County, Ga., 1880s

Dug up from a downtown street, these hand-thrown pipes were made for urban use. The collar fragment shows how one segment was cemented to the next. Davidson was a White County potter who had moved to Atlanta by 1880; this looks like a White County glaze.

216. Pickling jar, salt glaze with Albany slip inside

MARKED "KLINE & BROWN MANUFACTURERS, ATLANTA, GA."

Atlanta, Fulton County, Ga., 1880s

The holes in the rim were for securing a lid; "4" was stamped upside down to indicate seven gallons. Charles Kline married Emma Brown at Jugtown; by 1883 they had moved to Atlanta. His partner may have been his father-in-law, potter William S. Brown.

217. Churn, salt glaze with Albany slip inside, cobalt-blue decoration

CHARLES S. KLINE

Atlanta, Fulton County, Ga., 1880s

The stylized fruit or blossom motif is one of two designs seen on Kline's work. Supposedly trained in Ohio, he brought to Georgia a northern approach to stoneware.

218. Jug, salt glaze with Albany slip inside

EDWARD C. OR BOWLING P. BROWN (MARK PARTIALLY OBSCURED)

Atlanta, Fulton County, Ga., 1880–1900

The many brick drips on this three-gallon jug suggest advanced deterioration of the kiln. Notice the handle attachment at the mouth, typical of Jugtown and Atlanta jugs. Ed was a grandson of pioneer potter Bowling Brown, and son of Bowling's potter son, Bowling P.

219. Whiskey jug, salt glaze with Albany slip inside, cobalt-blue stenciling

Atlanta, Fulton County, Ga., ca. 1890

Rufus M. Rose had a store downtown and a distillery at Vinings. Several local potters made jugs for his firm, which moved to Chattanooga, Tennessee, with Georgia's 1907 pro-

hibition and later became Four Roses. The cylindrical jug type with a stacking ledge around the shoulder was developed in the late 1800s.

220. Whiskey jug, salt glaze with Albany slip inside

ATTRIBUTED TO THE BROWN FAMILY

Atlanta, Fulton County, Ga., 1880s

This quart jug in the "bon bon" shape typical of Atlanta was dug from a local trash dump where it had been discarded— perhaps from a tavern—as we might throw away a plastic milk jug today.

221. Pitcher, Albany-slip glaze

THOMAS W. COFIELD

Atlanta, Fulton County, Ga., ca. 1900

The maker was the son of potter Thomas B. Cofield, who had married Bowling Brown's daughter back in Jugtown before moving to Atlanta.

222. Whiskey jug, Albany-slip glaze

WILLIAM WASHINGTON ROLADER SHOP

Atlanta, Fulton County, Ga., ca. 1900

After marrying potter Thomas B. Cofield's daughter at Howell's Mills, Rolader moved to nearby Moores Mill Road, where he built a log cabin and shop. Cofields and Browns worked at the shop, which operated into the 1920s.

223. Ring bottle, secret-formula glaze

E. JAVAN BROWN, AT EVAN'S POTTERY

Skyland, Buncombe County, N.C., 1975

In 1924 Javan and his brother Davis, sons of Atlanta potter James O. Brown, established the Brown Pottery at Arden, North Carolina. Toward the end of his career Javan worked at the shop of his son, Evan, in nearby Skyland. He called this an "old-time" ring jug, unglazed and porous on one side so evaporation would keep the water cool.

224. Storage jar, alkaline glaze

ATTRIBUTED TO GEORGE D. FERGUSON

Barrow County, Ga., 1860s

The circular mark on this jar is similar to one on a dated 1868 syrup jug signed by George, grandson of Charles H. Ferguson, whose Edgefield training resonates in this jar's form and glaze.

225. Churn, salt glaze over Albany slip
226. Milk pan, salt glaze over Albany slip
227. Lidded "kraut jar," salt glaze over Albany slip
All Barrow County, Ga., 1880s
As trade resumed with the North after the Civil War and Albany slip became available by rail, Barrow County potters began to combine it with salt glaze for a distinctive double coating. The Pennsylvania German–influenced southern upland tradition of making sauerkraut prompted north Georgia potters to produce large cylindrical jars for the purpose.

228. Pitcher, salt glaze over Albany slip
WILLIAM R. ADDINGTON
Gillsville, Jackson County, Ga., 1880s
Trained in Barrow County, Addington relocated to northern Jackson County near Gillsville, using the closest post office in his county, Maysville, on his stamp. He was the first Barrow County potter to move to Gillsville.

229. Face jug, Albany slip highlighting hair and eyes
ATTRIBUTED TO CHARLES P. FERGUSON
Gillsville, Jackson County, Ga., ca. 1900
Having married Eli Hewell's potter daughter Catherine, Charlie (grandson of Charles H. Ferguson) came with the Hewells from Barrow County. He first worked at the Addington shop (then owned by James Henderson), where this piece was made (attribution based on a marked and dated example by the same hand).

230. Whiskey jug, Albany-slip glaze
SAMUEL RAYBURN "RAY" HOLCOMB
Gillsville, Hall County, Ga., ca. 1930
Ray was the grandson of John Robert Holcomb, who came with his brother J. Cicero to Gillsville from White County in the 1880s.

231. Jar, Albany-slip glaze
HENRY H. HEWELL
Winder, Barrow County, Ga., 1920s
Henry, son of Nathaniel Hewell, stayed in Barrow County after others of his family migrated to Gillsville in the 1890s.

232. Pitcher, Albany-slip glaze
JOHN F. HEWELL
Gillsville, Hall County, Ga., 1920s
John was a son of Eli Hewell, who had led the twenty-mile migration from Barrow County.

233. Miniature "monkey," or water, jug, Albany-slip glaze
WILLIAM JEFFERSON HEWELL, AT THE SHOP OF "DADDY BILL" DORSEY
Mossy Creek, White County, Ga., ca. 1910
Another son of Eli Hewell, Will spent much of his time working for potters farther north at Mossy Creek.

234. Poultry fountain, Albany-slip glaze
ATTRIBUTED TO MARYLAND HEWELL
Gillsville, Hall County, Ga., 1920s
Maryland was yet another son of Eli Hewell. The vacuum created in this cleverly designed form allowed the water inside to refill the mouth without overflowing. Such fountains served the area's developing poultry industry.

235. Strawberry pot
HAROLD HEWELL
Gillsville, Hall County, Ga., 1992
Harold, son of Maryland Hewell, is the oldest of the three generations now working together at Gillsville. This pot is typical of the large garden wares that are his specialty.

236. Birdhouse
GRACE NELL WILSON HEWELL
Gillsville, Hall County, Ga., 1984
Grace is the wife of Harold Hewell and one of the few women in Georgia's long history of folk pottery.

237. *Big John* face jug, ash glaze
CHESTER HEWELL
Gillsville, Hall County, Ga., 1990
Chester, son of Harold and Grace and manager of Hewell's Pottery, challenged himself to make some of the largest and smallest face jugs. He adopted melted-glass decoration after visiting North Carolina folk potter Burlon Craig, who had revived the Catawba Valley technique.

238. Face jug, ash glaze

MATTHEW HEWELL

Gillsville, Hall County, Ga., 1986

This is one of a group of small face jugs made by Matthew, elder son of Chester Hewell, at age fourteen as he was saving for his first pickup truck. Now married with a son, Eli, he began potting when three and was making salable wares by the age of five.

239. Face jug, ash glaze

NATHANIEL HEWELL

Gillsville, Hall County, Ga., 1992

Nathaniel, Chester Hewell's younger son, made this piece at the age of fifteen. He and his brother, Matthew, now work full-time at Hewell's Pottery.

240. Face jug, ash glaze

HAROLD HEWELL

Gillsville, Hall County, Ga., 1993

Although Harold's father, Maryland Hewell, is thought to have made face jugs, Harold did not learn to make them from him but had to consult his grandson, Matthew, for instruction! This is one of the few he has made.

241. *Lady Di* face jug, ash glaze

GRACE HEWELL

Gillsville, Hall County, Ga., 1997

Feminine in its features, this is number 126 in a limited edition commemorating England's "Lady Di" and inspired by events of her death. The inscription on the back wall reads, "Diana / Princess of Wales / 'Queen of Hearts' / Loved by the World / 1961–1997."

242. Pitcher, "glass" glaze with cobalt-blue band

MATTHEW HEWELL

Gillsville, Hall County, Ga., 1994

This smooth version of ash glaze with powdered glass was used by Maryland Hewell in the 1930s and has been revived by Matthew's father, Chester Hewell.

243. Syrup jug, ash glaze

ATTRIBUTED TO THE DAVIDSON FAMILY

Mossy Creek, White County, Ga., ca. 1850

Virginia-born Frederick Davidson migrated through the Carolinas and was at Mossy Creek by 1820; four of his sons became potters. Melted-glass decoration is rare outside North Carolina but is found on a few Mossy Creek examples, pointing to the North Carolina background of these potters.

244. Storage jar, ash glaze

ISAAC HENRY CRAVEN

Mossy Creek, White County, Ga., 1870s–1880s

Potter John V. Craven came from Randolph County, North Carolina, to Mossy Creek in 1825. His son, Isaac, used the local ash glaze. Isaac's North Carolina background can be seen in the flattened jar rim, on which he scratched the gallon capacity in Roman numerals (in addition to the Arabic number under each handle).

245. Syrup jug, "iron sand" glaze

ISAAC H. CRAVEN

Mossy Creek, White County, Ga., 1870s–1880s

Isaac was known for a version of ash glaze that substituted iron-bearing sand for the usual white sand. It could color the glaze black, dark brown, or blood red.

246. Whiskey jug, "iron sand" glaze

ISAAC H. CRAVEN

Mossy Creek, White County, Ga., 1870s–1880s

Isaac's jugs are distinguished by an incised mouth collar and upper handle embracing the neck.

247. Canning jar, "iron sand" glaze

ISAAC H. CRAVEN

Mossy Creek, White County, Ga., 1870s–1880s

The bursts of color in the dark glaze probably result from rutile (titanium dioxide) in the clay.

248. Syrup jug, ash glaze

JOSEPH TARPLEY "TARP" DORSEY

Mossy Creek, White County, Ga., 1880s

Tarp's jugs have a weak ring collar at the mouth. His father, potter David Dorsey, migrated from North Carolina through upper South Carolina and was at Mossy Creek by 1840.

249. Crock, lime glaze

TARP DORSEY

Mossy Creek, White County, Ga., 1880s

This jar with a single loop handle may have been intended as a "lap," or small, churn.

250. Pitcher, "flint" glaze

TARP DORSEY

Mossy Creek, White County, Ga., 1880s

The Dorseys were noted for this tough, glassy subtype of lime glaze that substituted burned and crushed quartz rock for sand.

251. Churn, ash glaze

WILEY CHRISTOPHER MEADERS

Mossy Creek, White County, Ga., early 1900s

The wares of Wiley, eldest son of Meaders Pottery founder John Meaders, have uniformly thin walls and appear almost black with his usual dark clay showing through the semi-transparent glaze.

252. Cream riser, lime glaze

ATTRIBUTED TO CHEEVER MEADERS

Mossy Creek, White County, Ga., 1920s–1930s

This squatty pitcher-type milk pan was a specialty of later Mossy Creek potters. The loop handle on this example is applied at an angle, a feature typical of Cheever, who took over the Meaders Pottery in 1920 as the youngest son of founder John Meaders.

253. Whiskey jug, "flint" glaze

CHEEVER MEADERS

Mossy Creek, White County, Ga., 1950s

This was Cheever's water jug when working in the pottery shop, which had no running water.

254. Piggy bank, "spar," or Bristol, glaze, oxide paints

ARIE WALDROP MEADERS

Mossy Creek, White County, Ga., 1960s

The piggy bank, based on the jug form when thrown on the wheel, is an older tradition, but Arie, Cheever's wife, also created a unique line of pottery birds and animals.

255. Syrup jug, ash glaze

LANIER MEADERS

Mossy Creek, White County, Ga., 1982

In his functional wares Lanier, son of Cheever and Arie, closely followed local tradition, including the elongated syrup-jug form typical of Mossy Creek since the 1840s. By the 1980s, however, Lanier was making mostly ornamental wares such as face jugs.

256. Jug, Albany-slip glaze

CLEATER J. MEADERS

Cleveland, White County, Ga., 1920s

Known for the symmetry of his wares, Cleater used accenting lines around the shoulder to indicate gallon capacity.

257–60. Miniature jug, bowl, pitcher, and crock, glazed fully or just inside with Albany slip

CLEATER J. MEADERS'S CHILDREN

Cleveland, White County, Ga., early 1930s

A photo in Allen Eaton's *Handicrafts of the Southern Highlands* shows four of Cleater's children firing their own miniature kiln. According to one of them, Frank Bell Meaders, they were "trying to follow their daddy," selling their work to tourists passing through Cleveland.

261. "Flower jug," ash glaze
CLEATER "C. J." AND BILLIE MEADERS
Warner Robins, Houston County, and Cleveland, White County, Ga., 1988
The quintal or multinecked vase for cut flowers, made in north Georgia and North Carolina's Catawba Valley, harks back to England and came to Europe from Persia along with the tulip.

262. Face jug, lime glaze
LANIER MEADERS
Mossy Creek, White County, Ga., 1967
Made for the Smithsonian Institution's first Festival of American Folklife in Washington, D.C., this order marked the beginning of Lanier's pottery career at the age of fifty. The features, stuck without blending on the jug wall, tended to crack when fired.

263. Face jug, lime glaze
LANIER MEADERS
Mossy Creek, White County, Ga., 1968
This experiment, in which Lanier caved in the jug wall to create sunken cheeks and humanize the face, initiated a more sculptural approach; Lanier was becoming a creative artist in his inherited tradition.

264. Jack-o'-lantern devil jug, ash glaze
LANIER MEADERS
Mossy Creek, White County, Ga., 1971
Lanier made only a few of these special jack-o'-lanterns, with white clay melted from the eye sockets. He explained the devil inspiration this way: "That's the way I was feeling that day!"

265. Two-faced candelabra jug, ash and lime glaze
LANIER MEADERS
Mossy Creek, White County, Ga., 1978
In response to a folk-art dealer's request, Lanier began making two-faced jugs, which he came to call "politician" jugs after watching the televised Watergate hearings. Some later examples have hornlike candle holders.

266. Wig stand, ash glaze
LANIER MEADERS
Mossy Creek, White County, Ga., 1974
Inspired by local teenagers who dressed up his face jugs with wigs and hats, Lanier made a small number of these wheel-thrown heads, one of which he enjoyed at home topped with an orange wig.

267. Snake-and-grape vase, lime glaze
LANIER MEADERS
Mossy Creek, White County, Ga., 1977
Even with such elaborate pieces Lanier did not think of himself as an artist. "When you see me putting snakes on," he said, "you know I'm getting tired. It's an excuse to slow down and not make so much pottery." The Meaders family began making Oriental-shaped vases about 1930 in response to a tourist market. The grape motif was developed by Lanier's mother, Arie; his own contribution is the snake, inspired by real ones around the shop.

268. Fish bottle, earthenware, copper oxide–tinted lead glaze
ATTRIBUTED TO JOHN FREDERICK HOLLAND
Salem, Forsyth County, N.C., 1820s
Spirits flasks in the shapes of fish, squirrels, bears, crayfish, and turtles were made by North Carolina's Moravian potters using plaster molds.

269. Lidded sugar jar, earthenware, mock lead (Gerstley borate) glaze, polychrome slip trailing
DAVID FARRELL
Seagrove, Moore County, N.C., 1993
This is a reproduction of a late 1700s Moravian piece by Rudolf Christ of Salem. David and his wife, Mary Livingston Farrell, apprenticed at the Jugtown Pottery in the 1970s before opening Westmoore Pottery, where they specialize in interpretations of historic American and European wares.

270. "Dirt dish," or pie plate, earthenware, lead glaze

Randolph, Moore, or Chatham County, N.C., mid-1800s

Even after the adoption of stoneware, Seagrove-area potters continued to make such dishes because porous earthenware resists thermal shock when used for baking. The bottom of this example is fire-blackened from cooking.

271. Whiskey jug, salt glaze

NICHOLAS FOX

Chatham County, N.C., 1840s

As in Germany, Seagrove-area potters dumped the glazing salt directly onto their stonewares through holes in the arched ceiling of their groundhog kilns (rather than through the firebox), accounting for the freckled deposit seen here. The Foxes are known for superbly thrown forms sometimes enhanced by combed bands of circumferal lines.

272. Syrup jug, salt glaze

JACOB DORRIS CRAVEN

Moore County, N.C., 1870s

The Cravens were among the oldest and most prominent pottery families in the Seagrove area. Their patriarch, Peter Craven, is said to have been an English potter who migrated to central North Carolina about 1760. Descendants potted in Georgia, Tennessee, and Missouri as well as North Carolina.

273. Cream pot, salt glaze

Randolph, Moore, or Chatham County, N.C., ca. 1900

This characteristic North Carolina hat shape also was made by Catawba Valley potters in alkaline-glazed stoneware and may derive from a similar Moravian or Welsh earthenware form.

274. Syrup jug, ash glaze, melted-glass decoration

ATTRIBUTED TO THE HEAVNER FAMILY

Catawba County, N.C., 1870s

North Carolina potters used the simple yet effective decorative technique of placing broken bottle glass on handles and rims before firing, which melted in runs that contrast with the glaze.

275. Double monkey jug, ash glaze

ATTRIBUTED TO FLOYD PROPST

Henry, Lincoln County, N.C., 1930s

A type of water jug common to Mediterranean Europe and Africa, the monkey jug has a stirrup handle and canted spout. The double type, with one compartment for whiskey and the other for a water "chaser," was a later Catawba Valley tourist specialty, as the "North Carolina" stamp on the bottom of this example suggests.

276. Lidded pitcher, swirl ware, "glass" glaze

ATTRIBUTED TO ENOCH REINHARDT

Henry, Lincoln County, N.C., 1930s

The Reinhardts combined light and dark clays for an agate ware attractive to tourists. A smoother version of ash glaze, with glass crushed in water-powered hammer mills, was then in use. The blue coloring, often seen on Catawba Valley stonewares, is from rutile (titanium dioxide) in the clay crystallizing in a reduction kiln atmosphere.

277. "Churn-jar," glass glaze

BURLON B. CRAIG

Vale, Lincoln County, N.C., 1977

North Carolina's last old-fashioned folk potter and 1984 National Heritage Fellow, Burl Craig acquired the Catawba Valley stoneware tradition from neighbor potters before buying Harvey Reinhardt's shop and kiln in 1945. His "discovery" by collectors in the 1970s prompted him to revive older local forms and techniques, such as swirl ware and melted-glass decoration.

278. Storage jar, ash glaze colored with iron-bearing mineral

ATTRIBUTED TO AZZEL W. DAVIDSON

(MARKED "A.W.D.")

Sand Mountain, DeKalb County, Ala., ca. 1860

Brothers Azzel and Abraham Davidson were trained as potters at Mossy Creek in White County, Georgia, and migrated to northern Alabama in the 1850s. Azzel died in the Civil War.

279. Syrup jug, lime glaze, tooled decoration
ATTRIBUTED TO ARCHIBALD MCPHERSON
Sand Mountain, DeKalb County, Ala., 1870s–1880s
The McPherson, Henry, and Belcher pottery families inter-married in Randolph County and moved to DeKalb County by 1870. Wavy or straight lines were combed in the clay while still on the wheel.

280. Home-brew crock, two-tone lime glaze, tooled decoration
ATTRIBUTED TO ARCHIBALD MCPHERSON
Sand Mountain, DeKalb County, Ala., 1870s–1880s
Such two-tone wares are among Alabama's most distinctive. An iron-bearing mineral was added to the glaze for the dark portion. A lid fit into the water-filled well surrounding the mouth of this specialized form, creating an airtight seal that allowed bubbling gases from fermenting wine or malt liquor to escape.

281. Churn, alkaline glaze
Randolph County, Ala., ca. 1900
The second loop handle near the bottom to facilitate emptying is characteristic of Alabama churns.

282. Storage jar, salt glaze with alkaline glaze inside
ATTRIBUTED TO THE BOGGS FAMILY
Randolph County, Ala., 1880s–1890s
This piece displays an unusual glaze combination used by some Alabama potters.

283. Whiskey jug, salt glaze over Albany slip
Randolph County, Ala., 1890s–1920s
The continuous or "bombshell" slope from neck to shoulder is typical of later Alabama jugs.

284. Piggy bank, Albany-slip glaze
NORMAN "JUG" SMITH
Lawley, Bibb County, Ala., 1973
One of the last old-fashioned folk potters in Alabama, Smith worked in a log shop he built himself.

285. Pie plate, Bristol glaze with cobalt-blue marbling
JERRY AND SANDRA BROWN
Hamilton, Marion County, Ala., 1996
Jerry, 1993 National Heritage Fellow and son of Atlanta-trained Horace Brown, runs an old-fashioned shop with mule-powered clay mill in the northwestern part of the state. His wife, Sandra, normally does the decorative work on such pieces.

286. Miniature chair-making operation
CARL L. STEPP
McCaysville, Fannin County, Ga., 1970
A chopping ax, wood-splitting maul with iron wedge, grindstone, shaving horse, drawknife, mallet, and finished mule-ear chair are represented.

287. Hatchet, hand-forged iron blade
ATTRIBUTED TO JOHN LANDON PICKELSIMER
Morganton, Fannin County, Ga., mid-/late 1800s
Handmade Georgia ax blades are rare; this example is even more unusual in that, like European axes, it lacks a poll or weighted back end.

288. Clawhammer, hand-forged iron head
Wilson County, Tenn., 1850s
This basic carpentry tool was owned by James Steed.

289. Auger
Georgia, mid-1800s
Made in a range of diameters, an auger is a hole-boring tool, more easily made but less efficient to use than such drills as a brace and bit. The clinched rat-tail end securing the shank to the handle of this example is a sign of handcrafting.

290. Frame saw
Union County, Ga., mid-1800s
Such a saw was used to cut curves, such as the top of chair slats or the felloes (rim segments) of wagon wheels.

291. Plane
Fry, Fannin County, Ga., late 1800s
This small wood-shaving tool with chip-carved decoration was owned by gunsmith George Lanning.

292–94. Drawknives, hand-forged iron
(SMALL) CALVIN PIERCE
Murrayville, Hall County, Ga., 1870s
(medium) Trenton, Dade County, Ga., 1800s
(large) Cleveland, White County, Ga., 1800s
Woodworkers pull this tool toward them to shape and shave wood clamped to a shaving horse, or viselike bench. The two smaller examples were recycled from old files.

295–96. Squares
(wood blade) Washington County, Ga., early 1800s
(iron blade) Fry, Fannin County, Ga., late 1800s
This basic carpenter's tool is used to mark a right-angled straight line.

297–98. Compasses
(light) Fry, Fannin County, Ga., late 1800s
(dark) Union County, Ga., 1800s
Combined with the square as an emblem of Freemasonry, the compass is used to mark an arc or circle. The light-colored example was owned by gunsmith George Lanning.

299. Scratch gauge
Union County, Ga., late 1800s
With its adjustable stop, this gauge could produce ornamental scratch beading on cabinetry.

300. Chair maker's gauge, hardwood
LON REID
Choestoe, Union County, Ga., 1950s
This gauge was used for marking the locations of holes to be cut in the posts for the rungs and slats of a child's chair.

301. Chair maker's gauge, hardwood
LON REID
Choestoe, Union County, Ga., 1960s
This rarer kind of gauge was for measuring the diameter and length of rung ends before they were driven into holes bored in chair posts. The small hole was for "toy" (miniature) chairs.

302. Slat-back chair
Blairsville, Union County, Ga., mid-1800s
The straight rear posts with finials are an early style that sometimes continued to be made into the twentieth century.

303. Mule-ear chair
NATHANIEL PHILLIPS
Wolf Creek, Rabun County, Ga., 1880s
This chair was made for weaver and seamstress Mahalia Mosley Williams. The bark seat is about two inches higher than normal to facilitate work at her sewing machine, said to be the first in Rabun County.

304. Mule-ear chair frame, maple and oak
JASON REID
Choestoe, Union County, Ga., 1920s
The posts of this example were turned on Jason's great-wheel lathe. His seat rungs widen to support the sitter and show the impression of the split-oak "bottom" once woven around them. About an inch has been worn off the feet from use.

305. Mule-ear chair, ash and oak
JASON REID
Choestoe, Union County, Ga., ca. 1935
When his great-wheel lathe "tore up," this master chair maker shaped octagonal posts with a drawknife, maintaining his delicate two-slat design for a "settin'," or side, chair.

306. Mule-ear chair, ash, oak, and maple

LON REID

Choestoe, Union County, Ga., 1969

Lon shaped all his chair parts with a drawknife on a shaving horse. While sturdy, his chairs lack the gracefulness of those made by his father, Jason.

307. Mule-ear chair, white oak

SAMMY BEAVERS

Cumming, Forsyth County, Ga., 1938

Beavers made this chair for his sister, who painted it. Lacking a lathe, he carefully rounded his posts with a drawknife and smoothed them with sandpaper.

308. Square-posted slat-back chair

JOE NELMS

Kinseytown, White County, Ga., ca. 1920

This was Nelms's first chair, roughed out with an ax and finished with a pocketknife. Shaping the posts square was his solution to not having a lathe. He later built a pole lathe, using it until his death in 1967.

309. Pole, or boom-and-treadle, lathe

WALTER SHELNUT

White Creek, White County, Ga., 1971

Walter made this lathe—much like the one he used—for the Burrison Folklife Collection. A chisel, supported on the rest, shaped a chair post (which turned a full revolution between the iron points of the two heads) with each downstroke of the foot treadle. A pine sapling provided the spring power. It took Walter about five minutes to turn a post.

310. Chisel, hand-forged iron blade

WALTER SHELNUT

White Creek, White County, Ga., 1971

Walter used such chisels for turning his chair posts. He made this one in his log blacksmith shop to accompany the folklife collection lathe.

311. Shaving horse

WALTER SHELNUT

White Creek, White County, Ga., 1930s

Water used this shaving horse until his death. It is an ancient European type of tool (*Schnitzelbank* in German) used to smooth seat splints, rough out posts before turning, and shape other chair parts. When the pedal is pushed, the head locks the wood against the bench, leaving the hands free to pull a drawknife.

312. Glut, dogwood

WALTER SHELNUT

White Creek, White County, Ga., 1960s

Walter used this wedge with a two-handed maul to split timber.

313. Mallet, sourwood head and oak handle

WALTER SHELNUT

White Creek, White County, Ga., 1977

Walter made this chair-assembly tool for the folklife collection.

314. Mule-ear chair, ash and oak

WALTER SHELNUT

White Creek, White County, Ga., 1970

Laying a notched-stick gauge along a turned post while still in the lathe, Walter marked rings with a pencil where holes were to be cut for rungs and slats. The rear posts were curved by soaking in hot water and wedging in a frame until they dried. Both he and his father, Jack, used nails rather than pegs to secure the posts to the top slat. They used no glue; southern folk chairs were assembled with seasoned rungs and green posts so the joints would shrink tight. Walter charged six dollars for this chair.

315. Toy chair, maple and oak

WALTER SHELNUT

White Creek, White County, Ga., 1975

Walter made such miniatures for neighbor children.

316. Rolling pin, poplar

WALTER SHELNUT

White Creek, White County, Ga., 1974

Walter turned this on his pole lathe. Poplar is easy to work and imparts no taste to food with which it comes in contact.

317. Huntboard, yellow pine, original paint

Elbert County, Ga., early 1800s

In nineteenth-century Georgia, such tall-legged sideboards were called "slabs." This example was owned by the Dillishaw family.

318–25. Ant traps, ash glaze

CLEATER "C. J." AND BILLIE MEADERS

Warner Robins, Houston County, and Cleveland, White County, Ga., 1997

The feet of the huntboard and pie safe are fitted with old-style pottery traps that would have had water or kerosene in the outer wells to protect against vermin.

326–34. Corner cupboard, yellow pine

ATTRIBUTED TO JOHN MILTON MEADERS

Mossy Creek, White County, Ga., late 1800s

The founder of the Meaders Pottery also was a carpenter and blacksmith; this piece was found in the old family home. It is filled with old and recent White County stoneware, some by the Meaders family.

———————

335. Tavern table, yellow pine, old paint

Elbert County, Ga., late 1700s

336–38. Set of chairs, cowhide bottoms

Alabama, late 1800s

339–42. Tablewares, lead-glazed earthenware

BEN OWEN, JUGTOWN POTTERY

Seagrove, Moore County, N.C., 1950s

The stretcher base of the table is an early feature.

343. Dough tray, poplar

Washington County, Ga., 1850s

This biscuit-making implement was used on the plantation of Henry Sills Taylor.

344–47. Pie safe, yellow pine, original paint (with old Georgia folk pottery added)

Laurens County, Ga., 1850s

Food safes for keeping leftovers and cooling pies have decorative pierced-tin panels to admit air but not flies.

———————

348. Bed, yellow pine, original paint

Lula, Hall County, Ga., mid-1800s

349. Pieced quilt, "Wild Geese" design

Lula, Hall County, Ga., ca. 1900

350. Chamberpot, "glass" glaze

BURLON CRAIG

Vale, Lincoln County, N.C., ca. 1980

This "corded" bedstead with elaborately turned posts was used by an African American family. A rope network holds the mortise-and-tenon-jointed frame together and supported a mattress. The family that used the bed made the quilt to fit it. A chamberpot—the original indoor toilet— often was kept under a bed for night use.

———————

351. Light stand, yellow pine, original paint

Warren County, Ga., 1840s

352. Candlestick, lime glaze

JOHN MEADERS (A BROTHER OF LANIER)

Mossy Creek, White County, Ga., 1983

The tall-legged table, grain-painted to resemble bird's-eye maple, was used at the Lockhart-Roberts-McGregor house in Warrenton.

———————

353. Washstand, yellow pine, original paint

Greene County, Ga., 1840s

354–55. Bowl-and-pitcher set, ash glaze
LANIER MEADERS
Mossy Creek, White County, Ga., 1969

356–57. Rugs, braided wool and cotton
MRS. JOHN ALTICE
Commerce, Jackson County, Ga., 1950s

358. Rocking chair, cherry posts and arms, original paint
Bibb County, Ga., mid-1800s
The yellow-pine rockers are old but later additions. Cowhide seats are typical of middle and south Georgia, where herds of cattle were raised for market.

359. Child's chair
Washington County, Ga., 1850s

360. Black-stocking doll
VIOLA JOHNSON
Hog Hammock, Sapelo Island, McIntosh County, Ga., ca. 1990
This little chair was made for Claudia Augusta Taylor Irwin on the plantation of Henry Sills Taylor.

361. Sampler, silk thread on linen
ELIZABETH ALSTON
Lamar's School House, Bibb County, Ga., 1833
Provenanced Georgia samplers are uncommon.

362. Blanket chest, sweet-gum primary wood
Eastern Piedmont Georgia, late 1700s
The large, exposed dovetails are an early construction feature.

363. Walking stick, walnut, carving of a woman
Georgia, early 1900s
This stick was owned by Neil Holiway of Millen, Jenkins County, in east-central Georgia, but a published example probably by the same hand is attributed to the Georgia coast.

364. Staff, carving of a snake, alligators, and what appear to be a lynching scene and "shotgun" house
Georgia, early 1900s
This stick was found in an antiques shop in Douglas County, but its background is unknown.

365. Walking stick, mahogany, carving of a man's head and alligators
ARTHUR "PETE" DILBERT
Savannah, Chatham County, Ga., 1980s
Dilbert learned to carve simple toys and net needles from "older fellas" in the river fishing community of Pin Point. He began carving walking sticks in the 1960s while a longshoreman. His alligator motif relates to the saying "Don't let the 'gator beat you to the pond," referring to the competition among work crews loading cargo in a ship's hold.

366. Cane, carving of a man's head
HARMON YOUNG
Forest Park, Clayton County, Ga., ca. 1972
Young said of his work, "I'm more interested in walkin' sticks than I is anything else, and faces. . . . I been buildin' men ever since I was little. That's the only thing I wanted to do. I'd take and whittle out a little ol' man with my knife."

367. Wagon and steer, boxwood
GEORGE PATTON
Gainesville, Hall County, Ga., 1968
Whittled by Patton as a gift for his brother, the subject is stylized, with spokes painted on the solid wheels and with the steer too small and the driver too large for the wagon.

368. Covered wagon and ox team
CARL L. STEPP
McCaysville, Fannin County, Ga., 1931
A machinist who built and repaired equipment for copper mines in his section of the mountains, Stepp took a naturalistic approach to the subject. With all its detail, it took seventy-two hours to complete.

369. Work basket, rivercane, plant dye
North Georgia, 1800s
This Native American basket was found in Bartow County (part of original Cherokee County), Georgia, and could predate the 1838 Cherokee Removal to Oklahoma on the Trail of Tears.

370. Storage basket, rivercane, red dye
Robbinsville, Graham County, N.C., ca. 1905
Such Native American forms may have led to flat-bottomed baskets of white-oak splits now commonly made throughout the South. This example, purchased on the Snowbird Reservation, appears to be colored with synthetic dye, which Cherokee basketweavers adopted as early as the 1880s.

371. Storage basket, rivercane, butternut and bloodroot dyes
ROWENA BRADLEY
Painttown, Swain County, N.C., 1990
Bradley is one of the best-known Cherokee basket makers of the older generation. Her work illustrates the return to plant dyes encouraged by educator Gertrude Flanagan in the 1930s.

372. Basket, double-woven rivercane, bloodroot dye
LUCILLE LOSSIAH
Cherokee, Swain County, N.C., 1995

373. Wastebasket, rivercane, bloodroot and butternut dyes
LUCILLE LOSSIAH
Cherokee, Swain County, N.C., 1995

374. Shopper basket, rivercane with oak handles, bloodroot and butternut dyes
LUCILLE LOSSIAH
Cherokee, Swain County, N.C., 1994
This is a recent form created for the tourist trade.

375. Shopper basket, white-oak splits with red-maple curls, bloodroot and walnut-root dyes
LUCILLE LOSSIAH
Cherokee, Swain County, N.C., 1994

376. Beginning of a rib basket, white oak
NELDA JOAN TODD
Woodbury, Cannon County, Tenn., 1994
Of European origin, rib or bow baskets begin as a foundation and handle hoop attached at a right angle to a rim hoop. Thin splits are then woven around curved ribs of varying lengths to create a "granny's fanny" shape.

377. Rib basket, white oak
North Georgia, mid-/late 1800s
The rib basket's shape is suited for gathering and carrying eggs; the two pockets inside keep the eggs from rolling and breaking.

378. Footed "gizzard" rib basket, white oak
Gilmer County, Ga., late 1800s
The Appalachian maker of this example probably borrowed the decorative technique of dyed stripes from the Cherokee tradition.

379. "Melon" basket, white oak
TOBE WELLS
Elberton, Elbert County, Ga., 1984
Wells is an African American woodworker who operates a sawmill. His bow basket has a fully rounded bottom. He colored the splits for the blue-gray striped pattern by soaking them three days in a pond.

380. Bow basket, white oak
HULON WALDRIP
Lawrenceville, Gwinnett County, Ga., 1979
Waldrip is one of the few recent Georgia basket makers to produce this more complex type of white-oak basket.

381–83. Nest of miniature rib baskets, white oak
GEORGE MCCOLLUM
Athens, McMinn County, Tenn., 1994
McCollum studied with Ken and Kathleen Dalton of Coker Creek, Tennessee, as part of a basket-making revival. He began specializing in miniatures when challenged to make tiny baskets for dollhouses and as a response to dwindling timber supply.

384. Unfinished basket, white-oak splits
HULON WALDRIP
Lawrenceville, Gwinnett County, Ga., 1977
Flat-bottomed baskets of white-oak splits now prevalent in the South may have developed as a combination of Native American and European traditions.

385. Lidded hamper basket, white-oak splits
Georgia, 1800s
Such baskets are said to have been used to collect goose down for featherbeds.

386. Egg basket, white-oak splits
M. J. RICHARDSON
Acworth, Cobb County, Ga., 1956
The maker's wife slapped red paint on the handle and rim to keep him from selling it, but after fourteen years of use she sold it herself.

387. Egg basket, white-oak splits
FELT DUNCAN
Holly Springs, Cherokee County, Ga., 1972
Nails became so cheap that Duncan could use them to secure his rims, instead of double-lacing the rims as his father had done.

388. Easter basket, white-oak splits
LaGrange, Troup County, Ga., mid-1960s
The ornamented handle gives this basket, attributed to a blind African American maker, an especially tactile quality.

389. Cotton or hamper basket, white-oak splits
JOHN REEVES JR.
Greenville, Meriwether County, Ga., 1992

390. Handled basket, white-oak splits, blue Rit dye
JOHN REEVES SR.
Greenville, Meriwether County, Ga., 1992

391. Handled basket, white-oak splits
LOUISE REEVES BROWN
Greenville, Meriwether County, Ga., 1993

392. "Itty bitty" handled basket, white-oak splits
CATHERINE REEVES JOHNSON
Greenville, Meriwether County, Ga., 1993

393. Handled basket, white-oak splits, red Rit dye
MARY REEVES FINCH
Greenville, Meriwether County, Ga., 1993

394. Roll basket, honeysuckle vines
FLORA DYSART
Rydal, Bartow County, Ga., 1956
The refined work of sisters Flora and Lena Dysart (whose photograph by Doris Ulmann appears in Allen Eaton's *Handicrafts of the Southern Highlands*) is derived from the European willow-basket tradition.

395. Roll basket, swamp willow
SALLY ANDERSON
Shoal Creek, White County, Ga., 1975

396. Fanner, coiled bulrush and palmetto strips
Charleston County, S.C., 1800s
Coiled fanners, or winnowing baskets, were part of the coastal African American rice-processing tradition.

397. Fanner, coiled bulrush
Savannah, Chatham County, Ga., 1800s
This example probably was painted after retired from use.

398. Fanner, coiled marsh grass and palmetto strips

ALLEN GREEN

Sapelo Island, McIntosh County, Ga., 1985

Green (who died in 1998) was one of the last Georgia basket makers to work in the coastal African American coiled-grass tradition.

399. Handled basket, coiled pine needles

REESIE WELLS

Thomson, McDuffie County, Ga., 1986

Pine needle baskets are part of a tradition stimulated by the handcraft activity of women's clubs. This example by a white maker is bound with colored raffia in a fern-stitch pattern.

400–402. Fibers of the sort used in folk textiles:

flax for linen, Lumpkin County, Ga., 1860s; wool from Hambidge Center sheep, Rabun County, Ga., 1960s; cotton grown by the Davidsons of Banks County, Ga., 1968

403. Flax heckle with cover, wood and iron

Crawfordville, Taliaferro County, Ga., mid-1800s

Flax for linen cloth is strong but complicated to prepare for the "low," or treadle, spinning wheel. After harvesting, stacking, removing the seeds, rotting in water, breaking up the stalk, and removing the husk and pith, the flax was run through the heckle's teeth to separate the long from the short fibers. This example is said to have been slave-made at Liberty Hall, the plantation of Alexander H. Stephens, vice president of the Confederacy.

404. Flax break, hardwood, chip-carved decoration

Possibly Alabama, mid-1800s

The hinged upper section was repeatedly raised and lowered as a bundle of rotted flax stalks was passed between the meshing blades. This broke up the husk and pith, which were cleaned from the silky fibers with a wooden scutching knife.

405. "Big" or "walking" wheel

Greene County, Ga., mid-1800s

This type of wheel was used for wool and cotton. One hand turned the wheel as the other fed carded (combed) fiber to the revolving iron spindle, which twisted it into thread. Looms were abandoned as factory-made cloth became readily available, but spinning wheels were kept longer to produce knitting yarn.

406. Cloth, cotton, plaid pattern

MS. SIDNEY FOWLER

Blount County, Ala., 1870s

This bolt of homespun, eight yards long, was stored away just as it came from the loom, never to be used for warm-weather dresses or shirts.

407. Dress, cotton

Blairsville, Union County, Ga., ca. 1875

This blue dress was worn by Mary Catherine Watson Jones. Such surviving examples of homespun clothing are uncommon.

ALTERNATE

407A. Dress, cotton and wool

Durham County, N.C., 1850s

This brown homespun dress was made for the Williams family of Fairport Plantation.

408. Counterpane, cotton, "Saturn Stripe and Honeycomb" design

MAHALIA MOSLEY WILLIAMS

Wolf Creek, Rabun County, Ga., ca. 1890

A counterpane (pronounced "countypin" in the mountains) is an all-white bedcover with a textural pattern. The maker's sewing machine chair can be seen in "The Chair Maker's Shop" section.

409. Pillow covered with a piece of hand-woven coverlet

Washington County, Ga., 1850s

The typical southern bed coverlet has an undyed cotton warp and "tabby," or filling, and dyed woolen weft. Blocks of color built up by the overshot weft create the pattern.

This indigo-dyed coverlet was made on the plantation of Henry Sills Taylor; a family member later recycled the least-worn part for a pillow.

410. Coverlet, wool and cotton, overshot "Habersham Burr" pattern

ETHEL COLLINS

Choestoe, Union County, Ga., 1920?

This appears to be Ethel's first coverlet, woven at age sixteen. The design, a variation of "Pine Bloom," is the same one used as a backdrop in 1920 photos.

ALTERNATE

410A. Coverlet, wool and cotton, overshot "Single Chariot Wheel and Table" pattern

ETHEL COLLINS

Choestoe, Union County, Ga., 1949

The dark brown dye is walnut-based, the turquoise synthetic.

411–12. Weaving drafts (photographs)

These are manuscript instructions for setting up coverlet warp threads on the loom; as Ethel Collins Clement (who played the pump organ) noted, they look like music. The earliest, dated 1841, was used by her grandmother, Rutha Nix Collins. The second, dated 1911, was used by Ethel's sister, India.

413. Blanket, wool

ETHEL COLLINS

Choestoe, Union County, Ga., 1949

414–21. Swatches, cotton

Choestoe, Union County, Ga., early 1900s

These sample pieces were part of the Collins family's repertoire of homespun clothing fabrics.

422. Weaving shuttle, hardwood

ATTRIBUTED TO FRANCIS JASPER "BUD" COLLINS

Choestoe, Union County, Ga., early 1900s

This boat-shaped shuttle was used by Ethel Collins and her sisters. Their father, Bud, built the family loom with help from a master-carpenter cousin.

423–24. Cards, wood and steel

L. S. WATSON AND CO.

Leicester, Worcester County, Mass., ca. 1900

These factory-made implements were used by the Collins family to align fibers for spinning.

425–27. Suit, wool "jeans," or sturdy twill weave, walnut dye

AVERY AND ETHEL COLLINS

Choestoe, Union County, Ga., ca. 1935

Surprisingly late for homespun, this brown, three-piece winter suit was made for Francis "Bud" Collins, prosperous farmer, mill and store owner, and state legislator. At the 1993 opening of the Atlanta History Museum, Governor Zell Miller fondly recognized this suit as belonging to his great-uncle.

428. Whole-cloth quilt, cotton, all-white trapunto (finger-stuffed) floral design

Greene County, Ga., 1820s

This quilt, one of the oldest in the Atlanta Historical Society collection, was owned by James and Sarah Wilkerson Culberson.

ALTERNATE

428A. Pieced quilt, cotton, "Eight-Pointed Star" variation with strips

ESTELLA DANIEL

Emerson, Bartow County, Ga., 1920s

The star blocks of this African American quilt are arranged in vertical columns that do not line up horizontally.

429. Appliquéd quilt, cotton

PHILOCLEA EDGEWORTH CASEY EVE

Louisville, Jefferson County, Ga., 1830s

The designs for this typical early appliquéd quilt, including the floral-basket central medallion, were cut from roller-printed, glazed chintz.

429A. Appliquéd quilt, cotton

BRODERIE PERSE

Henry County, Ga., ca. 1850

The floral designs, central medallion flower basket, and zoning strips were cut from roller-printed chintz fabric.

430. Pieced and appliquéd quilt, cotton, "Cherry Tree" design

Chatsworth, Murray County, Ga., 1860s

The batting of this Plemons family quilt is unginned cotton, the seeds pounded flat so they would not be felt.

430A. Pieced and appliquéd quilt, cotton, "Whig's Defeat" pattern

SUSAN J. LOYD

Rome, Floyd County, Ga., 1856

Susan made this a year before her marriage to Joseph H. Lumpkin. As much care was given to the interlocking-ring stitching as to the colored pattern, which is known also as "Turkey Tracks."

431. Pieced quilt, wool and cotton, "Cross" pattern

Central North Carolina, mid-1800s

This quilt consists almost entirely of homespun clothing scraps.

431A. Pieced quilt, cotton, "Log Cabin" pattern

Southern, early 1900s

This popular American pattern type appeared about the time of the Civil War and soon was borrowed by quilters in the British Isles. It consists of squares made up of concentric strips that become increasingly shorter toward the center. The dark and light strips can be juxtaposed in one of several subpatterns, each having its own name (e.g., "Barn Raising," "Courthouse Steps").

432. Pieced crazy-quilt top, satin and velvet

MINNIE MCNORTON AND OLA MCDONALD

Homer, Banks County, Ga., 1889–1948

Minnie and her girlfriends collected the crown linings and bands from their boyfriends' used hats to begin many of the squares of this "friendship" quilt top, which is a coded social history of the town of Homer in the late Victorian era. Health problems kept Minnie from joining the squares, so she gave them to her friend Ola to finish.

432A. Pieced crazy quilt, velvet, silk, and satin

MARGARET JOSEPHINE VANDYKE INMAN

Atlanta, Fulton County, Ga., ca. 1890

Organized by a diagonal black velvet grid, the patches are decorated with embroidered flowers, fans, animals, and the initials of the maker's five children. The lace border is unusual.

433. Pieced quilt, cotton, "Circle Saw" pattern

MARY R. SHELL

Madison, Morgan County, Ga., 1930

This unique design was inspired by circular blades at the sawmill where the African American maker's husband worked. The "teeth" are made from sewing scraps; the top was dyed with red clay and salt "on a cloudy day, so the color is cloudy."

433A. Pieced quilt, cotton, "Brick Work" and strip pattern

ANNIE B. HOWARD

Madison, Morgan County, Ga., 1957

This African American quilt was made as a light cover, its thin middle layer apparently a quilt top. With its framed center and improvised strip border, Anglo-American and African American design elements are combined.

434. Pieced and appliquéd quilt, cotton, "Cotton Boll" pattern

Georgia, late 1800s

Wear of the pattern's colored material reveals that it was stitched onto the white top.

435. Appliquéd quilt, cotton, narrative design (photograph)
HARRIET POWERS
Athens, Clarke County, Ga., 1898
Harriet Powers's explanation of the squares of her second known quilt (from top, left to right):

1. Job praying for his enemies. Job's crosses. Job's coffin.

2. The dark day of May 19, 1780. The seven stars were seen 12. N. in the day. The cattle all went to bed, chickens to roost, and the trumpet was blown. The sun went off to a small spot and then to darkness. [Black Friday was the most famous of "dark days," when the air became polluted with smoke from forest fires.]

3. The serpent lifted up by Moses and women bringing their children to look upon it to be healed.

4. Adam and Eve in the garden. Eve tempted by the serpent. Adam's rib by which Eve was made. The sun and moon. God's all seeing eye and God's merciful hand.

5. John baptising Christ and the spirit of God descending and rested upon his shoulder like a dove.

6. Jonah cast over board of the ship and swallowed by a whale. Turtles.

7. God created two of every kind, male and female.

8. The falling of the stars on Nov. 13, 1833. The people were frighten and thought that the end of time had come. God's hand staid the stars. The varmints rushed out of their beds. [The Leonid meteor storm.]

9. Two of every kind of animals continued. Camels, elephants, gheraffs, lions, etc.

10. The angels of wrath and the seven vials. The blood of fornications. Seven headed beast and 10 horns which arose out of the water.

11. Cold Thursday, 10. of Feb. 1895. A woman frozen while at prayer. A woman frozen at a gateway. A man with a sack of meal frozen. Isicles formed from the breath of a mule. All blue birds killed. A man frozen at his jug of liquor. [A severe cold snap; the temperature fell to minus one degree F. in the Athens area on the morning of February 8.]

12. The red light night of 1846. A man tolling the bell to notify the people of the wonder. Women, children, and fowls frightened but God's merciful hand caused no harm to them. [Meteor shower on the night of August 11.]

13. Rich people who were taught nothing of God. Bob Johnson and Kate Bell of Virginia. They told their parents to stop the clock at one and tomorrow it would strike one and so it did. This was the signal that they had entered everlasting punishment. The independent hog which ran 500 miles from Ga. to Va. her name was Betts.

14. The creation of animals continues.

15. The crucifixion of Christ between the two thieves. The sun went into darkness. Mary and Martha weeping at his feet. The blood and water run from his right side.

Courtesy Museum of Fine Arts, Boston; bequest of Maxim Karolik.

436–38. Blacksmithing tools, hand-forged iron
JOHN LANDON PICKELSIMER
Morganton, Fannin County, Ga., ca. 1900
The long tongs held hot iron, the snips cut sheet metal, and the pincers cut bolts or pared horses' hooves.

439. Wheelwright's "traveler," hand-forged iron
White County, Ga., late 1800s
This tool measured the circumference of an iron wagon-wheel tire. The ring (recycled from an old horseshoe) was rotated around the edge of the wheel rim, and the number of revolutions—kept track of by counting how many times the notch in the ring passed the pointer extending from the handle—was reproduced on the flat tire stock.

440. Screw plate, iron
Cherry Log, Gilmer County, Ga., mid-1800s
Before factory-made screws and nails became common, blacksmiths made them by hand. This tool for cutting screw threads may have been used by a mountain gunsmith for the breech plugs that sealed the back of rifle barrels.

441. Hay-rake blade, hand-forged iron
Gilmer County, Ga., 1800s

442. Hedge shears, hand-forged iron
Murrayville, Hall County, Ga., ca. 1900
These clippers were owned by Lloyd Ellis.

443. Sheep bell, iron mixed with copper
Chatsworth, Murray County, Ga., late 1800s
This bell was used by the Plemons family.

444. Bear trap, hand-forged iron
Union County, Ga., 1800s
Bears were both a menace to farm animals and a source of meat, pelts, and grease.

445–46. Dental pliers, hand-forged iron
JOHN LANDON PICKELSIMER
Morganton, Fannin County, Ga., ca. 1900
Ancient ironworkers were thought to have healing powers. A trace of this mystic aura may surround these tools, used by a mountain blacksmith to pull his neighbors' teeth.

447. Nail grabber, hand-forged iron
Georgia, ca. 1900
This implement is said to have been used at a hardware or general store to remove nails from the barrels in which they were kept so as to save wear and tear on the hands.

448. Turntable trivet, hand-forged iron
Milledgeville, Baldwin County, Ga., early 1800s
This implement for open-hearth cooking was used at the Stetson-Nesbit-Morris house.

449–50. Andirons, hand-forged iron
Macon, Bibb County, Ga., 1860s
These "fire dogs," decorated with entwined snakes that also function as handles, were used on the Domingos estate.

451. Atlanta History Center Gate, painted wrought iron
DESIGNED BY PHILIP SIMMONS, EXECUTED BY JOSEPH "RONNIE" PRINGLE AND CARLTON SIMMONS
Charleston, Charleston County, S.C., 1996
Ronnie Pringle and Carlton Simmons are Philip's cousin and nephew, respectively. The design features the Atlanta History Center logo (taken from a floor motif in the Philip Shutze–designed Swan House) symbolizing earth, sky, and water. The snake, bird, and fish support this symbolism and are coastal motifs used individually in earlier Simmons gates. The interlocked rings and flame refer to the 1996 Centennial Olympic Games in Atlanta.

452. Lamp, copper
Georgia, ca. 1900
The brass screw fitting at the mouth probably took a factory-made wick holder with a glass chimney for burning kerosene.

453. Coffeepot, copper
Washington County, Ga., 1860s

454. Measure, tin with brass maker's plate
M. M. MADDREY
Athens, Clarke County, Ga., ca. 1880
Maddrey and partner W. A. Dale are listed as tinners in the 1881–82 *Sholes' Georgia State Gazetteer.*

455–60. Teaspoons, silver
J. BUNKLEY (MARKED ON HANDLE BACKS)
Sunbury, Liberty County, Ga., 1780s
This set was made for Mary Sharpe Jones Lowe, whose initials are engraved on the handles.

461. Boy's squirrel rifle, percussion, .38 caliber
JAMES A. GILLESPIE (MARKED "JA.G." ON SILVER BARREL INLAY)
Blairsville, Union County, Ga., ca. 1870
Gillespie rifles are distinguished by brass (rather than iron) "furniture" and a ring-shaped tang end. The forward-curving spur on the trigger guard is a Henderson County, North Carolina, feature. The following handmade tools and parts (nos. 462–95), dating from the third quarter of the nineteenth century, were used by James and most probably were made by him.

462. Rifling guide (incomplete), hardwood and iron
This tool, mounted on a bench and with a cutting rod attached to the front and a handle to the back, was twisted to cut rifling, or spiral grooves, inside barrels for accurate shooting.

463–64. Cutting ends of "freshing" rods
These were used to recut worn rifling. A lead plug was molded inside the old barrel. Into the plug was set one or two steel sawtooth cutters (their "bite" adjusted with paper shims). The other end of the rod was secured to the iron nose of the rifling guide, with the barrel held in place on another bench.

465. Adjustable cutter
Used for incising ornamental rings in the muzzles (fronts) of rifle barrels, this tool was designed to fit into the rifling guide's nose.

466. Rasp (rod broken off)
Using spring tension to fit snugly inside any barrel, this tool removed burrs from freshly cut rifling.

467. Ramrod die plate, iron
This plate was designed for sizing various diameters of wooden ramrods. The ramrod fit below a rifle's barrel and was used for loading.

468–76. Drawshaves, gouges, chisels, and knives
These were used for shaping and finishing wooden rifle stocks.

477–78. Planes
These were used to cut barrel channels along the tops of rifle forestocks. The larger example (its blade and key missing) has its lower edge shaped like an octagonal barrel.

479. Screwdriver
The hatch marks on the iron reveal that this was recycled from an old file, as were some of the other tools.

480–82. Nipple wrench (with factory-made nipple and percussion cap)
This wrench was used to replace the tubular nipple that screwed into the ignition chamber near the back of a rifle barrel. When the front trigger was pulled, the cocked hammer flew forward and struck a percussion cap placed over the nipple, sending sparks from the fulminate of mercury in the cap through the ignition chamber to ignite the black gunpowder in the back of the barrel. The explosive gases propelled the lead bullet toward its target.

483–85. Bullet molds, iron (with lead bar)
Molten lead was poured into these molds to form balls (bullets).

486–90. "Cherries," steel (with wood and iron brace)
These were used for cutting cavities in bullet molds. The drilling was done by closing the soft iron halves of the mold block over the cutting ball of the revolving cherry, the other end of which was locked into a brace.

491. Breech plug and barrel tang, iron
The plug screwed into the rear of the barrel to create a seal. The tang secured the barrel to the stock; its ring end is a Gillespie hallmark.

492. Double set trigger mechanism, iron
Before firing, the rear trigger was first squeezed, setting the front "hair" trigger to go off with just a light pressure (the screw that adjusted the weight of the pull is missing).

493–94. Butt plate and trigger guard, iron
These items of "furniture" are typical of mountain rifles—but not those of the Gillespies—in their material.

495. Butt plate, brass
Such brass "furniture" is most often found on Gillespie rifles.

496. Christmas "dough face," cloth with quill teeth
MAEBELLE WHITE
Alto, Banks County, Ga., 1975
Disguised "fantastic riders" or "sernaters" once went by horse or foot to entertain neighbors at Christmastime. This southern custom, like its British forerunner, "mumming" or "guising," helped maintain community spirit. In most areas "sernatin'" died out with the coming of cars, but it survived as late as 1950 in northeast Georgia's Rock Springs community, where White re-created this homemade mask or "dough face" as a memory from her youth.

497. Model mountain farmstead

CARL L. STEPP

McCaysville, Fannin County, Ga., 1972

This idealized miniature of Stepp's childhood home suggests the frontier self-sufficiency that continued in more isolated areas into the twentieth century. The model began as a log smokehouse but expanded to include a furnished one-room log cabin, rat-proof corncrib, outhouse, and well house.

498. *Uncle Remus, His Songs and His Sayings,* 1938 edition (first published 1880)

JOEL CHANDLER HARRIS

499. *Nights with Uncle Remus,* 1911 edition (first published 1881)

JOEL CHANDLER HARRIS

500. *Uncle Remus's Home Magazine*
December 1909

501. Movie poster for re-release of *Song of the South*

WALT DISNEY PRODUCTIONS

1972

502. Brer Rabbit doll

MADE FOR MOUSEKETOYS BY CANASA TRADING CORPORATION

Sri Lanka, 1994

503. *Further Tales of Uncle Remus*

JULIUS LESTER

1990

504–5. Shucking pins, hardwood and leather

(dark) Buncombe County, N.C., 1800s

(LIGHT) CARL SUTTON

Cleveland, White County, Ga., 1969

These implements were worn on the middle finger inside the hand to facilitate tearing the shucks from ears of corn.

506–7. Cornshuck dolls

CAROL TUGGLE

Atlanta, Fulton County, Ga., 1973

Tuggle learned this folk art from her grandmother in Waverly, Chambers County, Alabama. In her family tradition, the dolls represent pioneers and Indians and have featureless faces.

508. Miniature cornshuck mop (with other household items)

CARL L. STEPP

McCaysville, Fannin County, Ga., 1969

Shucks were doubled over and jammed into holes bored in a long-handled board. The mop was then used with soapy water and sand to scrub wooden floors. Shucks also were used to stuff mattresses and pillows, to plait chair seats and doormats, and as sausage casings.

509. Old European violin

"Repaired" by a handyman of fiddler Bob Martin at Reynolds, Taylor County, Ga., early 1900s

The difference between a violin and fiddle lies in the kind of music played. This example was made for classical music but was adapted for folk music when brought to the South. Echoing bagpipe music of the British Isles, southern fiddling features a drone or harmonic sound produced by bowing more than one string at a time, aided by a flattened bridge.

510. Fiddle, galvanized iron and wood canister body

Roswell, Fulton County, Ga., late 1800s

This fiddle probably sounded tinny. It cannot be held in the normal position, so was played vertically, resting on the thigh. The neck brace, tailpiece, and nut are of hand-forged iron.

511–13. Fiddle, poplar (with broomstraws)

J. W. EASLEY

McCaysville, Fannin County, Ga., 1950

The label inside this instrument is signed, dated, and inscribed "King Town Special," referring to McCaysville's

early name. In a tradition called "beating straws," the fiddler's partner tapped a pair of broomstraws on the strings between where they were being noted and bowed. This accentuated a tune's rhythm so it could be heard over the din of dancers' feet.

514. Fiddle
SHERMAN CAGLE
Jasper, Pickens County, Ga., 1967
This instrument's top is straight-grained forest pine from a ceiling board of a century-old local church that was being remodeled; the sides and tailpiece are cherry from a tree on Cagle's farm; and the back is "fiddle-back," or curly, maple obtained by his son in the lumber industry.

515. Limberjack, painted yellow pine
WILLY (SURNAME UNKNOWN)
Macon, Bibb County, Ga., 1950s
This African American folk doll was operated by anchoring under the thigh one end of a thin paddle while tapping its free end, on which the doll's feet were placed, in time to music. The jointed doll, held by the stick at its back, was thus made to dance.

516. *Kora*
West Africa, mid-1900s
This souvenir miniature of a venerable African instrument belongs to a family of gourd-bodied, skin-headed lutes that are ancestors of the American banjo.

517. Fretless banjo
Union County, N.C., late 1800s
The banjo's popularity in blackface minstrel shows prompted factories to mass-produce the instrument with guitarlike metal frets in the fingerboard. Handmade banjos often kept the earlier fretless neck, which facilitates a sliding sound suited to old-time (pre-bluegrass) picking.

518. Fretless banjo
M. C. TEACHAM (SIGNED AND DATED INSIDE)
Probably east Tennessee, 1894
Banjos used for southern folk music have five strings, one of them a high-pitched drone tuned partway up the neck. Fondness for a drone sound to complicate the melody may explain why mountain musicians adopted the African American instrument.

519. Fretless banjo, cigar box
H. V. BOYD (SIGNED ON BACK)
Sparta, White County, Tenn., mid-1900s
This cigar-box instrument illustrates the "make-do" tradition of adaptive reuse.

520. Fretless banjo, black walnut
LEONARD GLENN
Sugar Grove, Watauga County, N.C., 1974
With its three-piece wooden body and inset, small-diameter skin head, this banjo is typical of those handmade in Appalachia for a century. Leonard and his son, Clifford Glenn, are among the best-known folk instrument makers in western North Carolina.

521. *Scheitholt,* black walnut
HENRY BRUBACHER (ACCORDING TO AN INSCRIPTION ON THE TAILPIECE)
Lancaster County, Pa., ca. 1810
This Pennsylvania German zither had seven strings, two of which were noted on the wire frets, the others strummed open as drones. A southern upland fondness for the drone sound in fiddling may have contributed to Appalachian adoption of the *Scheitholt.*

522. Appalachian dulcimer, black walnut
East Tennessee, 1860s–1880s
This teardrop shape is one of several into which the Pennsylvania German *Scheitholt* evolved in Appalachia. The surviving two (of four) tuning keys are hand-forged iron, the frets are wire, and the bridge and nut are bone.

523. Appalachian dulcimer, butternut and black walnut with rosewood tuners and wire frets

MCALLEN MYERS

Young Harris, Towns County, Ga., 1969

Kentucky folk singer Jean Ritchie popularized the dulcimer in the 1960s and stimulated a revival in its playing and making. At that time the wasp-waisted shape typical of Kentucky dulcimers became the norm. The heart-shaped sound holes are a carryover of the Pennsylvania German folk-art motif.

524. Appalachian dulcimer, curly cherry with rosewood tuners

ROBERT MIZE

Blountville, Sullivan County, Tenn., 1992

A native of Rabun County, Georgia, Mize learned woodworking from his cousin, McAllen Myers. However, he borrowed his dulcimer design from Kentuckian Homer Ledford, one of the first revivalist makers, who took his pattern from an instrument by J. E. Thomas. The Delrin plastic bridge and nut on this example are the modern equivalent of the bone used on early dulcimers.

525. Pulpit, painted yellow pine

South Georgia, late 1800s

This pulpit was used in an unidentified African American church.

526–29. *Original Sacred Harp,* **1911 and 1991 editions, with other shape-note hymnals**

The names of the notes (fa, sol, la, mi) for all parts of a song's harmony are customarily sung before the words; this is known as solmization.

530–31. Slide-whistle pitchpipes, walnut cases

(small) Georgia, late 1800s; (large) South Carolina, late 1800s

These handmade pitchpipes were used for church singing. The larger one has a lead strip stamped with the notes of the scale inset into the wooden slide.

532. Devil's costume, satin

Atlanta, Fulton County, Ga., ca. 1970

This costume was worn for Big Bethel African Methodist Episcopal Church's folk play, *Heaven Bound,* by Henry Furlow, who played Satan for nearly fifty years before retiring in the late 1970s.

533. Angel's wings, paper

Atlanta, Fulton County, Ga., 1940s

These wings were preserved from early productions of *Heaven Bound.*

534. *Heaven Bound* **poster**

Atlanta, Fulton County, Ga., 1994

535–36. Christening mugs, milk glass

Austria, early 1700s

537–38. "Birth pennies," copper

England, 1701 and 1797

The mugs, customary christening gifts in Europe, were brought by Salzburger immigrants Ann and Catherine Floerl to Ebenezer, Effingham County, Georgia, in the 1730s. As another Salzburger custom, the pennies were given at birth to Christian Herman Dasher and James Wisenbaker of Georgia.

539. Christening gown, cotton

MRS. JOHN M. BERRY

Rome, Floyd County, Ga., 1868

Christening gowns are still traditionally made in the South. This example was made for Venerable Mitchell.

540. Grave marker, painted yellow pine

SIGNED "W. R."

Luthersville, Meriwether County, Ga., 1835

This wooden marker, made for John C. Martin, was preserved (and replaced with a stone marker) by descendants, who turned it into a coffee table.

541. Jug, ash glaze, possibly a grave "decoration"
Middle Georgia, ca. 1870
The small hole pierced in the wall of this jug suggests use on an African American grave. Such careful breaking was said to "break the chain of death."

542. Cat, buckeye
HOPE BROWN
Brasstown, Clay County, N.C., 1992

543. Squirrel, butternut
JAMES A. MORRIS
Brasstown, Clay County, N.C., 1992

544. Bull, cherry
CLAUDE HAWKINS
Cookeville, Putnam County, Tenn., 1992
About 1930, Olive Dame Campbell, founder of the John C. Campbell Folk School in Brasstown, North Carolina, persuaded a group of men at the "whittlers' bench" of a local store to carve for sale. The resulting Brasstown Carvers, to which these three belong, are still active.

545. Bear, cherry
VIRGIL LEDFORD
Wolfetown, Swain County, N.C., 1992

546. Bear cub, walnut
JOHN SMITH
Bryson City, Swain County, N.C., 1992
The Cherokee makers took classes from renowned Cherokee sculptor Amanda Crowe, who trained at the Art Institute of Chicago. Such carvings are marketed by Qualla Arts and Crafts Mutual in Cherokee, North Carolina.

547. Frog on a toadstool, tupelo
C. M. COPELAND JR.
Fitzgerald, Ben Hill County, Ga., 1980s
Recalling childhood visits with Georgia mountain whittlers, Copeland began carving in 1956 and made it his profession. Using both hand and power tools, he has produced more than a hundred thousand carvings, sold mainly at craft fairs.

548. Bowl, pewter, dogwood design
DEE SHOOK AND LEO FRANKS, RIVERWOOD PEWTER SHOP
Dillsboro, Jackson County, N.C., 1992
With skills acquired at Penland School (founded by his aunt, Lucy Morgan), Ralph Morgan established Riverwood Pewter in the 1940s, teaching the craft to brothers Ray and Dee Shook. The sheet metal (a lead-free Brittania alloy of tin, copper, and antimony) is hand-hammered on wooden molds.

549. Shawl, silk, "Dynamic Symmetry" design
THE WEAVERS OF RABUN
Rabun Gap, Rabun County, Ga., mid-1900s
The Weavers of Rabun was the brainchild of Mary Crovatt Hambidge, who was inspired by handweaving she saw in Greece. She employed local mountain women to produce a fashionable line of homespun clothing sold at her Rabun Studios outlet in New York City.

550. Vase, salt glaze, cobalt-blue and incised decoration
JAMES H. OWEN
Moore County, N.C., 1915–20
A folk potter's early appeal to an outside market, this vase may have been made for sale at the Village Store, Juliana Busbee's New York City tearoom, before she and her husband, Jacques, opened the Jugtown Pottery in central North Carolina in 1921.

551. Vase, "frogskin" (salt over Albany slip) glaze
BEN OWEN III
Seagrove, Moore County, N.C., 1994
"Translations"—wares combining local glazes and forms with those of the Far East—were developed at the Jugtown Pottery, where the maker's grandfather, Ben Owen Sr., worked for many years.

552. Coiled-grass basket materials

ASSEMBLED BY JANIE HUNTER

Johns Island, Charleston County, S.C., 1969

Sweetgrass and longleaf pine needles make up the coils, with palmetto strips to bind them together. Before development limited access to sweetgrass, all three materials could be gathered near the makers' homes. Hunter, leader of the Moving Star Hall Singers and 1984 National Heritage Fellow, was learning basketry late in life when she assembled these materials.

553. "Bone," or sewing awl, stainless steel

ANNIE SCOTT

Mt. Pleasant, Charleston County, S.C., 1980s

This specialized tool is used for splitting the palmetto into strips and opening a space in the coil through which to pull the palmetto binder. Once made of animal bone, it is now customarily made from a metal teaspoon.

554. Basket, sweetgrass

Mt. Pleasant, Charleston County, S.C., ca. 1940

This style of basket was marketed by Clarence Legerton's Sea Grass Basket Company as early as 1920.

555. Knitting basket, sweetgrass

FLORENCE MAZYCK

Mt. Pleasant, Charleston County, S.C., 1994

This basket, with bulrush added for strength, is of a design related to earlier lidded containers.

556. "In and out" or "snake" basket, sweetgrass

ALETHIA FOREMAN

Mt. Pleasant, Charleston County, S.C., 1994

Of a later design, this basket is coiled counterclockwise, a sign that the maker is left-handed.

557. "Milk bottle" basket, sweetgrass

ELIZABETH MAZYCK

Mt. Pleasant, Charleston County, S.C., 1994

This symmetrical basket of a later design includes bulrush.

558. "Missionary bag," sweetgrass

HERLINE COAKLEY

Mt. Pleasant, Charleston County, S.C., 1992

This is a difficult later design mastered by only a few makers.

559. Hat, sweetgrass

ALEATHIA MANIGAULT

Charleston, Charleston County, S.C., 1992

This updating of the old palmetto hat, which includes bulrush, can be worn in several different ways.

560. "Wall hanger" or "centerpiece," sweetgrass

SUE MIDDLETON

Mt. Pleasant, Charleston County, S.C., 1994

This piece, with added bulrush, clearly shows the decorative direction this basketry tradition has taken in response to a tourist market.

561. "Laser jug," ash glaze

LANIER MEADERS

Mossy Creek, White County, Ga., 1967

Lanier had read an article on lasers, which he interpreted as concentrated red light. He made a pair of "laser jugs" based on the old syrup-jug form, with holes for lightbulb sockets and an electric cord. The mouths were meant to face each other and produce a steel-piercing beam; but one jug was ruined in the firing. The experiment reminds us that contemporary southern folk potters take part in the modern world.

562. Syrup jug, ash glaze

CLEATER "C. J." AND BILLIE MEADERS

Warner Robins, Houston County, and Cleveland, White County, Ga., 1992

At the centennial celebration for the founding of the Meaders Pottery, this commemorative piece, inscribed with the names of all the family potters, was presented to the Atlanta History Center by its makers. It demonstrates the family's awareness of its place in southern ceramics history.

563. Jar, ash glaze, tooled decoration

MICHAEL CROCKER

Lula, Banks County, Ga., 1993

Crocker, who trained at the Wilson and Craven garden potteries in northeast Georgia, has great respect for the old alkaline-glazed stoneware tradition. In its size (nearly three feet tall) and poetic inscription, this four-handled jar pays indirect homage to Dave, the South Carolina slave potter. The poem reads, "Of great size this jar I have made, After many long years of learning the trade. Though there's not much for it now to hold, A part of the past our eyes can behold. From eighty-five pounds of clay this piece was turned, May it honor old-time potters from whom I have learned. Once the needs of our daily lives it met, Now a still reminder . . . lest we soon forget."

564. Rooster, lime glaze

EDWIN MEADERS

Mossy Creek, White County, Ga., 1982

565. Chicken bowl, "glass" glaze with melted-glass decoration

GRACE HEWELL

Gillsville, Hall County, Ga., 1996

These whimsical fowl illustrate the contemporary folk potter's orientation to a collectors' market. Edwin, Lanier Meaders's younger brother, learned to make stoneware roosters from their mother, Arie, who developed the design; both it and Grace's bowl are hand-built on a wheel-thrown body.

566. Unfinished quilt, "Grandmother's Fan" pattern

TOP BY EDNA MCGHEE

Jacksboro, Campbell County, Tenn., 1988

567. Quilting frame, white pine

R. E. MULINIX

Kingston, Bartow County, Ga., 1986

The sewing machine–pieced top and polyester batting illustrate southern quilters' adaptation to modern technology.

The stitching was done by children at Atlanta History Center Folklife Festivals from 1988 to 1991 and supervised by Martha Mulinix of Kingston, a major figure in contemporary Georgia quilting. Her husband built the frame based on one his father made in the 1920s.

568. Centennial Olympic Games quilt, *Go for the Gold—A Heart of Gold*

CINDY ROUNDS RICHARDS

Decatur, DeKalb County, Ga., 1996

In 1992 the Georgia Quilt Project, formed to research quilts throughout the state, began recruiting volunteers to make four hundred lap-size quilts to welcome participants in the 1996 Olympics. For project chair Anita Weinraub, "This was an opportunity to share quiltmaking—part of our cultural heritage—with the world." A duplicate of one of the original gift quilts, this extraordinary example expresses the sensibilities of a studio quilter.

569–71. *Pysanky*, or Easter eggs, wax-resist dyes

Atlanta area, Fulton County, Ga., early 1990s

Job transfers largely account for Atlanta's small Ukrainian American community. As in Europe, the eggs—decorated with symbols of spring—are given as gifts, but here they take on the added function of ethnic identity.

572–73. Drake and hen wood-duck decoys, painted tupelo

ERNIE MILLS

Perry, Houston County, Ga., 1990 and 1993

These are working decoys, with keel, hole for anchor line, lead balance weight, and paintbrush stippling "to cut the shine." The white "eyeliner," a Delmarva Peninsula trait, is thought to make the eyes more visible to flying ducks. With their finer carving and painting, however, these are Ernie's premium grade decoys, meant mainly for collectors.

574–80. Tools, patterns, and in-process decoys

MADE OR USED BY ERNIE MILLS

Perry, Houston County, Ga., mostly 1980s–early 1990s

Ernie is one of the last carvers in the country to shape his bodies with a hatchet rather than power tools.

581–82. Bobbin lace in process, linen thread, "Bucks Point" pattern
BETTY KEMP

583–84. Pillow stand and seventy lathe-turned bobbins, various woods
MELVILLE ANGUS "MAK" KEMP
Powder Springs, Cobb County, Ga., 1994
Bobbin lace making is a weaving process that follows a pricked paper pattern, with a pillow and pins serving as the loom. The bobbins, "spangled" with glass beads for weight, are manipulated as shuttles to create the lace. Betty brought this pillow from England and later recovered it.

585. Hat for Hmong girl's New Year's costume
MAY YANG MOUA
Decatur, DeKalb County, Ga., 1989
Hmong textile arts began with decorated clothing; designs and techniques then were transferred to flower-cloth wall hangings.

586. Flower-cloth wall hanging, appliqué with cross-stitch
MAY SIONG MOUA
Lawrenceville, Gwinnett County, Ga., 1996
This traditional design of interconnected bands, which may represent family lineage or the irrigated fields surrounding a village, is typical of the Blue Hmong subgroup; the design also appears on the collars of girls' costumes.

ALTERNATE
586A. Flower-cloth wall hanging, reverse-appliqué
MAY YANG MOUA
Decatur, DeKalb County, Ga., 1989
This design features the water-snail motif.

587. Story cloth, silk-thread embroidery
MAY SIONG MOUA AND SIONG PANG
Lawrenceville, Gwinnett County, Ga., 1996
Plants and animals of Laos are typical subjects for story cloths; according to May, this design shows Laos as a Garden of Eden.

ALTERNATE
587A. Story cloth, silk-thread embroidery
MAY TONG MOUA
Lilburn, Gwinnett County, Ga., 1991
This wall hanging illustrates the Hmong exodus from Laos. While Communist forces attack a Hmong village (at top), the fleeing villagers (wearing pack baskets) cross the Mekong River to be welcomed by Thai soldiers and immigration officials.

588. Turtle pincushion
MAY SIONG MOUA
Lawrenceville, Gwinnett County, Ga., 1996
This is one of the newer items created for sale at crafts fairs. It features the traditional water-snail design in cross-stitch.

589. Statue of La Virgen de la Caridad, painted plaster
Spain, 1995
Cubans in Atlanta decorate a statue of the Virgin of Charity on September 8 (or the closest Sunday) to honor this patron of Cuba. The image itself is not folk art, but its use in the feast-day celebration involves folk customs. The original statue, now in a church in El Cobre, Cuba, was found in the Bay of Nipe around 1605. According to legend, three fishermen were caught at sea in a storm; when they found a floating statue of the Virgin, the storm was calmed and they were saved.

590. Home altar
LOURDES CHAVEZ
Atlanta, Fulton County, Ga., 1995
Built for this exhibition, the altar honors Mexico's beloved saint, Our Lady of Guadalupe. It also asks San Antonio, the patron saint of lost things, for the affections of a former sweetheart. The density and bright colors reflect Mexican aesthetics. Chavez explains, "The altar is very full, leaving little empty space. This comes from the Aztec idea that empty space is dangerous." The hummingbird is an Aztec symbol of love.

591–92. Woman's and man's dance costumes

ELENI APOSTOLOKOS HOPES

Atlanta, Fulton County, Ga., 1995

Hopes, director of Troupe Hellas Greek Folkloric Society of Atlanta, has studied Greek folk dance and dress in her travels and created a wardrobe for the troupe representing twenty areas of Greece and Asia Minor. The female costume, or *desfina*, typical of the village of Roumeli, is paired with a *foustanella*, the traditional garb of a Greek soldier.

593. *Sunny Days* costume, paper, satin, mylar, and wire

ATLANTA CARIBBEAN ASSOCIATION

Atlanta, Fulton County, Ga., 1993

This costume was designed for the theme "Caribbean Days and Nights." For the first time since the Peach Carnival began, the Atlanta Caribbean Association took first prize in 1993, besting more established nonlocal groups. Atlanta bands have won the competition since then, working on their costumes months ahead.

594–608. Airplanes, folded notebook paper

GEORGIA STATE UNIVERSITY FOLKLORE STUDENTS

Atlanta, Fulton County, Ga., 1992–95

Learned informally in childhood, these sculptures reflect the importance of paper in our service-oriented society and exhibit the variation characteristic of all folk arts.

Suggested Readings

Adams, E. Bryding, ed. *Made in Alabama: A State Legacy*. Birmingham, Ala.: Birmingham Museum of Art, 1995.

Arnow, Jan. *By Southern Hands: A Celebration of Craft Traditions in the South*. Birmingham, Ala.: Oxmoor House, 1987.

Baldwin, Cinda K. *Great and Noble Jar: Traditional Stoneware of South Carolina*. Athens: University of Georgia Press, 1993.

Barker, Garry G. *The Handcraft Revival in Southern Appalachia, 1930–1990*. Knoxville: University of Tennessee Press, 1991.

Bridges, Daisy Wade. *Ash Glaze Traditions in Ancient China and the American South*. Charlotte, N.C.: Ceramic Circle of Charlotte (Journal of Studies 6) and Southern Folk Pottery Collectors Society, 1997.

Burdick, Nancilu B. *Legacy: The Story of Talula Gilbert Bottoms and Her Quilts*. Nashville, Tenn.: Rutledge Hill Press, 1988.

Burrison, John A. *Brothers in Clay: The Story of Georgia Folk Pottery*. Athens: University of Georgia Press, 1983.

———. *Handed On: Folk Crafts in Southern Life*. Atlanta: Atlanta Historical Society, 1993.

———, ed. *Storytellers: Folktales and Legends from the South*. Athens: University of Georgia Press, 1989.

Cauthen, Joyce H. *With Fiddle and Well-Rosined Bow: Old-Time Fiddling in Alabama*. Tuscaloosa: University of Alabama Press, 1989.

Coleman, Gregory D. *We're Heaven Bound! Portrait of a Black Sacred Drama*. Athens: University of Georgia Press, 1994.

Conway, Cecelia. *African Banjo Echoes in Appalachia: A Study of Folk Traditions*. Knoxville: University of Tennessee Press, 1997.

Downs, Dorothy. *Art of the Florida Seminole and Miccosukee Indians*. Gainesville: University Press of Florida, 1995.

Eaton, Allen H. *Handicrafts of the Southern Highlands*. 1937. Reprint, New York: Dover Publications, 1973.

Egerton, John. *Southern Food: At Home, on the Road, in History*. New York: Alfred A. Knopf, 1987.

Fleetwood, W. C., Jr. *Tidecraft: The Boats of South Carolina, Georgia, and Northeastern Florida, 1550–1950*. Tybee Island, Ga.: WBG Marine Press, 1995.

Hill, Sarah H. *Weaving New Worlds: Southeastern Cherokee Women and Their Basketry*. Chapel Hill: University of North Carolina Press, 1997.

Horton, Laurel. *Social Fabric: South Carolina's Traditional Quilts*. Columbia: McKissick Museum, University of South Carolina, n.d.

Irwin, John Rice. *Alex Stewart: Portrait of a Pioneer*. Exton, Pa.: Schiffer Publishing, 1985.

———. *Baskets and Basket Makers in Southern Appalachia*. Exton, Pa.: Schiffer Publishing, 1982.

———. *Guns and Gunmaking Tools of Southern Appalachia*. Exton, Pa.: Schiffer Publishing, 1983.

———. *Musical Instruments of the Southern Appalachian Mountains*. Exton, Pa.: Schiffer Publishing, 1983.

———. *A People and Their Quilts*. Exton, Pa.: Schiffer Publishing, 1983.

Joyner, Charles. *Shared Traditions: Southern History and Folk Culture*. Urbana: University of Illinois Press, 1999.

Koverman, Jill Beute, ed. *I Made This Jar . . . : The Life and Works of the Enslaved African-American Potter, Dave*. Columbia: McKissick Museum, University of South Carolina, 1998.

Law, Rachel Nash, and Cynthia W. Taylor. *Appalachian White Oak Basketmaking: Handing Down the Basket.* Knoxville: University of Tennessee Press, 1991.

Leftwich, Rodney L. *Arts and Crafts of the Cherokee.* Cherokee, N.C.: Cherokee Publications, 1970.

Neat Pieces: The Plain-Style Furniture of Nineteenth-Century Georgia. Atlanta: Atlanta Historical Society, 1983.

Roberson, Ruth Haislip, ed. *North Carolina Quilts.* Chapel Hill: University of North Carolina Press, 1988.

Rosenbaum, Art. *Folk Visions and Voices: Traditional Music and Song in North Georgia.* Athens: University of Georgia Press, 1983.

Rosengarten, Dale. *Row upon Row: Sea Grass Baskets of the South Carolina Lowcountry.* Columbia: McKissick Museum, University of South Carolina, 1986.

Smith, Jane Webb. *Georgia's Legacy: History Charted through the Arts.* Athens: Georgia Museum of Art, 1985.

Smith, L. Allen. *A Catalogue of Pre-Revival Appalachian Dulcimers.* Columbia: University of Missouri Press, 1983.

Vlach, John M. *The Afro-American Tradition in Decorative Arts.* 1978. Reprint, Athens: University of Georgia Press, 1990.

———. *Charleston Blacksmith: The Work of Philip Simmons.* Athens: University of Georgia Press, 1981.

Wadsworth, Anna, ed. *Missing Pieces: Georgia Folk Art, 1770–1976.* Atlanta: Georgia Council for the Arts, 1976.

Wagner, Pamela. *Hidden Heritage: Recent Discoveries in Georgia Decorative Art, 1733–1915.* Atlanta: High Museum of Art, 1990.

Whisnant, David E. *All That Is Native and Fine: The Politics of Culture in an American Region.* Chapel Hill: University of North Carolina Press, 1983.

Wigginton, Eliot, et al., eds. *The Foxfire Book* and *Foxfire 2* through *10.* New York: Doubleday, 1972–93.

Wilson, Sadye Tune, and Doris Finch Kennedy. *Of Coverlets: The Legacies, the Weavers.* Nashville, Tenn.: Tunstede, 1983.

Zug, Charles G. *Turners and Burners: The Folk Potters of North Carolina.* Chapel Hill: University of North Carolina Press, 1986.

Index of Folk Artists

Artists are listed by their familiar, rather than full legal, names. Maiden names of married women are given when they clarify family connections. The artists' skills, as represented in the exhibition, are indicated in parentheses; page numbers illustrating artists or their work are italicized.